THE WHITE HOUSE
COLLECTION OF
AMERICAN CRAFTS

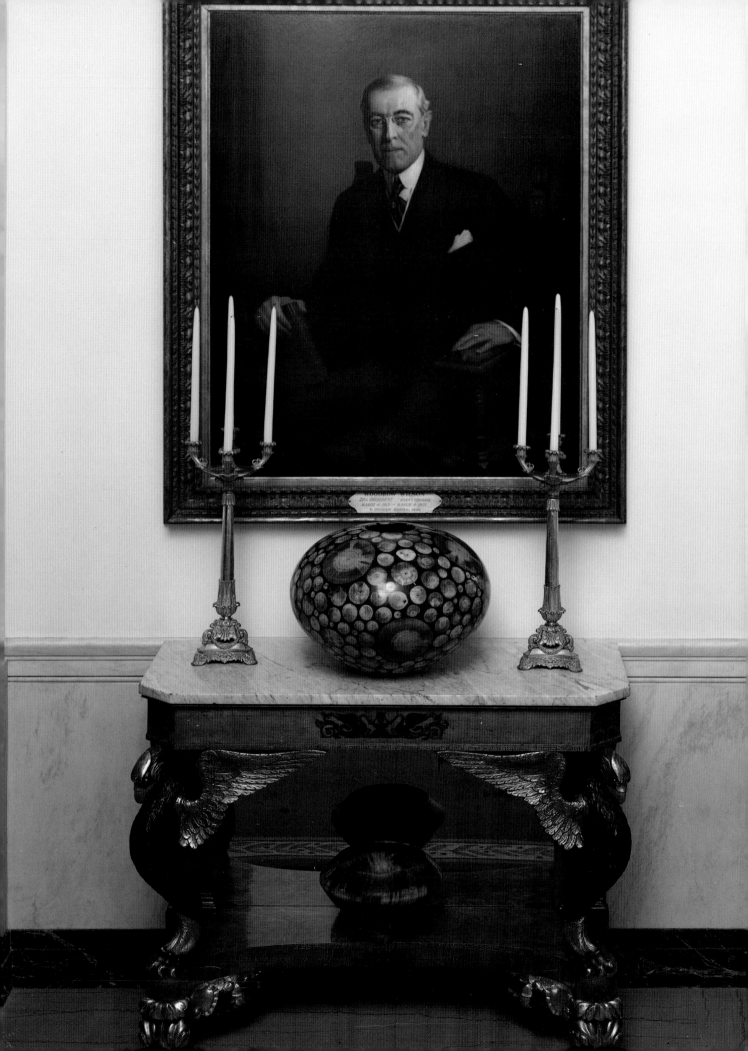

THE WHITE HOUSE COLLECTION OF AMERICAN CRAFTS

MICHAEL W. MONROE
WITH AN ESSAY BY BARBARALEE DIAMONSTEIN
FOREWORD BY ELIZABETH BROUN

PHOTOGRAPHY BY JOHN BIGELOW TAYLOR

HARRY N. ABRAMS, INC., PUBLISHERS

EDITOR: ELISA URBANELLI
ART DIRECTOR: SAMUEL N. ANTUPIT
DESIGNER: LIZ TROVATO
PHOTOGRAPHIC STYLIST: S. DIANNE DUBLER

Library of Congress Catalog Card Number: 95–75050
ISBN 0–8109–4035–3

Published in 1995 by Harry N. Abrams, Incorporated, New York
A Times Mirror Company

This book was published to accompany an exhibition at the
National Museum of American Art
Smithsonian Institution
Washington, D.C.
April 28, 1995 through September 4, 1995

Printed in the United States of America by Berger McGill, Cincinnati, Ohio

Page 2: **WHITE PINE MOSAIC BOWL** *(on tabletop)* BY PHILIP MOULTHROP
AND **TRANSLUCENT WOOD BOWL** *(on shelf below)* BY RONALD E. KENT, in The Grand Staircase

CONTENTS

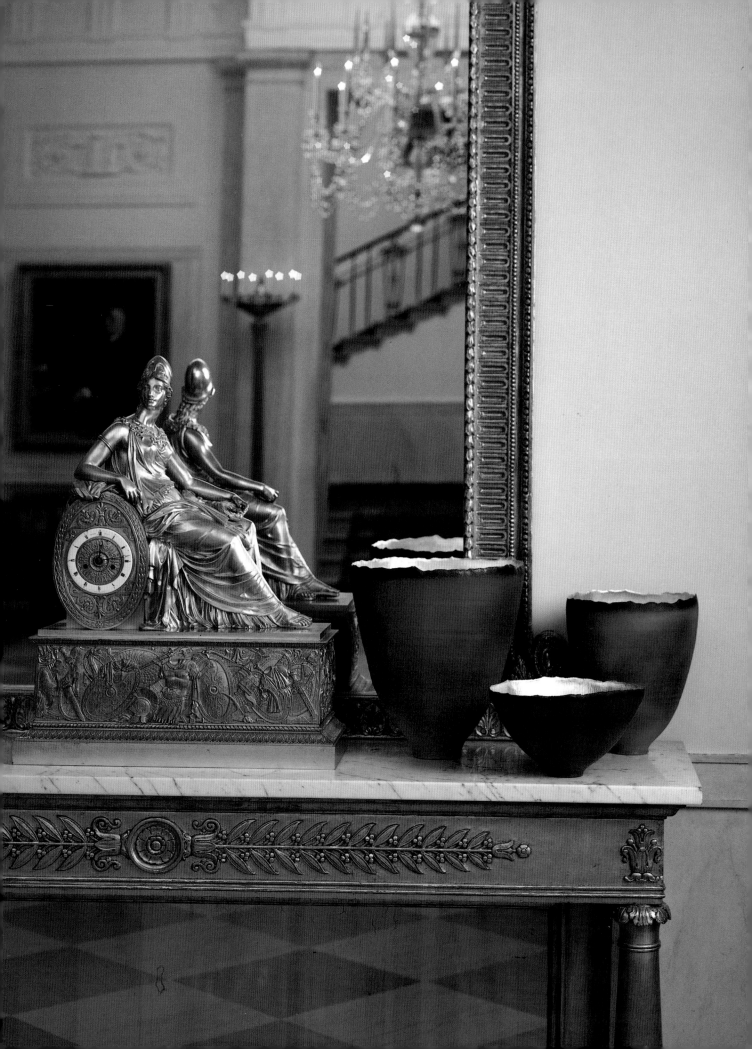

OPENING STATEMENT

The President and I like to think of the White House as the American people's house. Not only is it a place where the executive branch conducts the people's business, it is also a 200-year-old living museum of American art and history. Thousands of visitors tour the building each day, taking in the elegant simplicity of James Hoban's architecture, the natural beauty of the gardens, and the grandeur of the formal rooms. Visitors leave with a new appreciation of the rich culture that links our past, present, and future as Americans.

In January 1993, when the President and I moved into the White House, we became guardians of this living museum and the traditions it represents. We wanted to make sure the White House continued to reflect the vital role that art and culture have played in our democracy for more than two centuries. And with our nation just beginning to celebrate the "Year of American Craft," it seemed only fitting to make the "people's house" a showcase for one of our nation's oldest cultural forms.

Crafts have been an integral part of American life since Colonial times, as objects of utility and as aesthetic additions to our daily surroundings. But there is also a human dimension that connects us in a special way to American crafts. These artists create with their hands. And they pass on their skills from generation to generation: from fathers to sons, mothers to daughters, and grandparents to grandchildren. As a result, what might have been a dying art form after the Industrial Revolution is today one of our most vibrant, creative forms of cultural expression.

The idea of displaying American crafts in the White House began long before our celebration of the Year of American Craft. For example, First Lady Ellen Wilson decorated rooms in the private quarters with weavings from Tennessee and the Carolinas. First Lady Eleanor Roosevelt furnished an upstairs bedroom with crafts from her Val-Kill project and from the Works Progress Administration. Presidents and First Ladies often have displayed crafts at holiday celebrations and as table centerpieces at White House functions.

The Year of American Craft in 1993 presented us with a wonderful opportunity to display contemporary American crafts in the formal public rooms of the White House.

To help assemble a collection, I turned to one of the nation's experts, Michael W. Monroe, Curator-in-Charge of the Smithsonian Institution's Renwick Gallery of the National Museum of American Art. His idea was to identify works of leading artists as well as those who are just emerging. The seventy-two objects he selected come from all regions of the country and include works in wood, glass, metal, fiber, and clay. All were donated by the artists or their patrons.

I only wish every one of our citizens could have seen these exquisite works displayed at the White House, along with craft ornaments decorating the many Christmas trees on view that first holiday season. Thousands of Americans shared in their beauty over the holidays, and more than 1.5 million others have had a chance to enjoy them while visiting the White House in the months since then.

The President and I are delighted that this magnificent White House collection of American crafts will now be on display at the National Museum of American Art and available to an even wider audience. The pieces represent the extraordinary beauty and diversity of American craftsmanship as well as the generous spirit of our artists. It is our hope that the exhibition, along with this book and a "virtual tour" on the Internet, will help further appreciation of crafts as an essential part of our cultural life.

Hillary Rodham Clinton

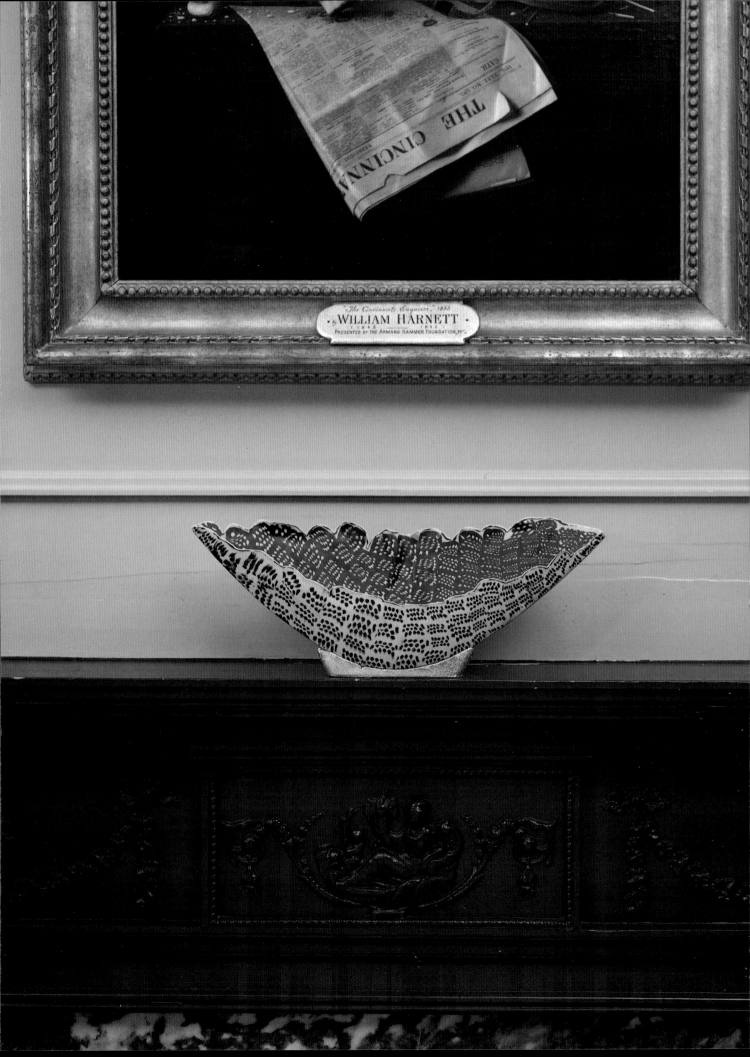

FOREWORD

President William J. Clinton and First Lady Hillary Rodham Clinton moved into the White House in January 1993, just at the beginning of the designated "Year of American Craft: A Celebration of the Creative Work of the Hand." Then-President George W. Bush had signed the presidential proclamation just months before to recognize the achievements of thousands of artists whose aesthetic ingenuity centers on craft processes and materials.

To make the celebration truly special, President and Mrs. Clinton graciously decided to turn their new home into a showcase for craft art, and just before the holidays in 1993, seventy-two donated objects were installed throughout the formal rooms of the White House. Since then, over one million guests and tourists have admired these remarkable works. This book and the public exhibition at the National Museum of American Art that it accompanies are ways of sharing the collection with a wider public.

One hallmark of American democracy has been the accessibility of our leaders, including the president. Stories abound from the early decades of our history about the unruly guests at Andrew Jackson's inauguration party who celebrated the era of the common man until the White House was left a shambles, or the many petitioners, job-seekers, veterans, and widows who daily lined the corridors of the house during Abraham Lincoln's presidency.

In the Gilded Age, celebrities in government, industry, and the arts began to cater to the interest of others in the way they lived by having their private living quarters removed far from the salons, smoking rooms, banquet halls, ballrooms, picture galleries, and lobbies of their homes, which were then embellished as quasi-public spaces for display and entertainment. The interior design movement of the 1870s spawned a sophisticated decorative aesthetic and the vogue for giving each room a distinctive character.

In the White House, too, the formal rooms were made over in the early 1880s by the nation's foremost design firm, headed by Louis Comfort Tiffany. Under his experienced hand, the first floor became a dazzling visual stage, with fashionable glass screens and other embellishments. The idea began to take hold that the president's residence was a unique ceremonial site for the nation. Decades later, as First Lady Jacqueline Kennedy led Americans on a televised tour of the home with its early furnishings newly restored, we learned again to feel the special connection to our shared culture that the White House offers.

In 1972, the Smithsonian opened a new museum dedicated to crafts in a landmark French Second Empire building across the street from the White House and next door to Blair House, where foreign heads of state stay on official visits. The Renwick Gallery—named for architect James Renwick, and administratively a part of the National Museum of

American Art—developed an ambitious exhibition program highlighting the rich diversity of art in craft mediums such as wood, metal, fiber, glass, and clay. There was a special focus in the program on the studio crafts movement begun in the late 1940s, a marriage of hand-craft traditions and postwar industrial processes and techniques. By the time the Renwick was founded in the early 1970s, a generation of inspired studio craft artists had established an exciting array of possibilities for expression.

New collectors responded enthusiastically to the new crafts featured at the Renwick, finding the combination of form and function, elegance and spontaneity, tradition and experiment to be irresistible. In 1977, Joan Mondale (herself a ceramicist) moved into the Vice President's residence, and she filled the home with the American art and studio crafts that she loved. In presenting this collection in a series of installations, Mrs. Mondale worked closely with Michael W. Monroe, curator at the Renwick Gallery.

Over the past decade, the Renwick has also built a collection of contemporary crafts representative of the best in America. To celebrate the official "Year of American Craft" in 1993, Michael Monroe, now curator-in-charge of the Renwick Gallery, selected almost 200 objects from the gallery's holdings for an exhibition called *American Crafts: The Nation's Collection.* When the President and First Lady decided to form the White House American craft collection, they naturally turned to Mr. Monroe to serve as curator. His idea was not to present a comprehensive survey of American crafts as one might encounter in a museum setting, but rather to make this a collection that is integrated with the furnishings of the house's formal interiors. Key objects were chosen for defined places in each room, with works selected to complement or embellish the character of each environment. As this book reveals, The White House Collection of American Crafts that resulted greatly enhances the ambience of the president's home.

Without doubt, it is the artists themselves who are truly responsible for the extraordinary success of this landmark collection. Each responded generously to the opportunity with an offering of creativity that constitutes a lasting gift to all American citizens. All works in the collection were donated either by the artists directly or by their patrons, for the purpose of enriching the White House with the finest examples of contemporary American craft art. The recognition of their talents by the White House is a fitting tribute to a long tradition of excellence in crafts. It is a pleasure for the National Museum of American Art through its Renwick Gallery to participate in forming this historic collection and sharing it with the American public.

Elizabeth Broun
Director, National Museum of American Art
Smithsonian Institution

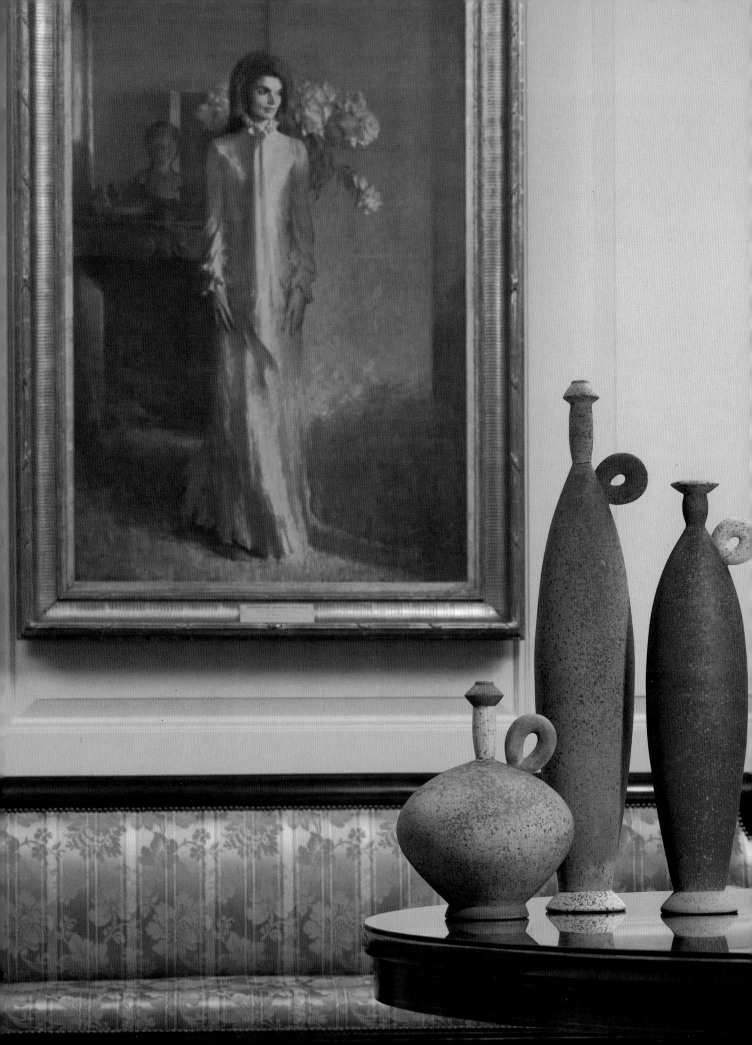

The White House Collection of American Crafts

Michael W. Monroe

We've tried to elevate the role and visibility of American artisans, because there is some very fine work being done. We look at some of the [decorative arts] that were given to the White House as gifts or were purchased during the nineteenth century—and they were crafts of their time, so I think it's important that we appreciate the artistry of crafts of our time.

Hillary Rodham Clinton
quoted in ARTnews, *September 1994*

Assembled in 1993, the White House collection of American crafts features seventy-two works by seventy-seven of America's leading craft artists of today. The support, encouragement, and visibility given to contemporary American crafts in the White House by President William Jefferson Clinton and First Lady Hillary Rodham Clinton serve as recognition of our country's longstanding tradition of craftmaking and a tribute to the richness and diversity of this important aspect of our heritage.

The pieces within the collection illustrate the skill, imagination, and vitality characteristic of craft in the 1990s. Using glass, wood, clay, fiber, and metal, these artists reveal their ability to manipulate materials in inventive ways, expressing their creative vision in objects of startling beauty. As the most industrialized century of our history draws to a close, this collection stands as testimony to a belief in the value of works of the hand. Despite our increasing reliance on computer technology, the intimate and physical qualities of the handmade object have never had more appeal.

The most frequently toured home in the United States, the White House is a symbol of America's history, leadership, ideals and aspirations. Well over a million visitors tour the White House annually to view the fine works on display: paintings and sculptures whose subjects include American themes, landscapes, and portraits of Presidents and First Ladies; antique furniture and decorative arts in period settings; and memorabilia of historical significance. From its first residents, John and Abigail Adams, in 1800 to the Clintons in 1993, each succeeding First Family has brought to the Executive Mansion its own interests and personal style. This is apparent in the manner in which each family goes about choosing and rearranging the artworks and furnishings and tailoring the spaces to suit its tastes and needs.

Mrs. John F. Kennedy's interests in the restoration of the White House and in acquiring American paintings and period furnishings, French antiques, and fine objects of decorative art inspired the founding of the White House Historical Association in 1961. Association funds are used to publish materials about the White House, to acquire works of art, and to assist in the care and refurbishment of the interiors of the house and its collection.

Support for American crafts in the White House is not without historical precedent. In 1882, President Chester Alan Arthur commissioned Louis Comfort Tiffany of New York City to create a dazzling colored-glass screen for the Cross Hall. Former First Ladies known for promoting crafts include Ellen Wilson, Eleanor Roosevelt, and Rosalyn Carter.

In 1913, Ellen Wilson, the first Mrs. Woodrow Wilson, created the "Blue Mountain Room," furnished with handwoven coverlets, fabrics, bureau scarves, and floor-coverings made by women from the Blue Ridge Mountains of North Carolina and Tennessee. The wives of government officials and the people of Washington, D.C., were welcomed to visit the room, meet the weavers, and place orders for their work, thus helping to sustain their craft.

An enthusiastic promoter of crafts, Eleanor Roosevelt, along with three other women, organized Val-Kill Industries in 1927. Established in Hyde Park, New York, it was a small workshop producing Colonial Revival furniture and other crafts to be sold exclusively through W. and J. Sloane of New York City. For models, the craftsmen looked at pieces in the American Wing of the Metropolitan Museum of Art which had opened in 1926 as a permanent gallery for decorative arts. The Roosevelts acquired pieces from a Val-Kill maple bedroom suite for the private quarters of the White House. Several coverlets, woven in Virginia under the auspices of the Works Progress Administration (WPA), were purchased later for use in the bedrooms.

In May of 1977, First Lady Rosalyn Carter hosted the Senate wives at a traditional luncheon in an untraditional style. Instead of setting tables with the official White House china and glassware, she chose instead to feature dinnerware, glasses, napkin rings, and centerpieces made by hand by contemporary American craft artists, who lent their pieces especially for the occasion. Each table at the luncheon in the State Dining Room highlighted the work of a different potter, glassblower, metalsmith, or basket maker.

The hallmark of the collection formed by President and Mrs. Clinton—and what distinguishes this effort to promote crafts from those before it—is the conviction that these pieces continue to be seen by the greatest number of visitors possible. Since the initial showing in December 1993, the collection has been displayed on a rotating basis in the public spaces of the White House, viewed and admired daily by visitors, special guests, and dignitaries. Many pieces have been featured as centerpieces for Presidential dinners and other social events. A late-eighteenth-century English library bookcase in the West Wing Reception Room near the President's Oval Office has exhibited several objects in the collection, and certain pieces were chosen by the First Family to be enjoyed in the private quarters.

"The Year of American Craft: A Celebration of the Creative Work of the Hand" was mandated by a Joint Resolution of Congress and a Presidential Proclamation that provided the stimulus and theme for the 1993 holiday season at the White House. President and Mrs. Clinton wholeheartedly embraced this effort as a way to encourage appreciation of hand crafts and pay them tribute as symbols of cultural richness and enduring excellence in America.

Conceived by a national body of leading craft artists and advocates, the Year of American Craft represented the broad spectrum of craft throughout the United States, Canada, Latin America, and the Caribbean. The primary goals were to heighten awareness of how craft reflects the cultural diversity and spiritual life of each country and to explore the ways in which contemporary crafts express our multiple visions.

Throughout the Americas, craftspeople, collectors, educators, and craft enthusiasts found innovative ways to share their belief that craft is the handprint of all cultures. Some of the various programs organized on the theme included national, regional, and local exhibitions; publications; public dialogue through conferences, symposia, and educational outreach for all

ages and levels of involvement; governmental resolutions and endorsements; celebrations and festivals; recognitions, awards, and fellowships; films and television coverage; scholarly research concerning the historical development of crafts and the social and economic impact of craft enterprises on their communities; and many collaborations among individuals, private institutions, public agencies, and professional communities at all levels.

The White House's participation in the Year of American Craft during the 1993 holiday season served as a fitting culmination to a yearlong national and international celebration. Throughout the season the Clinton family and visitors to the White House could view the crafts featured in this book on display in the public rooms of the White House, as well as the thousands of handcrafted ornaments and a quilted tree skirt donated for the Christmas tree, a "Children's Tree" decorated with ornaments by schoolchildren, a contemporary cast bronze Hanukkah menorah, the White House crèche, a "Wheat Weaver's Tree" featuring handwoven straw ornaments, and a gingerbread White House.

Standing in the center of the Blue Room, the official White House Christmas tree was an eighteen-and-a-half-foot Fraser fir. More than three thousand craft artists—from all fifty states, the District of Columbia, and the five territories that comprise the United States of America—were invited to create ornaments on the theme of angels. Each of the states and territories were represented by quilted segments of the tree skirt. Symbolizing the states, the segments featured such motifs as apple blossoms from Arkansas, buckeyes from Ohio, and marine life from Florida.

The seventy-two objects in the craft collection were installed in various locations throughout the White House, including the Ground Floor Corridor, the Library, the Vermeil Room, the China Room, the Diplomatic Reception Room, the North Entrance, the Cross Hall, the Green Room, the Blue Room, and the Red Room. This collection of objects does not pretend to be a broad, exhaustive survey of all facets of contemporary craftmaking practiced today. A curator organizing such a collection for a museum exhibition customarily would have the opportunity to exercise latitude in selecting the pieces, without regard for the architecture or decor of the museum environment. In contrast, the rationale and the parameters for selecting objects in the White House collection were narrowly defined.

The criteria for inclusion were determined by the architecture, the historical settings, and the furnishings, with careful consideration given to the color, texture, and scale of the period rooms. It was important that all of the craft mediums be represented: ceramic, wood, glass, metal, and fiber. There was little wall or floor space for textile hangings and furniture; wearable fiber pieces were deemed inappropriate. The most desirable settings for the objects were most often the antique pier tables, cabinets, bookcase-desks, fireplace mantels, work tables, and sofa tables that help to give the grand White House interiors their character.

The selected craft pieces respond, each in its own way, to the preexisting style and ambience of these historical spaces. The most appropriate type of object for the majority of these settings proved to be the vessel form. Among the richest areas of current craft expression, vessels and objects relating to the vessel form have been fashioned from all craft mediums. A number of the vessels were chosen because they relate directly to classical and traditional shapes of the past and responded eloquently to the aesthetic of their period settings. Sonja Blomdahl's symmetrical *Crimson/Green Blue* (p. 37), John S. Cummings's beautifully proportioned *Porcelain Vase—Sang-de-Boeuf* (p. 77), and Dante Marioni's elegant *Yellow Pair* (pp. 24, 44) are particularly evocative of forms that can be traced back to antiquity. For other artists, the exaggeration of form and color indicates a search for ways to break with traditions,

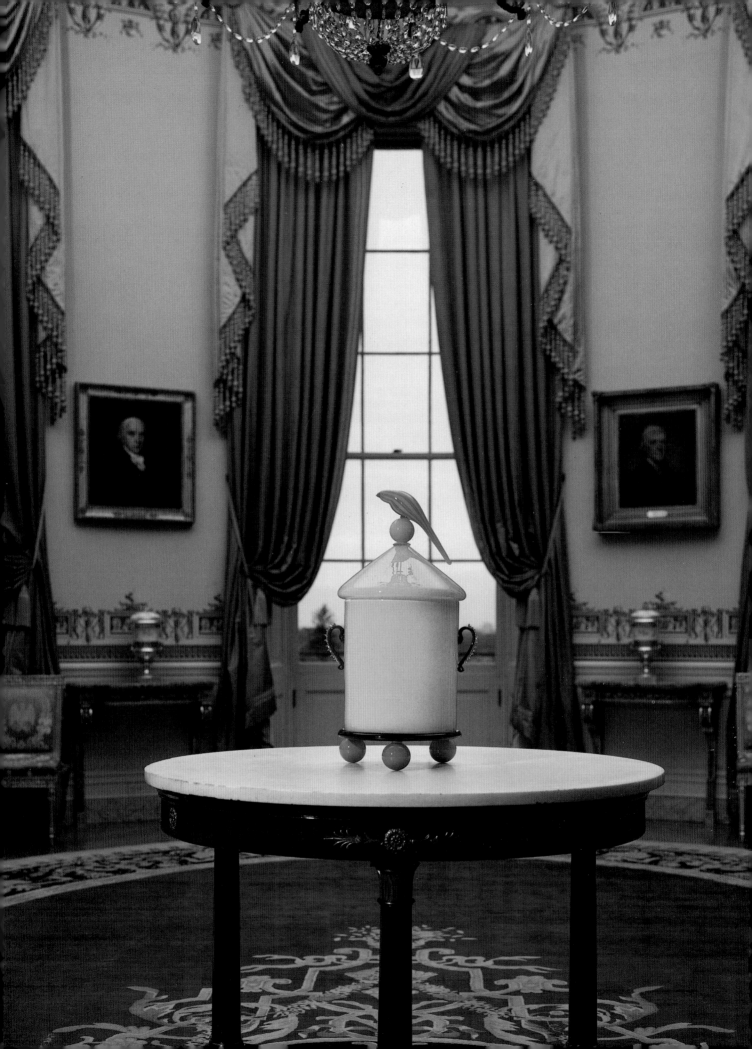

as expressed by Bennett Bean's boldly patterned *White House Bowl* (p. 73), the intensely colored, elongated bottles by Michael Sherrill (pp. 12, 69), and Mary Ann "Toots" Zynsky's freeform Pasymmetrical bowls in vibrant hues (pp. 50–1).

The placement of the objects in each room offered the rare opportunity to create provocative relationships between the pieces on display and their surroundings. For instance, Ronald Fleming's intricately carved redwood bowl embellished with a pattern of overlapping leaves proved to be an excellent choice for the Red Room (pp. 94–5). The elegant furniture in this room, with its dark and richly carved and finished woods, features the characteristic design motifs of the American Empire style: lions' heads, dolphins, and acanthus leaves. Fleming's leaves found resonance in the graceful, scrolled arms of the sofa and in other features of the decor. The bowl was placed on a small, round table made of mahogany and various fruit woods with a trompe-l'oeil marble top inlaid in a geometric pattern, an important piece of American Empire furniture created by New York cabinetmaker Charles-Honoré Lannuier in the early nineteenth century.

Currently used for official occasions involving a small number of guests, the Family Dining Room was particularly suited for two exquisite pieces of craft: Albert Paley's wrought-iron candlesticks and Edward Moulthrop's ashleaf maple bowl. Pictorial elements found in the elegant 1902 portrait of Edith Carow Roosevelt by Théobald Chartran (p. 22) suggested the placement of these objects on the sideboard below. The handle of Mrs. Roosevelt's parasol is repeated by the diagonal spears of Paley's candlesticks, while the spherical lathe-turned wood bowl echoes the oval frame that contains the portrait.

Often used on ceremonial occasions, the Grand Staircase features portraits of twentieth-century presidents (p. 2). Atop a handsome pier table on one of the landings, a striking spherical bowl by Philip Moulthrop and an equally dynamic piece by Ronald Kent were displayed. Both craftsmen use black for a dramatic effect in their work, just as the nineteenth-century cabinetmaker had done to accentuate the legs and apron of the table. The strong symmetry of the two contemporary pieces complements the demeanor of the formal 1936 portrait of Woodrow Wilson by Frank Graham Cootes.

David M. Levi's bright yellow and blue *Bird Jar* appears to be completely at ease in the Blue Room (p. 16). This oval room is furnished in the French Empire style and features acanthus leaves, imperial eagles, wreaths, urns, stars, and classical figures as decorative motifs. Levi's blown glass vessel, set on a mahogany marble-topped table purchased by President James Monroe in 1817, holds its own as the room's focal point. The jar echoes in color the graceful blue satin draperies with handmade fringe and gold valances. To the left of the center south-facing window hangs John Vanderlyn's 1816 portrait of James Madison and to the right is an 1800 portrait of Thomas Jefferson by Rembrandt Peale.

Remodeled as a library in 1935, the White House Library is appointed with books representing the full spectrum of American thought and tradition. Placed in the center of the room, on a drum table attributed to the New York cabinetmaker Duncan Phyfe, is potter Cliff Lee's carved porcelain vase with a pale celadon glaze (pp. 66–7), a piece inspired by historic Chinese ceramics. Its restful beauty befits this soft gray- and rose-colored environment for study and contemplation.

The Yellow Oval Room, decorated in the Louis XVI style of late-eighteenth-century France, has numerous superb examples of French and English decorative arts, Chinese urns of the same period, and a nineteenth-century Turkish Hereke carpet. The intense color of Dante Marioni's *Yellow Pair* (p. 24) reinforces the name of the room, and their attenuated, classical

forms are well suited to this formal drawing room for the President and his family. Just beyond the window is the Truman Balcony overlooking the South Lawn, and in the distance stands the Washington Monument.

The Center Hall serves as a spacious drawing room for the First Family and presidential guests. Recent families have used this space to display works by American artists. *Presence Clock #7* by Wendell Castle (p. 20) was placed atop a grand piano in front of an abstract painting by Dutch-born Willem de Kooning on loan to President and Mrs. Clinton. By placing the curvilinear legs and hands of Castle's animated timepiece against the dynamic, gestural brushstrokes found in the painting, the two works enhance each other, one in two dimensions and the other in three.

An octagonal eighteenth-century English partner's writing desk, also located in the Center Hall, provided an ideal setting for a blown glass vessel by Dale Chihuly (pp. 34–5). The cool and aqueous color of this undulating form contrasts beautifully with the architecture and the warm yellow and white color scheme of the informal sitting room.

Michael Sherrill's color-saturated *Incandescent Bottles*, displayed in the Vermeil Room beneath a contemplative 1970 portrait of Jacqueline Bouvier Kennedy Onassis by Aaron Shikler, stand out against the soft yellow of the paneled walls (p. 12). The attenuated bottles are a striking parallel to Shikler's elegant handling of his subject. The Vermeil Room functions as a gallery and, on formal occasions, as a ladies' sitting room. Other portraits in the room include those of First Ladies Patricia Ryan Nixon, Claudia (Lady Bird) Johnson, and Anna Eleanor Roosevelt.

The large Entrance Hall, used by guests as they arrive on the State Floor of the White House, is furnished with such pieces as a French pier table and a pair of French settees with exquisitely carved mahogany swans' heads (p. 28). The baroque character of John Littleton and Kate Vogel's contemporary blown glass sculpture finds harmony with the flowing contours of the swan's curved neck and its stylized wings, and the sculpture's swelling and bulbous forms are echoed in the curvilinear legs of the small side table. In the same space, a grouping of Cheryl Williams's *Three Prayer Bowls*, with their gold-leaf interiors, relate naturally to the gilded bronze of the French Empire clock, the framed mirror, and the apron of the French pier table purchased by President James Monroe in 1817 (p. 6).

Additional pieces in this collection are indicative of the astonishing diversity of objects made today, ranging from highly personal statements such as Jon Kuhn's dazzling geometric glass sculpture (p. 45) and Kari Lønning's nonfunctional woven and dyed rattan basketlike form (p. 89), to utilitarian pieces created for daily use, as in Mara Superior's delightful ceramic cocoa pot (p. 75), to Randy Stromsöe's ceremonial silver, pewter, and gold-leafed bowl (p. 63).

The backgrounds of the craft artists featured in the collection are as interesting and varied as the works they create. While many have had extensive formal training in university art departments or in private art schools, others have attended excellent arts and crafts schools that offer nondegree short-term courses or workshops specializing in strengthening technical and aesthetic skills.

Others, like full-time basket makers Sharon and Leon Niehues of Pettigrew, Arkansas, have availed themselves of the vast amount of technical information that is available from conferences, workshops, books, films, and periodicals. These artists, who began creating baskets twenty-one years ago, learned their craft by consulting a book by the Arkansas Extension Service. "It took years of practice taking a tree apart to enable us to get quality materials to weave

a nice basket. We do all the work with traditional hand tools. This is green woodworking—using the log while it's fresh after cutting."

The career of potter Nathan Youngblood of the Santa Clara Pueblo in New Mexico is a prime example of the time-honored tradition of an apprentice serving at the side of a master. His exquisite and elaborately detailed *Black Carved Jar* (p. 76) is the result of years of study with his grandmother Margaret Tafoya, among the last living representatives of the century's early recognized pueblo potters.

The art of craftsmanship is often transmitted from one generation to another. Melvin Lindquist, the most senior artist in the collection, was trained formally as an engineer and began wood turning in the 1930s as a vertical turret-lathe operator for the General Electric Company. It was at his home shop, however, that he applied his background as a machinist and engineer to developing new tools and to conducting innovative experiments with turning hollow forms, reverse turning, and horizontal and vertical parting techniques, all of which are widely used by wood turners today. Melvin's involvement in wood turning proved to be an influence on his son Mark, who continues to explore even newer possibilities in the medium. Whereas many of Melvin's pieces are influenced by the smoothness and symmetry of ancient Oriental, Greek, and Indian ceramic vases, Mark's forms are more likely to be rough hewn and informed by contemporary attitudes in wood sculpture.

Ignoring the taboos of purists in the field, Mark Lindquist often shapes his pieces using a chain saw to achieve rough-textured surfaces. This highly personal approach, and his energetic handling of the material, which results in a certain directness, asymmetry, and irregularity, challenge the norms of earlier generations.

There is further evidence within this collection that the passing of an interest in craft-making from generation to generation is not an uncommon phenomenon: ceramicist Laney Oxman and her son Zachary, a metalsmith; glassblower Harvey Littleton and his son John and daughter-in-law Kate Vogel, also glass artists; and wood turners Edward Moulthrop and his son Philip. Other artists, however, have taught themselves the techniques of the craft that they practice today as full-time professionals. One such example is Sam Maloof who, at the age of thirty-two in 1948, began what would become for him a lifelong odyssey to explore the beauty of wood and form, as expressed through his graceful rocking chair in this collection (p. 113). "From the day I started, I have been able to make my living working for myself and doing what I like to do, work in wood. I love the feel, the character of wood no matter what the species, and I enjoy making objects that are both functional and beautiful."

Aesthetic traditions and cultural influences from a variety of sources inform the work of several artists who remain close to a particular tradition in form or technique. Nathan Young-blood's participation in the pottery tradition of the Santa Clara Pueblo, Cliff Lee's work in porcelain (p. 74), John Cummings's vessel (p. 77) that recalls a traditional Chinese porcelain vase in its classical form and oxblood glaze, and Thomas Hoadley's hand-formed bowl (p. 72) employing the ancient Japanese nerikomi technique of using colored porcelains are excellent examples.

In contrast, other artists represented in this collection have been inspired to employ techniques borrowed from twentieth-century technology. Some notable examples include Edward Moulthrop, Philip Moulthrop, and Sidney Hutter.

Edward Moulthrop, known for his gargantuan turned wood bowls large enough for children to hide in, appropriated a method developed by Department of Agriculture researchers to

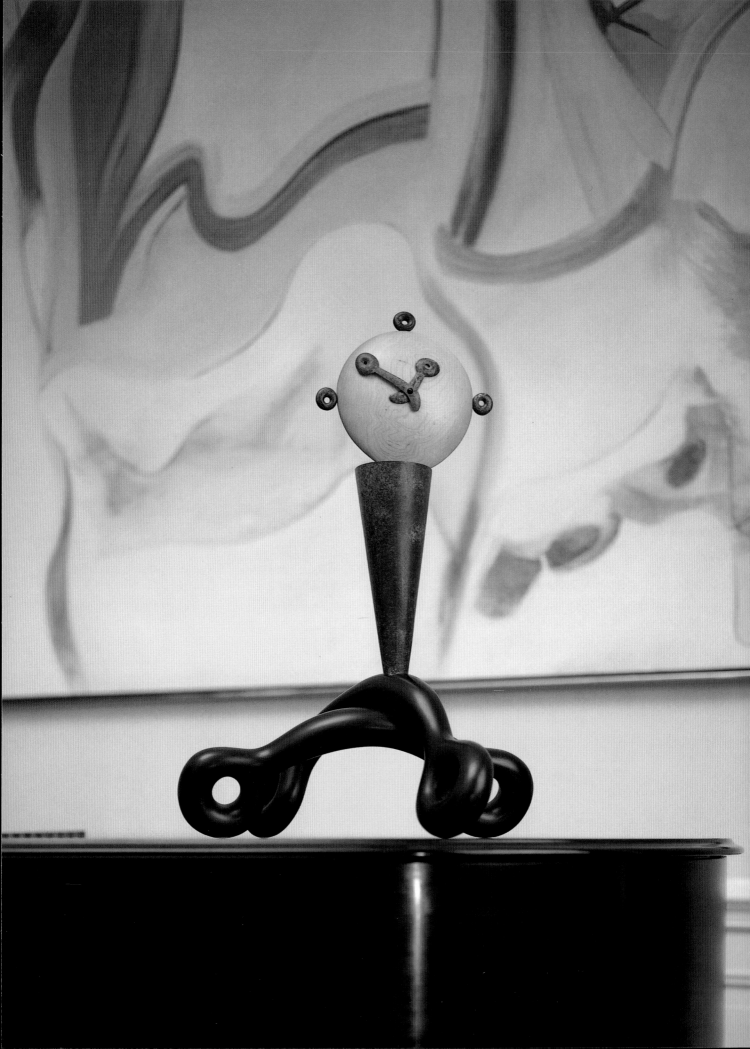

protect Army gun stocks from temperature changes. The polyethylene glycol solution in which his vessels are soaked for three months stabilizes the wood so that it will not shrink, crack, or split. He says, "If it weren't for this chemical, my large pieces would be impossible to make."

Edward's son, Philip Moulthrop, who turns elegant, globular wood bowls (p. 106), has conceived an unusual technique of gluing small segments of cross-cut pine branches to his forms and then filling and building up the surrounding areas with a black walnut dust mixed with epoxy. The blackened epoxy resin strengthens the structural integrity of the form and provides a dramatic unifying element that highlights the pattern of wood segments.

Sidney Hutter's *White House Vase #1* (pp. 52–3) is indicative of an attraction on the part of many craft artists to the strong, clean lines of modern design. These artists exploit technology to develop new skills, and their constant experimentation has brought dynamic new possibilities for expression. Like the Moulthrops, Hutter borrows lessons from the scientific community in order to make decorative, nonfunctional vessel forms. Taking advantage of a technique— originally developed for the electronics and glass industries—for melding colored dyes to glues that do not require catalyzers, Hutter uses adhesives cured with ultraviolet light to bind together pieces of cut and polished plate glass, of the type found commonly in window panes.

Also working in the glass medium is Mary Ann "Toots" Zynsky, whose determined effort to perfect a new technique has earned her a distinctive niche in the expansive world of artists working in glass. Using a unique method of constructing free-form vessels from layer upon layer of thin glass threads resembling lengths of spaghetti, Zynsky creates pieces that pulsate with brilliant color (pp. 50–1). Her exuberant forms—fused, slumped, and folded with heat— belie the customary rigidity associated with glass.

With the gradual reduction of college and art school teaching positions in the 1980s and 1990s, many craft artists found it necessary to develop sophisticated marketing skills in an effort to continue their craft. It is estimated that a quarter-million part- and full-time professionals earn at least a portion of their livelihood from their craft. Ellen Kochansky, like many in this collection, is such an artist. Inspired by her rural garden, as seen through the window of her studio, her quilt *Counterpane* (p. 91) is a sensitive interpretation of the beauty and order of nature. Kochansky moves comfortably between her role as an artist and the frenetic commercial sphere with its interior designers, department store buyers, and home fashion retailers. While her one-of-a-kind fiber wall hangings like *Counterpane* enhance the lobbies and offices of the corporate world, national retailers purchase in quantity the contemporary bed quilts produced by the company she founded, EKO Quilts.

Today, crafts have become more diversified than at any time in American history, as the contemporary American craft movement continues to expand its visibility and reach. Several artists represented in the White House collection enjoy national and international reputations, and their works are coveted by leading museums, corporations, and collectors. Dale Chihuly's blown glass piece *Cerulean Blue Macchia with Chartreuse Lip Wrap* (p. 46) shows his mastery of the medium. Chihuly began his career as an artist working independently, but he currently employs more than fifty full-time assistants to aid him in his efforts to bring the art of glass to continually expanding audiences. His foray into designing sets for the Seattle Opera's production of Claude Debussy's *Pelléas and Mélisande* was met with great critical acclaim, proving that the potential for new realms in craft is limited only by the imagination.

The seventy-two objects in the White House collection should be viewed as a small selection of the fine work being produced today. However, it does include works by artists from all regions of the United States, examples of all mediums, and pieces from established masters as

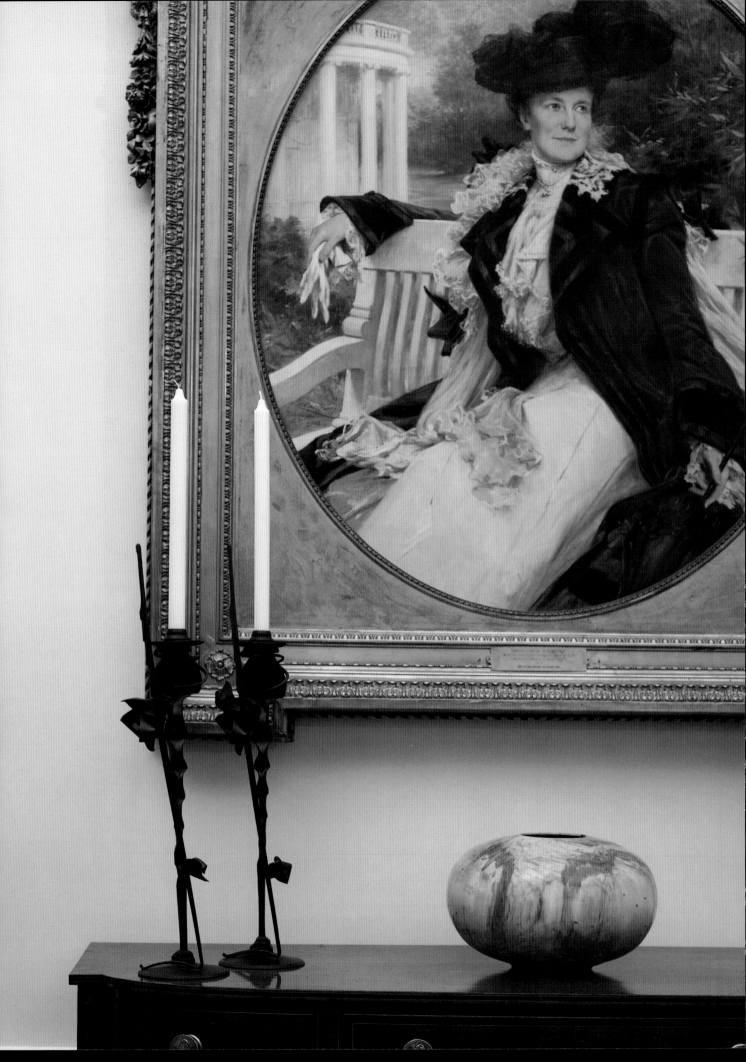

well as the emerging generation. From a Native American not formally schooled in craftmaking techniques but raised in the artistic traditions of his New Mexico pueblo home, to a graduate of a prestigious American design school now innovating glass-forming techniques in her Paris studio, all of the artists represented in the White House craft collection are American citizens and, in aggregate, all the finely crafted objects they produce serve as a material record that bridges the past and the present.

Sam Maloof, a completely self-taught, full-time craftsman who next year will become an octogenarian, completes seventy-five new pieces of furniture each year in a California studio he built himself. His walnut *Rocker #60* (p. 113) in this collection epitomizes the essence of craft, an object beautifully conceived and masterfully executed. Zachary Oxman is, at age twenty-seven, the youngest artist in the collection. This metalsmith, who has undergraduate and graduate degrees in art, produces bronze goblets, candle holders, and sculptures in a one-man foundry that he built in rural Virginia. His whimsical Hanukkah menorah, *A Festival of Light* (p. 62), depicts five men in tailcoats dancing for joy as they lift their candles to heaven. Separated in age by more than fifty years, Maloof and Oxman are living testimony to the vitality, spirit, continuity, energy, and enduring qualities of craft and the enormous satisfaction that it gives.

As Lady Bird Johnson once said, the White House gives its residents "a chance to do something for your country that makes your heart sing." The White House is a wonderful setting for highlighting causes, and without the vision, support, and enthusiasm of President and Mrs. Clinton, the craftspeople of America might not have had the opportunity to share with their fellow citizens the belief that through craft we can commemorate the multicultural heritage of our nation and pay homage to the artistic diversity that exists among all people.

CANDLEHOLDERS *(left)* BY ALBERT PALEY AND **RARE ASHLEAF MAPLE SPHEROID** *(right)* BY EDWARD MOULTHROP, in The Family Dining Room

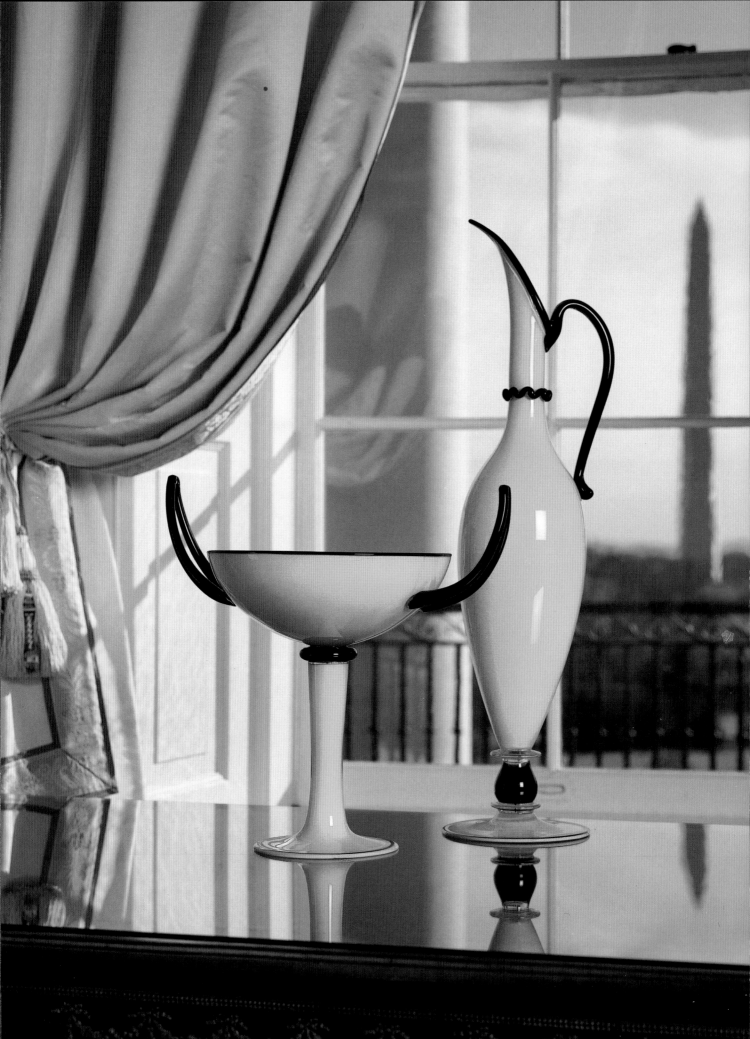

VALUES, SKILLS, AND DREAMS:
CRAFTS IN AMERICA
BARBARALEE DIAMONSTEIN

Americans are characteristically obsessed with technology and machines, but they also have become increasingly fascinated with things made by hand. Not only is there a genuine aesthetic regard for "handmade" objects, but there is also a desire to collect ceramics, glass, fiber arts, jewelry, metalwork, furniture, and woodwork in the same tradition that painting and sculpture have been acquired. Crafts have customarily been valued for utilitarian purposes; today this appreciation encompasses not only the broad spectrum of crafts that are both functional in use and beautiful in form, but also works that are purely decorative.

This growing recognition is reflected in the expansion of the world of crafts during the past thirty years, as is evidenced by the proliferation of museums devoted to crafts, the increase in juried craft fairs across the country, the organization and growth of craft associations, and the number of new specialty magazines and galleries devoted to the exhibition and sale of crafts. While teaching was once virtually the only way to earn a livelihood, hundreds of thousands of artisans now are able to sustain their lives with their craft, by selling their works to a rapidly expanding public.

The emergence of American crafts is linked to the evolution of American culture, commerce, and history. Native Americans have a rich and highly developed craft tradition that began long before the Colonial period. Among the European settlers who came to this country were furniture makers, potters, glass blowers, weavers, and metalworkers, whose skills were essential to establishing a new society in the Colonies. These craftspeople were treated with the same regard as artists, and they often worked in tandem with their "fine" art counterparts.

By the mid-nineteenth century the Industrial Revolution began to destroy this harmonious tradition. By making products more quickly and cheaply than was previously possible, machines usurped the role of the craftsmaker. As America flourished economically, aided by technology, the craft tradition was gradually weakened.

By the end of the nineteenth century, there were many who reacted vehemently against mechanization. Dismayed by the disintegration of quality as they knew it, followers of the American Arts and Crafts movement were strongly influenced by the ideology of the great English crafts designer-philosopher William Morris. They looked, as well, to the styles of European Art Nouveau, the German Jugendstil, and the Wiener Werkstätte for inspiration.

These American craftsmakers advocated a return to a simpler way of life, one uncluttered by modern gadgetry, and attempted to revive fine workmanship and a more chaste aesthetic, with a respect for natural materials. Gustav Stickley, the cabinetmaker and designer, was a leader of this craftsman style, as it was known. Stickley's solid, four-square designs were distinguished by simplicity and purity of design, and a harmony between interior decoration and architecture.

The Craftsman magazine, founded and edited by Stickley, gave this movement a voice during the period from 1901 to 1916. While Stickley's craftsman furniture and furnishings were highly regarded, even then his work was priced out of reach for most Americans.

Responding to what he perceived as a neglected audience for Arts and Crafts goods, the charismatic marketeer, Elbert Hubbard, established the Roycroft Community, a colony of craftspeople in East Aurora, New York, in 1895. The Roycrofters geared their products to the middle class and sold their furniture, lamps, and leather goods throughout the country by using the strategy of mail-order catalogues. The Arts and Crafts movement enjoyed a considerable popularity which persisted well into the early years of this century, and served as inspiration for a new generation of designers and architects including Frank Lloyd Wright.

The crafts movement continued to evolve. Regional arts and crafts organizations sprouted across the country. By 1894, the first college-level ceramics department in North America was established at Ohio State University in Columbus, followed in 1901 by the founding of the first school for ceramic arts at Alfred University in Alfred, New York.

Similar programs in ceramics and other mediums developed at about the same time: the Rhode Island School of Design in Providence (first metal arts class, 1901, textiles, 1903); the New Jersey School of Clayworking and Ceramics at Rutgers University in New Brunswick (1902); the Rochester Athenaeum and Mechanics Institute (1903, later the Rochester Institute of Technology); the Oregon School of Arts and Crafts in Portland (1906); and the California College of Arts and Crafts in Berkeley (1907, relocated to Oakland in 1924).

But despite these educational efforts and trends, industrial society prevailed and there were still relatively few professional craftsmakers. In this period, craft objects were no longer seen as necessary to supply the essentials of life, but rather as embellishments—charming, but nonessential, sometimes eccentric additions. As a result, crafts were liberated to become more expressive of human creativity.

During the interwar years the making of crafts remained somewhat insular and outside the mainstream, although several important crafts-related institutions were established during this period: Otis Art Institute in Los Angeles (1918, merged with New York's Parsons School of Design in 1978 and renamed the Otis Parsons School of Design), and the handicrafts department at the University of California (1919) in Los Angeles; the Penland Weavers (1923) in North Carolina, which later added the disciplines of pottery and metalwork to its curriculum, and is known today as the Penland School of Crafts; the Cranbrook Academy of Art in Bloomfield Hills, Michigan (1927, officially opened 1932), organized under the leadership of Finnish architect Eliel Saarinen; and Black Mountain College (1933), also in North Carolina, whose distinguished faculty included Anni and Josef Albers, former teachers at the Bauhaus; and the Tyler School of Art (1935) of Temple University in Philadelphia.

In addition to those schools established earlier in the century, the Arrowmont School of Arts and Crafts in Gatlinburg, Tennessee (1945, formerly the Pi Beta Phi Settlement School), the Haystack Mountain School of Crafts in Deer Isle, Maine (1950), and the Pilchuck Glass School (1971) in Stanwood, Washington, a premier center for glassmaking cofounded by Dale Chihuly, are among the many outstanding craft schools in America.

The Depression years saw the involvement of the government-sponsored Works Progress Administration (WPA) in significantly fostering crafts projects in programs similar to those for murals and public works. With such programs, the government continued to aid artists through difficult times, and crafts flourished mainly at the grassroots level.

World War II brought many significant changes, including those in the world of art. There was an influx of dislocated European artists, architects, craftsmakers, and intellectuals who became educators in America, and the expanding university system was there to receive them. Hand-in-hand with these new teachers were unprecedented numbers of students who pursued arts programs in universities, aided by the GI Bill. The trend was further bolstered by a pervasive dissatisfaction with industrial society—a fertile environment for interest in the handmade—which was partly a backlash against the technology of war and the devastation it wrought.

During the 1950s, younger craft artists embraced the "truth-to-materials" doctrine. The leaders of the movement, encouraged by university support, expanded the technical and aesthetic boundaries of each discipline. That set the stage for a broadly based group—a new craftsperson's movement. A particularly interesting phenomenon of this movement was the emphasis on collective production of crafts objects. While in past generations they tended to work independently within their chosen mediums, skilled craftsmakers now joined together, collaborating on the creation of more ambitious work.

The turmoil and change of the 1960s spurred an even greater awareness of crafts. As American youth explored alternative ways of living, they also sought alternative materials for aesthetic expression. For some it meant a new direction in their lives, an era of personal assessment, discovery, and reevaluation. For many, at the time, it meant a rejection of gross materialism—the making of a simpler life with more fulfilling work. This generation, which expanded on the work of their 1930s predecessors, made an enormous contribution to the growth of crafts as a viable profession.

For the past five decades, the American Craft Council has served not only as the primary catalyst, but also guided the crafts movement. The council was founded in 1943 by Aileen Osborn Webb whose aim was to encourage craftspeople and to foster appreciation for their work. Webb, herself a potter, was determined to develop marketing opportunities for artisans. In 1939 she helped organize the American Craftsmen's Cooperative Council and one year later founded America House, a retail operation and display space for crafts at Madison Avenue and East 52nd Street in New York City. Eventually the organization grew to include the American Craft Museum (then called the Museum of Contemporary Crafts), *American Craft* magazine (formerly *Craft Horizons*), the American Craft Association, American Craft Enterprises (which sponsors annual fairs), American Craft Publishing, the American Craft Information Center, and the World Craft Council.

The new craft museum, which opened in September 1956, was located on West 53rd Street, on the same block as the Museum of Modern Art. The timing was auspicious; the visual arts were emerging as a significant area of popular interest in our culture, and American artists were beginning to achieve international prominence. The museum opened with a professional director, Herwin Schaefer, a clear sign that it was committed to becoming a serious, major public institution. It was the first of its kind, devoted solely to exhibiting, researching, cataloguing, documenting, and commissioning contemporary crafts.

Until then, crafts had been exhibited in very few of the larger art museums in this country, and only on a sporadic basis. No serious effort was being made to promote the best crafts or to reinforce quality standards. From its inception, the American Craft Museum performed a central role, in formulating and communicating aesthetic and technical criteria, and in galvanizing the new crafts movement by showing work of the generally acknowledged mas-

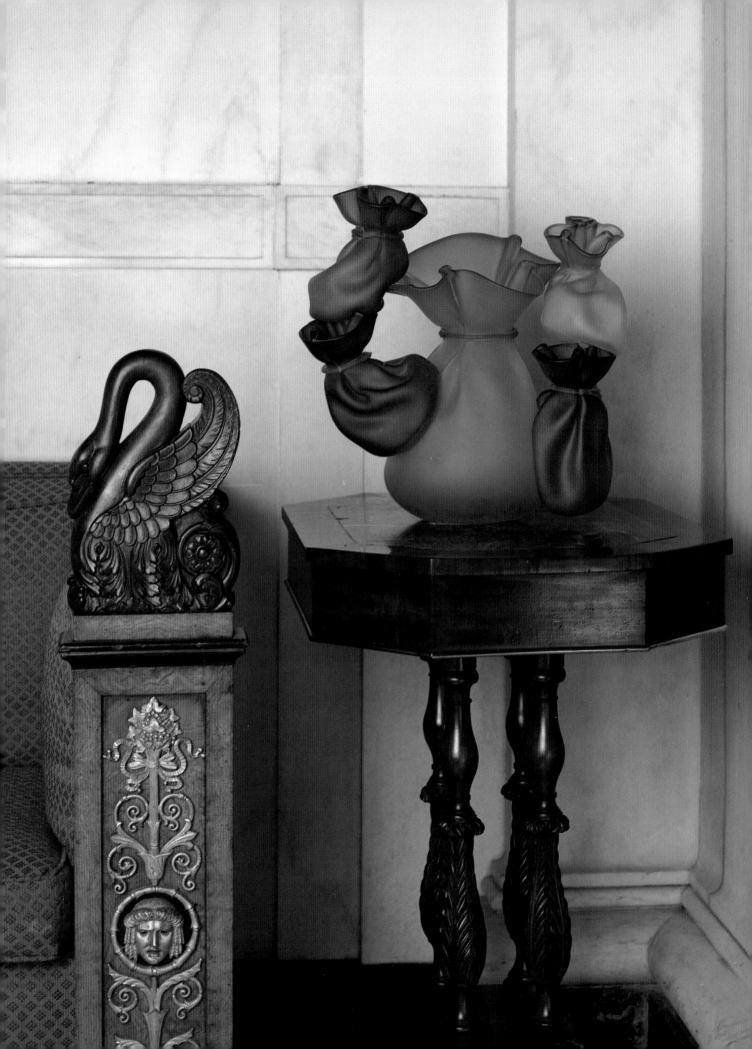

ters while simultaneously exposing new talent. It offered a showplace for the work of those who were rarely invited to display their work alongside that of "fine" artists in museums and galleries.

Paul Smith, director of the American Craft Museum from 1963 to 1987, played a crucial role in the renaissance of crafts. Smith joined the American Craft Council in 1957; he was hired to work on exhibitions and special projects, and shortly thereafter became assistant director. In 1963 he was appointed director, after the death of David Campbell (who had been the museum's third director), and served with distinction for the next twenty-four years.

By 1990, after a brief period of turmoil that preceded her, Janet Kardon was named director of the museum. With a strong background in contemporary art (she was formerly director of the Institute of Contemporary Art at the University of Pennsylvania) Kardon has worked vigorously and effectively to put American crafts in the larger context of international design. The editor of an ambitious series devoted to the history of twentieth-century American craft, she has also organized the large-scale accompanying exhibitions. The first two of the eight volumes in the series have been published and are entitled *The Ideal Home: 1900–1920* (1993) and *Revivals! Diverse Traditions: 1920–1945* (1994).

The Smithsonian's Renwick Gallery has played an important role also in bringing contemporary American crafts to the forefront. In 1972 it was founded as a curatorial department of the National Museum of American Art, and housed in the original 1859 Corcoran Gallery of Art building across Pennsylvania Avenue from the White House. Founding director Lloyd E. Herman established the Renwick as a leading showcase for international as well as American craft and design. Among the many exhibitions mounted during Herman's tenure (1972–86) were the pioneering *Woodenworks: Furniture by Five Contemporary Craftsmen* (1972), a show that forecast the flowering of the studio furniture movement, and the influential *Craft Multiples* (1975).

In 1986, Michael W. Monroe, curator since 1974, assumed leadership of the Renwick. He began to emphasize the museum's objectives to build a permanent collection of contemporary American craft objects and to enhance research and scholarship in the field, creating the annual James Renwick Fellowship in American Craft and a biennial prize to honor the best books on American crafts. The Renwick has also published monographs in the "Contemporary American Craft Series," and catalogues to accompany major exhibitions. Since the Renwick had built a contemporary collection within a historic building, it was logical, when First Lady Hillary Rodham Clinton decided, in 1993, to establish The White House Collection of American Crafts, that she would turn to the nearby museum and invite Michael Monroe to serve as curator of the collection.

A few major U.S. museums had established craft collections as early as the 1870s: the Museum of Fine Arts, Boston, and the Pennsylvania Museum (later Philadelphia Museum of Art); the Art Institute of Chicago followed in 1902. However, most of the specialized, craft-oriented institutions that play an active role today appeared after World War II, with most of them founded in the last twenty-five years: the Corning Museum of Glass in Corning, New York (1951); the Center for Folk Art and Contemporary Crafts in San Francisco (1972, reorganized as the San Francisco Crafts and Folk Art Museum in 1983); the Craft and Folk Art Museum in Los Angeles (1973); and the Everson Museum in Syracuse, New York (while founded in 1896, in recent years it has become an important research facility and exhibition center for American ceramics).

University art departments have also continued to nurture the development of crafts, where courses and student work extend beyond the traditional boundaries of painting, drawing, and sculpture. Many of the established schools have expanded their curricula and newer programs have evolved. Teaching has provided a line of progression for crafts, as these schools have fostered successive new generations of teachers. Within the academic framework, technology has also played a role in the development of new methods and materials.

Where once there had been a prevailing antitechnology attitude among craftspeople, now technical advances and expertise are being put in the service of their work. One aspect of the importance of this type of education may be seen in the way certain weavers have begun to use the jacquard loom, originally developed to mass-produce functional fabrics, by adapting it through computer programming to create fiber art. In turn, many disciplines have been altered by the development of new technology. For example, Mary Ann "Toots" Zynsky (at one time a student of Dale Chihuly at the Rhode Island School of Design) creates bowls with fused glass fibers which imitate fabric.

While teaching has been an essential outlet for craft artists, providing a lifestyle along with an occupation, there has been a growing interest in the marketplace, creating a dual focus for the craftsperson as teacher and creator-marketer. This new entrepreneurial attitude is evident among many longtime professionals. Woodworker Wendell Castle has said, "I don't see anything wrong with influencing industrial design or working for production. It's just that my vocabulary was not suitable. It's actually more suitable now. But the quality would again be the problem. It wouldn't be the forms." Conversely, Castle developed a technique called "stack lamination," in which the conventional method of layering and fusing wood pieces was reinvented to create unusual contoured forms and asymmetrical configurations. In this way, again, the craftsmaker uses technological innovation to achieve technical perfection and participates in the ongoing dialogue between technology and human creativity.

Throughout our history, there have been varying cycles in the pursuit and appreciation of the handmade object. Our national genius for improvisation combined with the still pervasive frontier spirit, as well as the great American preoccupation with individualism has engendered periods of great interest. It is clear that the making of crafts in our country merits serious attention as a key to understanding America's self-image, and how our culture has evolved. But still there are major problems to surmount.

Relatively few museums actively collect, display, or promote contemporary crafts. The majority of craft artists do not share the same economic rewards as their "fine art" colleagues, nor do they enjoy the same recognition for their work that contemporary painters, sculptors, performing artists, and architects do. Part of this may be attributed to the long tradition of anonymity in the history of American crafts; many craftsmakers—in silence—have left us a remarkable legacy.

There is also a certain reluctance on the part of the craftsmakers themselves to fully participate in the mainstream. Many of these artists have an extremely close affinity to their work and a direct involvement with their materials. The work is intricately intertwined with their lifestyle, lives that appear to be fulfilling and creative—and absorbed by hours of exhausting work. Woodworker Sam Maloof has said, "I never once thought about recognition because I thought, 'How wonderful it is to be able to earn a living working with my hands—to make things that I enjoy making and other people enjoy having.' So recognition never entered my head at all." What is clear is that working with one's hands offers not only a living, but a way of life.

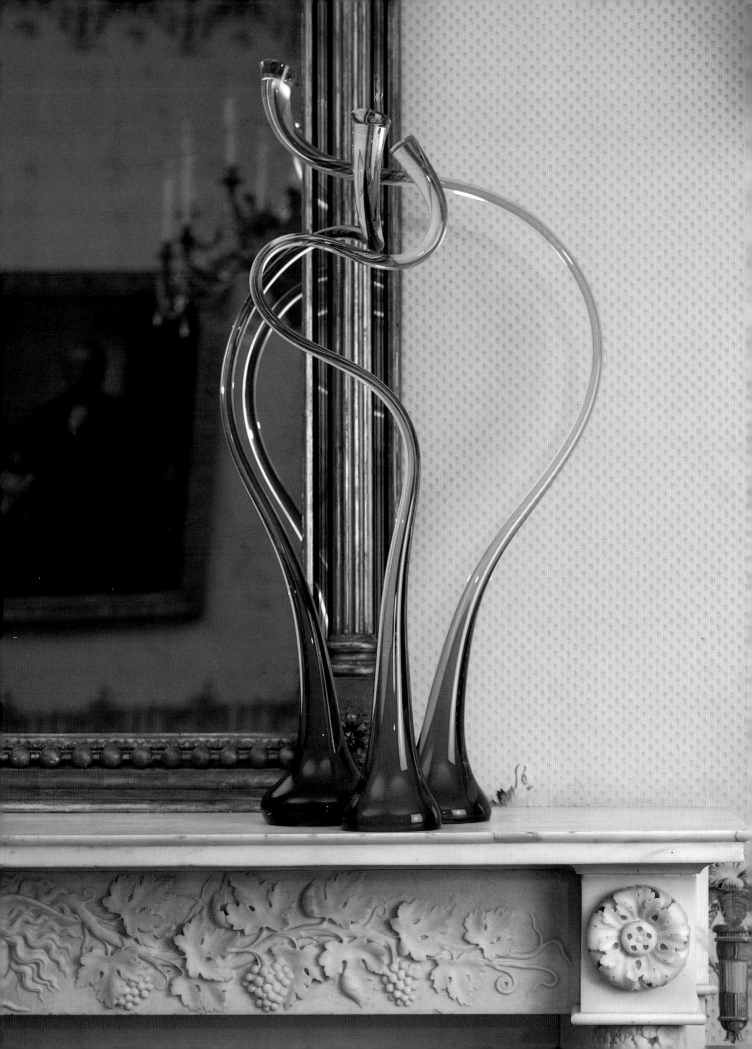

In many ways the credo of craftsmakers is self-reliance. In general, they appear to lead seamless lives, their professional and personal lives uniquely meshed. Perhaps it is the intimate physical engagement with the materials with which they work—there is virtually no remove between the creator and the created; what they make is what they are. It can be said that the craft artist's life and work are often about continuity—not only within the head, heart, and soul of the individual, but also as the individual participates in the larger crafts community.

Where are we headed today? The renewed appreciation of the craft world is certainly amplified by the increasing numbers of amateurs and hobbyists. Ceramics, textile arts, and woodworking are especially popular. Other signs include the proliferation of magazines and journals, such as *American Ceramics, American Craft, Ceramics Monthly, Craft International, The Craft Report, Fiberarts, Fine Woodworking, Glass,* and *Metalsmith,* and the wide variety of craft courses offered around the country.

However, there continues to be a need for scholarship and artistic criticism which will help bring crafts into the same realm as the so-called fine arts. Other countries of the world regard their indigenous crafts as an expression of their cultural patrimony, and Americans should do the same. The American public must find a way to celebrate crafts as an industry as well as an art, to reinforce the importance and the appeal of the handmade in today's throw-away culture.

The fact that Americans chose to memorialize the devastating loss of friends and family due to AIDS through the making of an enormous quilt is but one indication of the significance of crafts in our society (by the end of 1994 approximately 27,000 individual panels had been contributed to the project from all across the country and assembled into a quilt which, when last laid out, covered the entire Washington Mall). Indeed, the quilt is a quintessential example of collaborative craftmaking.

The President and Mrs. Clinton's support for the "Year of American Craft" (1993), and the fact that they held the first exhibition of contemporary crafts at the White House in December of 1993, and have assured that crafts have a place in, and are shown with, the White House collection, demonstrates the renewed significance of crafts. There is, as well, an increased focus on excellence and the realization that the handmade is once more enjoying the prominence in our culture that it so rightly deserves, as a symbol and expression of our most enduring American values, skills, and dreams.

GLASS

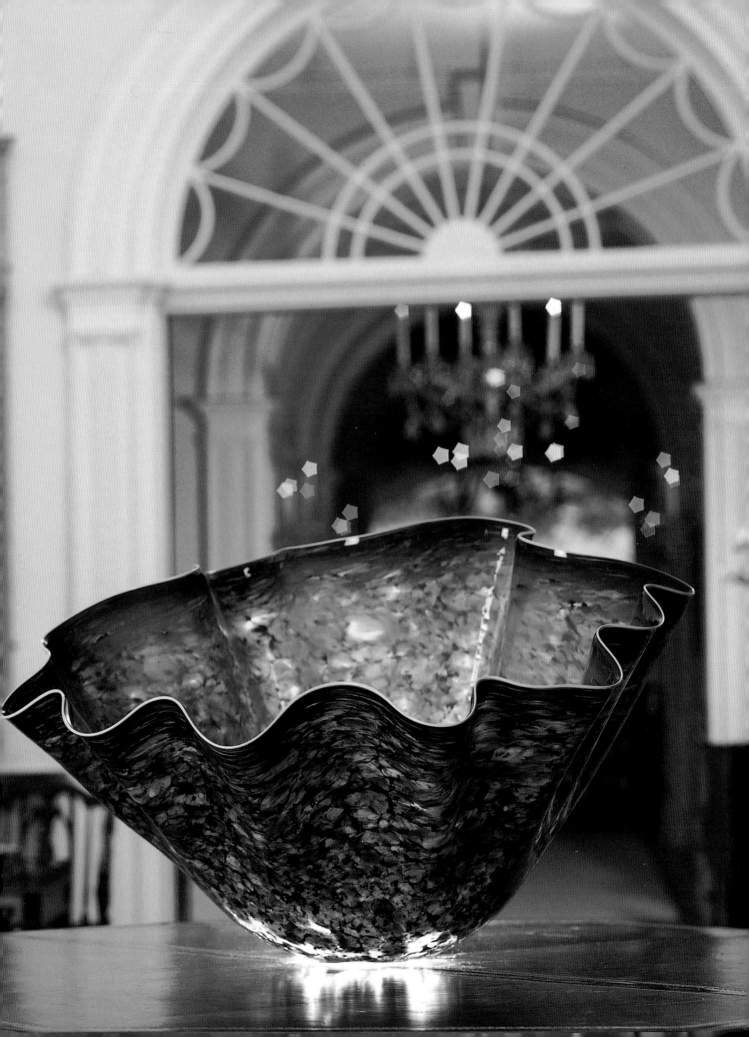

Below. JOHN LITTLETON AND KATE VOGEL. **IMAGO BAG.** 1993. BLOWN GLASS; ETCHED, 13¾ x 12½ x 9½″ (34.9 x 31.8 x 24.1 CM)

This spirited piece, with its central baglike form surrounded by four smaller ones, acts as a metaphor for the phases of life: birth, renewal, growth, and mutual dependence. The etched surfaces lend softness and warmth to the work, qualities that belie the nature of brittle glass.

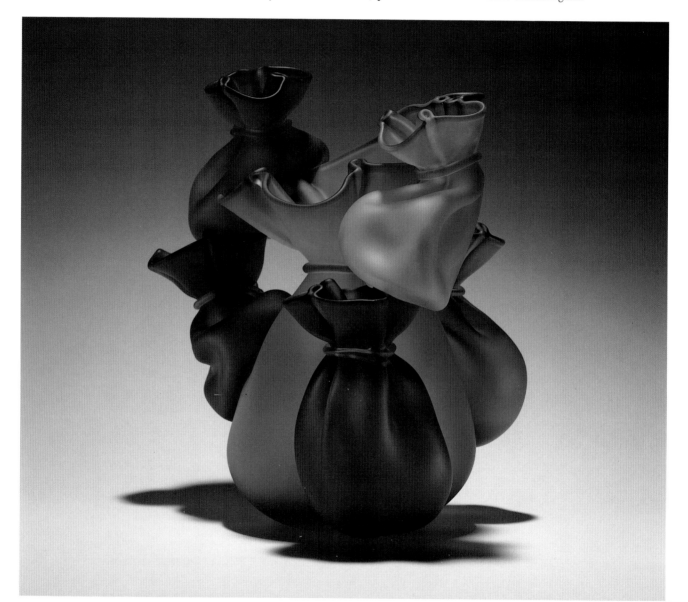

Right. SONJA BLOMDAHL. **CRIMSON/GREEN BLUE.** 1992. BLOWN GLASS, 16½ x 9¼″ (41.9 x 23.5 CM)

Symmetry and brilliant color are the essential visual elements for this glass blower. In this piece, Blomdahl emphasizes the curvaceous silhouette of the classically-inspired form. A clear band of glass that joins the crimson bottom of the vase to the green top acts as an optic lens to absorb light and produce a warm inner glow.

Previous pages: **CERULEAN BLUE MACCHIA WITH CHARTREUSE LIP WRAP** BY DALE CHIHULY, in The Center Hall, Second Floor

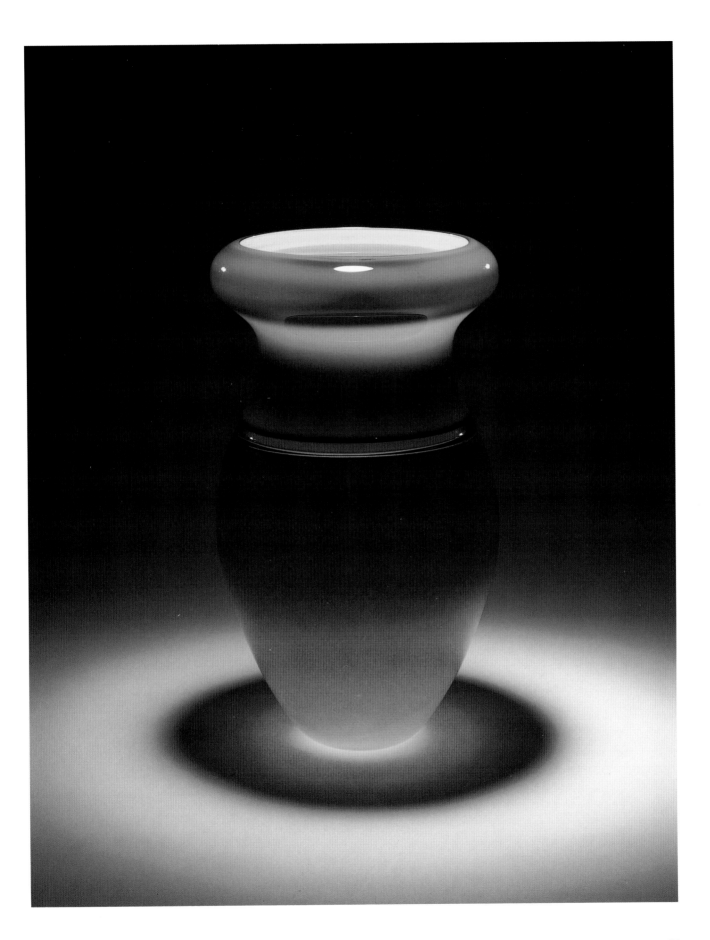

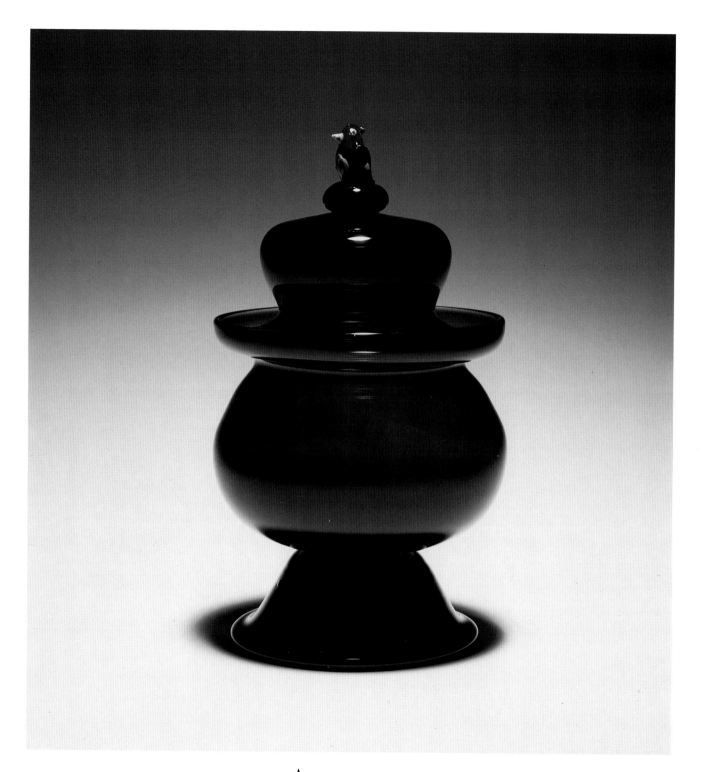

ED PENNEBAKER AND AMY NICHOLS.
COVERED BOWL WITH WOODPECKER FINIAL. 1993.
BLOWN GLASS,
7½ x 4⅛″ (19.1 x 10.5 CM)

At first glance, this covered bowl and lid, with their rich purple color and staid symmetry, present a very formal posture that disguises a delightful twist of humor—the image of a woodpecker perched on a bowler hat sitting on a man's head.

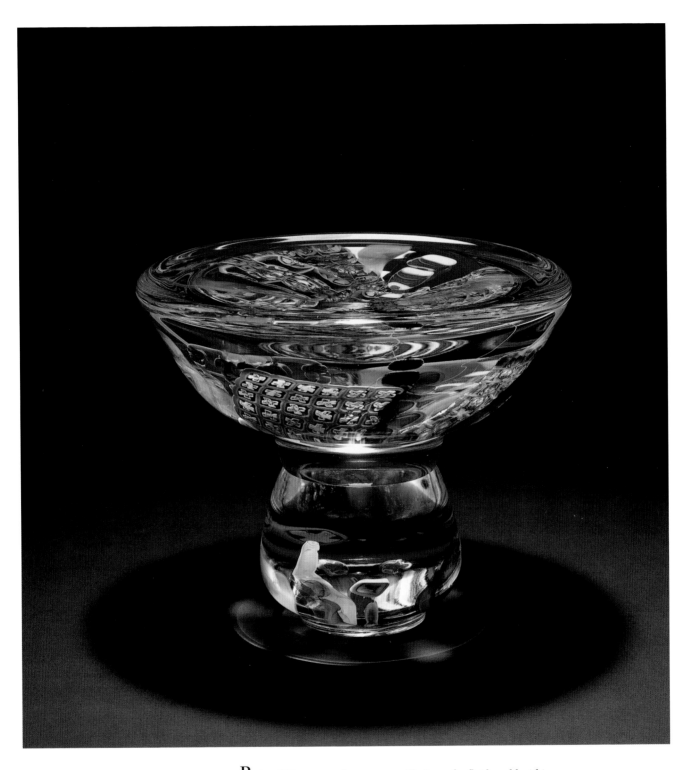

RICHARD Q. RITTER.
GRAIL SERIES #6. 1993.
BLOWN GLASS; SAND-ETCHED,
9¼ x 10¾″ (23.5 x 27.3 CM)

Richard Ritter uses glass to create illusions of a fluid world within solid crystal. The soft and liquid qualities of the glass and its transparent characteristics have inspired him to explore the possibilities of subtle colorations, internal form, texture, and depth.

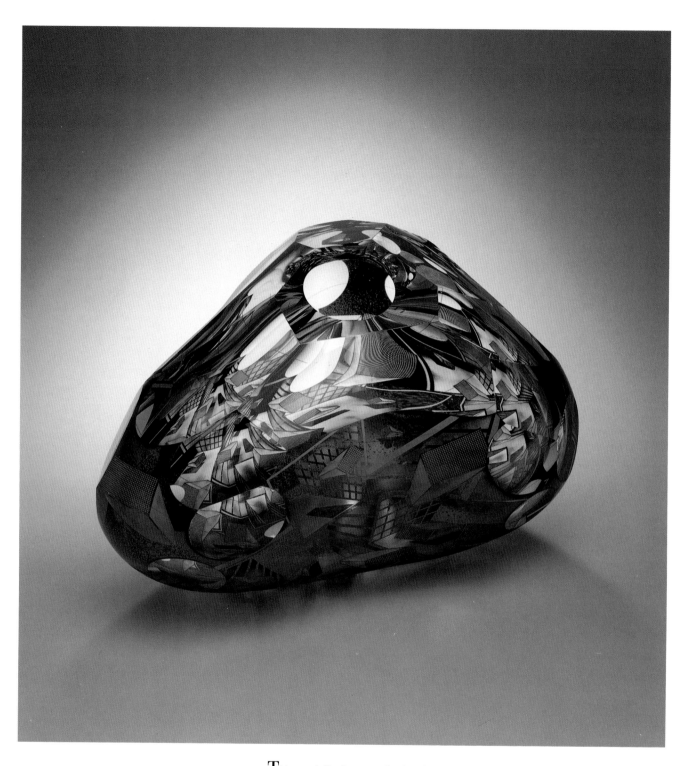

DAVID J. SCHWARZ.
Z-AXIS, OTHER FACETS 2-15-92. 1992.
BLOWN GLASS; GROUND,
POLISHED, SANDBLASTED, AND PAINTED,
10¾ x 16¼ x 14″ (27.3 x 41.3 x 35.6 CM)

This carefully drawn and colored glass sculpture demonstrates the artist's skill in designing convincing illusions of deep and unending space. Originally trained as an engineer, Schwarz finds satisfaction in faceting his glass pieces with great precision, duplicating the brilliance of a wonderfully cut gem.

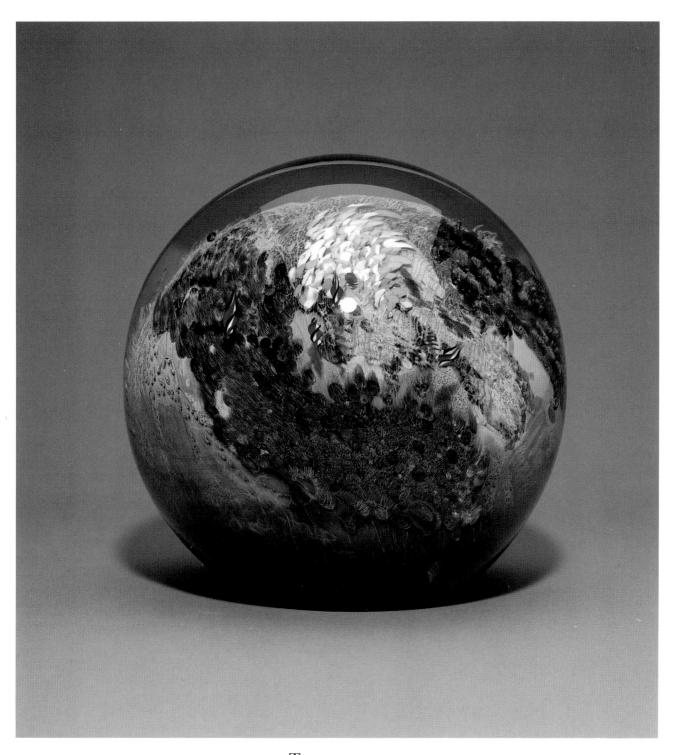

JOSH SIMPSON.
MEGAWORLD. 1994.
GLASS, SILVER REACTIVE GLASS, AND GLASS CANE INCLUSIONS;
MULTILAYERED, HOT FLAME, AND HOT WORKED,
10¼ x 9¾″ (23.5 x 21.6 CM).
GIFT OF STEWART G. ROSENBLUM IN HONOR OF
WILLIAM JEFFERSON CLINTON AND HILLARY RODHAM CLINTON

This large orb of exquisitely formed glass is reminiscent of the earth as photographed by NASA from outer space and reflects the artist's interests in the natural world, technology, and the cosmos. The floating shapes of continents, oceans, vast plateaus, and geological formations are trapped within the sphere's colorless outer layers.

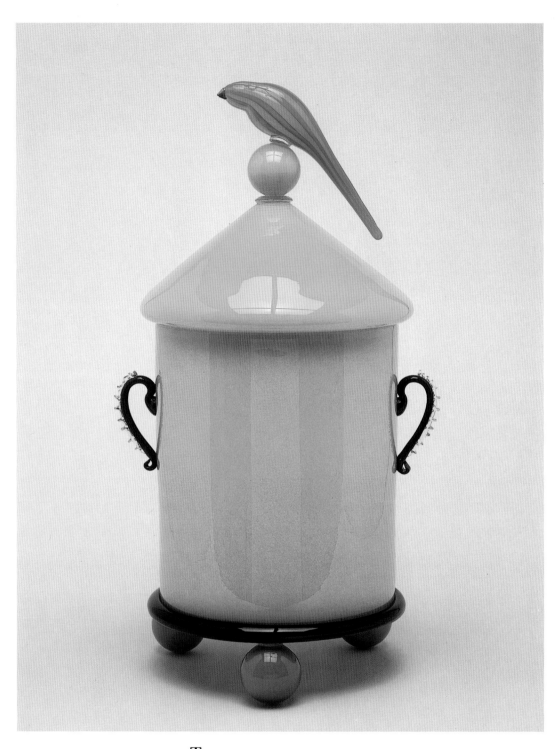

DAVID W. LEVI.
BIRD JAR. 1993.
BLOWN GLASS,
24⅜ x 13⅛ x 11⅜″
(61.9 x 33.3 x 28.9 CM)

This brilliant yellow and blue lidded glass jar unites the artist's love for classical container forms with his contemporary feeling for intensely saturated colors. The tropical bird perched on the lid lends a sense of whimsy to the piece.

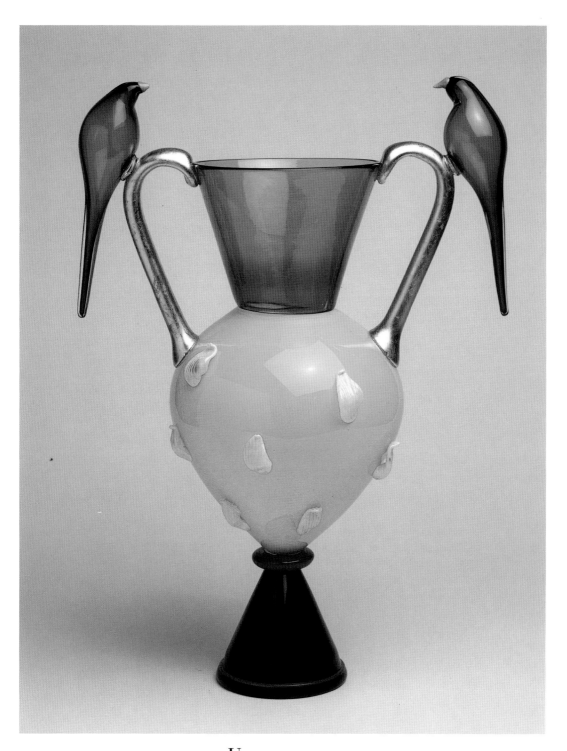

DIMITRI MICHAELIDES AND DAVID W. LEVI.
BIRD VASE. 1993.
BLOWN GLASS,
21 x 14½ x 8″ (53.3 x 36.8 x 20.3 CM)

Using a classical vase form, the two-handled *amphora*, these glassblowers added a decidedly twentieth-century ingredient to this vase with its raucous colors and tropical bird ornaments.

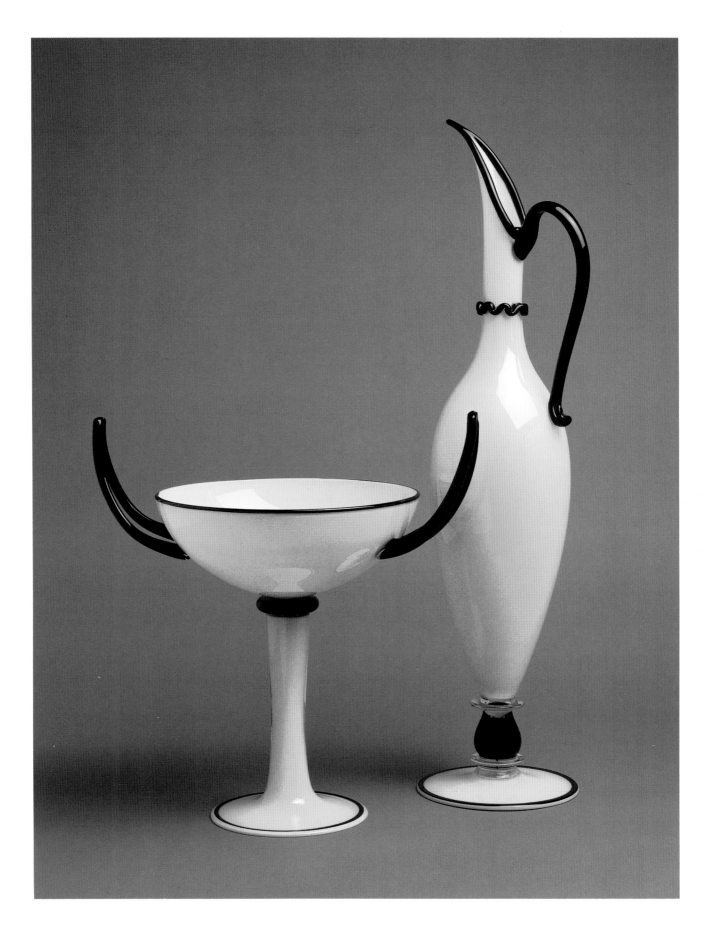

Left. DANTE MARIONI.
YELLOW PAIR. 1993.
BLOWN GLASS,
31 x 8″; 18 x 17½ x 11¾″
(78.8 x 20.3 CM; 45.7 x 44.5 x 29.9 CM)

Known for his love of classical pottery forms, such as the *kylix* (a shallow, footed bowl with side handles) and the *oinochoe* (a tall vessel with an elongated neck and single handle), Dante Marioni fashions hot glass into graceful, symmetrically articulate forms. While the shapes of these vessels join a centuries-old tradition, their shocking color palette, limited to one intensely saturated chrome yellow with black accents, suggests the era in which they were created.

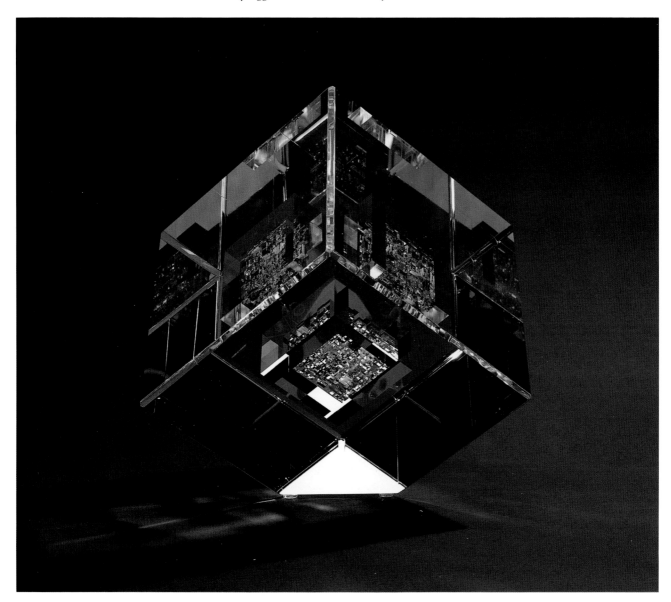

Above. JON KUHN.
PASTEL SKIES. 1993.
BORA-SILICATE, LEAD-FLUORIDE, AND COLORED GLASS;
GROUND, POLISHED, AND LAMINATED,
8¼ x 8¼ x 8¼″ (21 x 21 x 21 CM)

Attracted to the purity and intrinsic seductiveness of glass, Kuhn creates precise cubes of crisp geometry that dazzle the eye. Executed with exquisite care, the brilliant inner core is comprised of several hundred tiny pieces, cut and polished to within one-ten thousandth of an inch prior to being laminated together, and then embedded in transparent and refractive crystal.

Below. DALE CHIHULY.
CERULEAN BLUE MACCHIA WITH CHARTREUSE LIP WRAP. 1993.
BLOWN GLASS,
22 x 31 x 30″ (55.9 x 78.7 x 76.2 CM)

Known for his large and sculptural blown glass pieces, Dale Chihuly created this dynamic and pulsating form that seems to embody fluidity and motion. The brightly colored lip and immodest blotches of vibrant color undulate over the surface, bringing it to life.

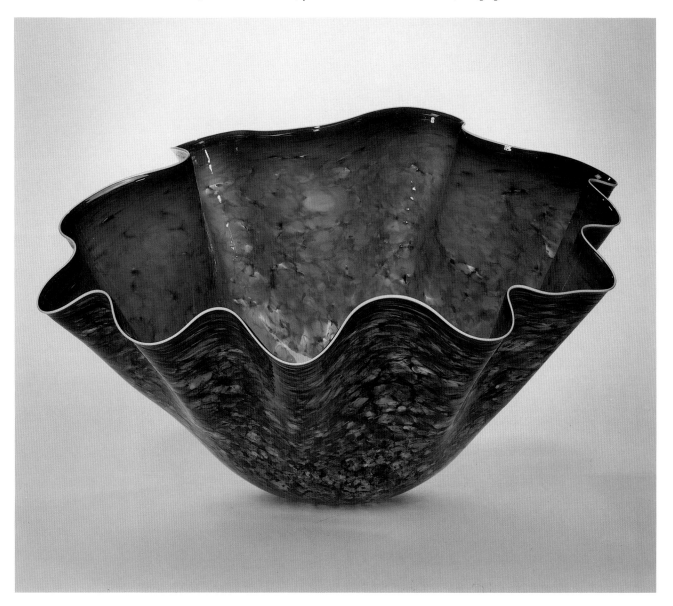

Right. HARVEY K. LITTLETON.
BLUE ORCHID IMPLIED MOVEMENT. 1987.
BLOWN GLASS AND BARIUM/POTASH GLASS
WITH MULTIPLE CASED OVERLAYS OF KUGLER COLORS,
36 x 14 x 5″; 31⅛ x 14 x 5″; 31⅝ x 10 x 4¼″
(91.4 x 35.6 x 12.7 CM; 79.1 x 35.6 x 12.7 CM;
80.3 x 25.4 x 10.8 CM)

In this glass sculpture, Harvey Littleton takes full advantage of the once flowing quality of molten glass and captures it in that state. The deep blue color in the teardrop base of each unit suggests a source of energy for these writhing tendrils as they reach skyward.

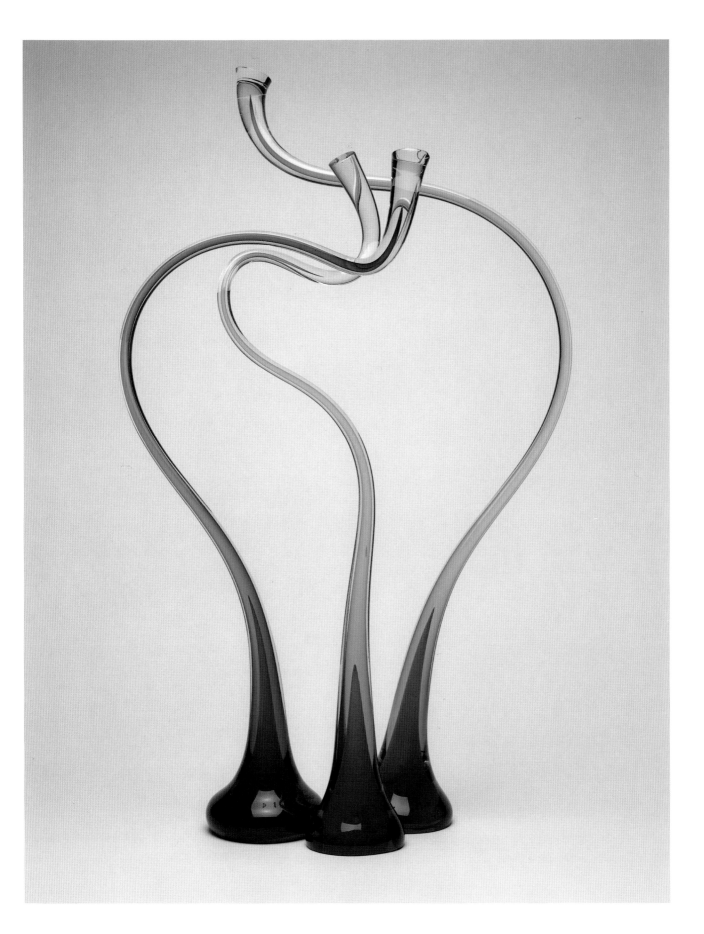

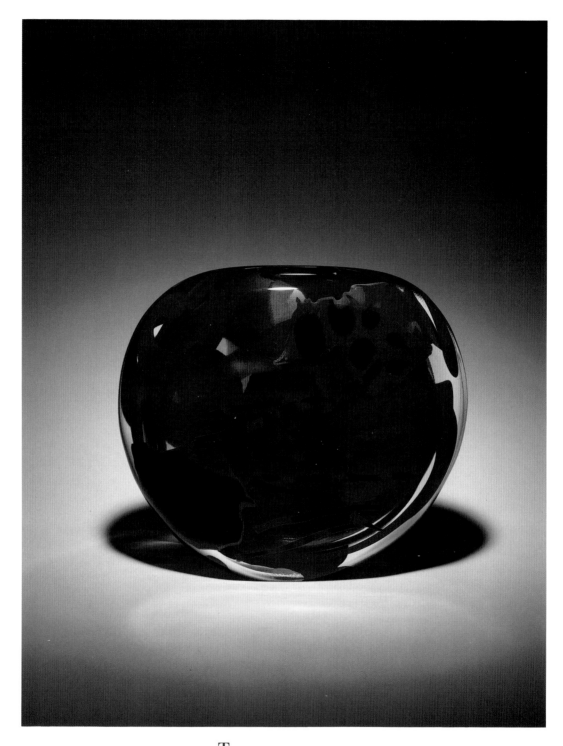

JOEL PHILIP MYERS.
VALMUEN XXXXX. 1991.
BLOWN GLASS,
14½ x 15 x 4″ (36.8 x 38.1 x 10.2 CM)

This glassmaker uses color to dazzle and delight. This piece was inspired by red flowers: paper poppies sold on Armistice Day, fields of wild poppies, and poppies in his Danish garden. In the large lozenge-shaped vessel, Myers built layers of transparent and translucent colors in a striking and dynamic composition.

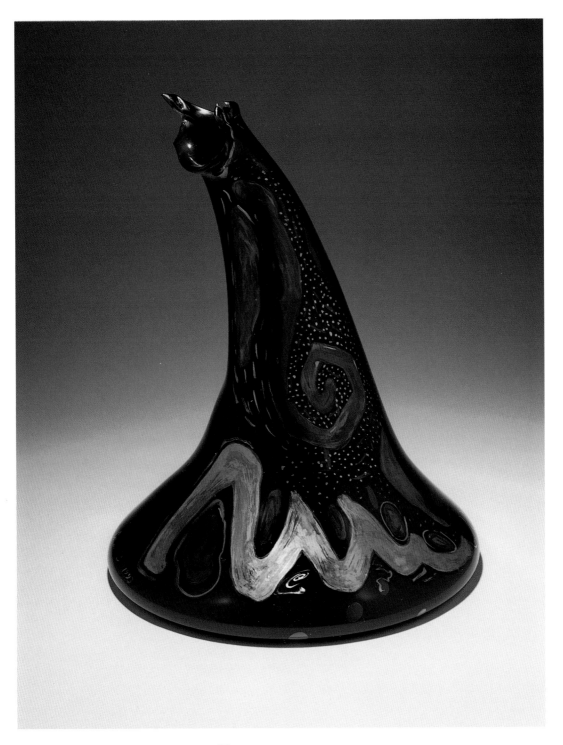

ANTHONY A. CORRADETTI.
AWAKENING. 1993.
BLOWN GLASS, MULTIPLE FIRINGS
WITH LUSTER PAINTS,
17 X 13″ (43.2 X 33 CM)

This attenuated blown vase with its wide base provided the artist with a broad surface on which to apply his painted imagery. Using multicolored lusters, Corradetti layers his colors between multiple firings to achieve rich surfaces. The black background is a perfect foil for the dreamlike quality of the painted images that twist and wrap around his forms.

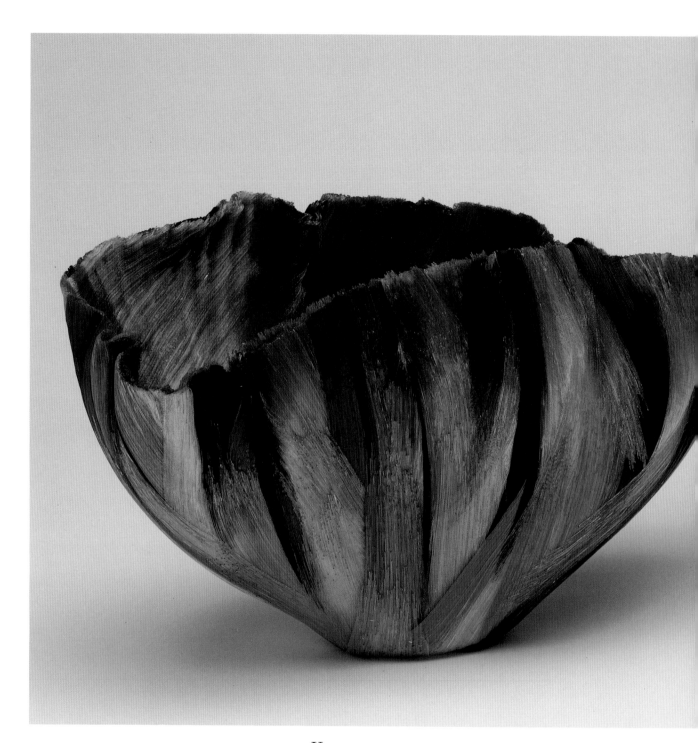

MARY ANN TOOTS ZYNSKY.
BEAU COUPLE FROM THE CHAOS AND ORDER SERIES. 1993.
GLASS; FUSED, SLUMPED, AND HAND-FORMED,
8 x 13 x 7″; 7¾ x 14 x 7″
(20.3 x 33 x 17.8 CM; 19.7 x 35.6 x 17.8 CM)

Known for perfecting a unique method of constructing free-form vessels from layer upon layer of thin glass threads, Zynsky creates pieces that vibrate with brilliant color. These exuberant pieces—fused, slumped, and folded with heat—belie the customary rigidity associated with glass. The rough edges and textured surface suggest freshly cut swatches of stiffened silk.

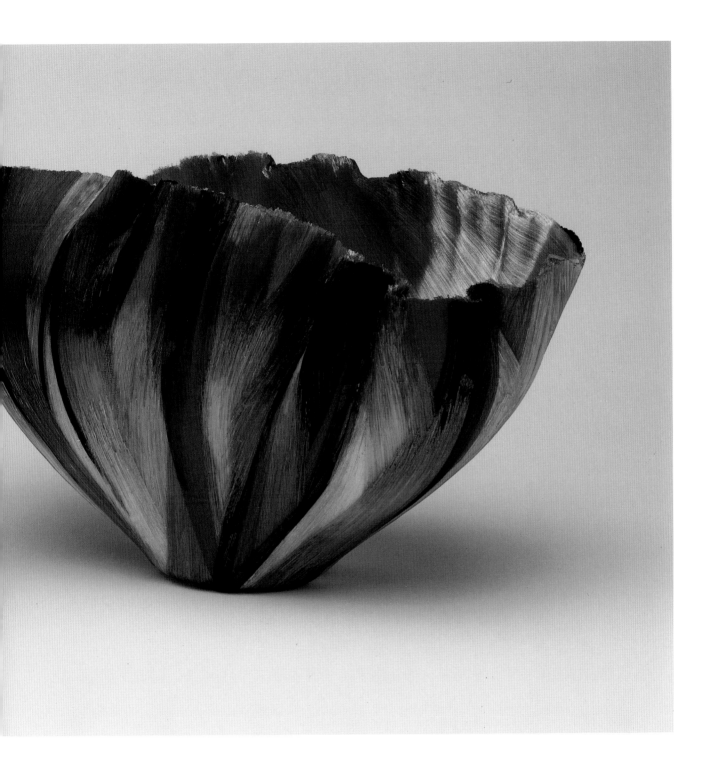

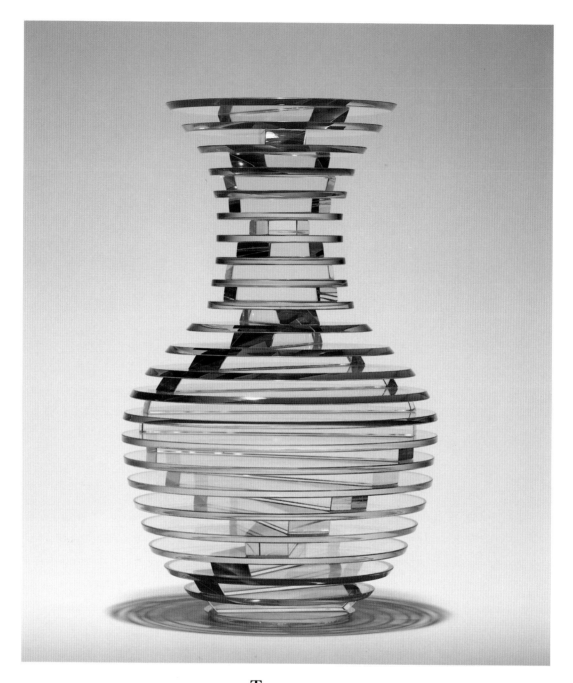

SIDNEY R. HUTTER.
WHITE HOUSE VASE #1. 1993.
PLATE GLASS; CUT, GROUND, POLISHED, AND LAMINATED;
AND ULTRAVIOLET CURING ADHESIVE,
16½ x 10″ (41.9 x 25.4 CM)

Traditionally, vases and other vessels were made for utilitarian purposes; however, a concern for purely decorative forms has become apparent in the work of many American craft artists. Created from commercially available plate glass, Sidney Hutter's geometric and mathematically exact vases are totally nonfunctional. Reflecting the influence of Cubism, Constructivism, and architecture, these vases are painstakingly assembled with ultraviolet curing glue and colored to produce various optical tricks.

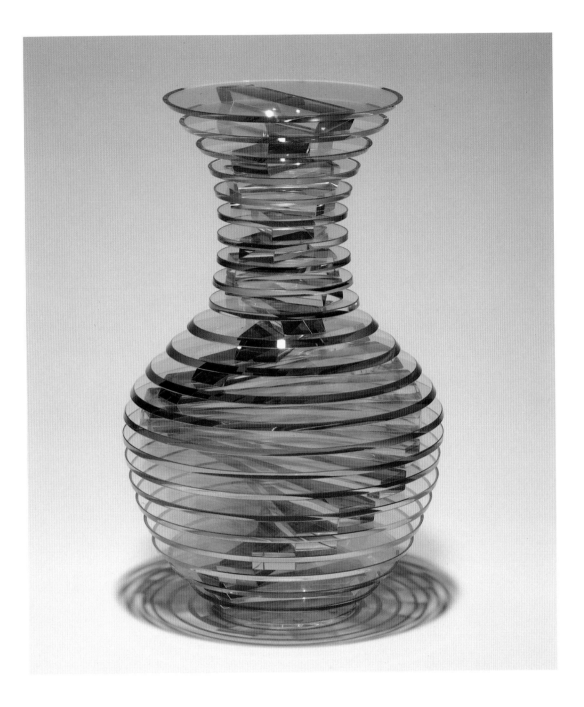

METAL

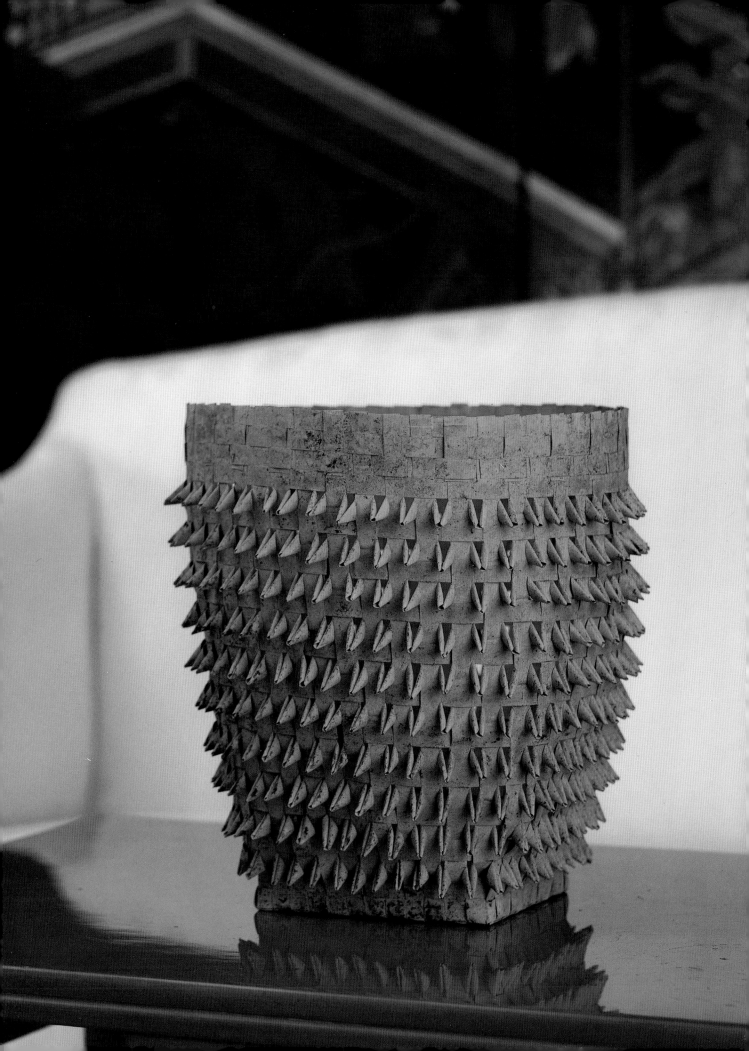

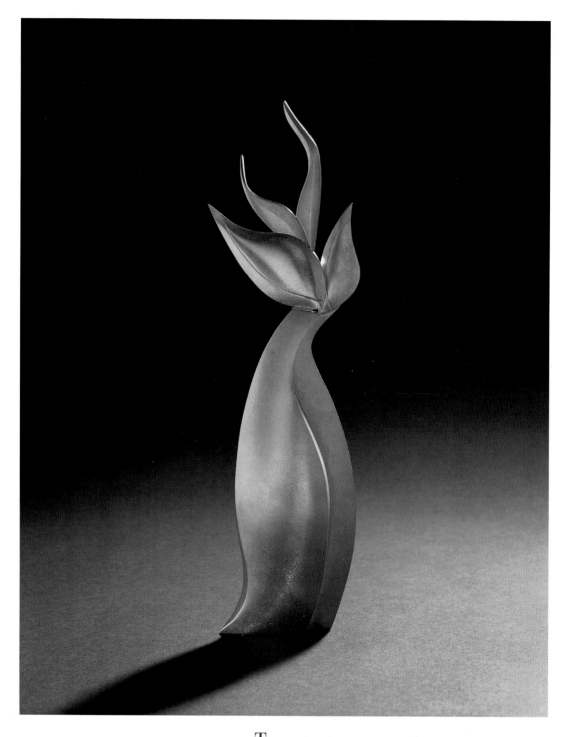

SUZANNE L. AMENDOLARA.
FLORA, SCENT BOTTLE. 1993.
STERLING SILVER AND 24K GOLD; SMITHED, FABRICATED,
HYDRAULIC-PRESSED, AND DYE-FORMED,
9⅜ X 2½ X 1⅝″ (23.8 X 6.4 X 4.1 CM)

This metalsmith strives to create functional containers that project a sense of beauty, fantasy, and femininity. Intended for use on very special or romantic occasions, *Flora, Scent Bottle* captures the gesture and grace of plant life, a major source of inspiration for Amendolara's work.

Previous pages: **PORCUPINE BASKET** BY KEN CARLSON, in The Center Hall, Second Floor

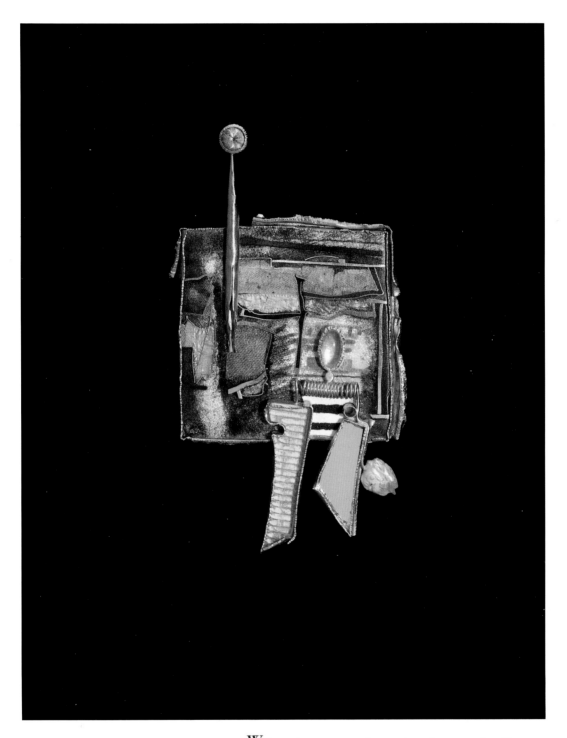

WILLIAM HARPER.
PENTIMENTI #1: THE GOLDEN FLEECE. 1987.
ENAMEL ON FINE SILVER AND FINE GOLD, 14K GOLD,
24K GOLD, STERLING SILVER, PERIDOT, MOONSTONE,
PEARL, PLASTIC, AND MIRROR; CLOISONNÉ,
6 X 3 X ½″ (15.1 X 7.2 X 1.1 CM).
GIFT OF NORMA AND WILLIAM ROTH

William Harper creates objects of startling originality. This brooch, created from such disparate and contrasting materials as 24k gold and plastic, is intended for self-adornment, yet it invokes the power and mystery of ritual amulets. A colorist and master of the cloisonné enameling technique, Harper's imagery is inspired by the art and design of various cultures, from the intricate complexity of Persian miniatures and rugs to the spirit and magic of African assemblage sculpture.

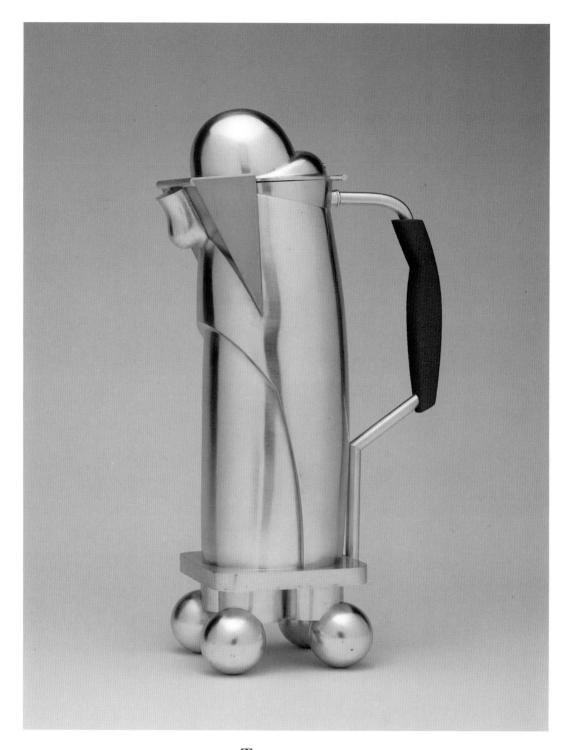

THOMAS P. MUIR.
ESPRESSO SERVER. 1991.
STERLING SILVER, NICKEL, AND ALUMINUM; FORMED,
FABRICATED, CAST, AND OXIDIZED,
10½ x 3¼ x 5¾″ (26.7 x 8.3 x 14.6 CM)

Thomas Muir was inspired by mechanical devices for the component parts of this functional vessel, which suggests the human figure in its gesture and shape. The unexpected forms and structural relationships he finds in machines and tools intrigue him more than natural forms as a source of imagery.

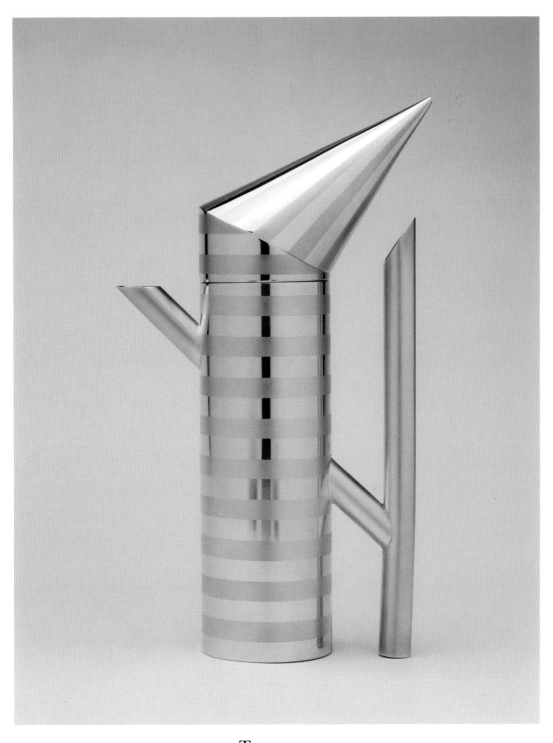

SUSAN R. EWING.
OBOR 1 COFFEE SERVER. 1990.
24K GOLDPLATE OVER BRASS; FORMED, FABRICATED,
SANDBLASTED, AND ELECTROPLATED,
10⅝ x 6¼ x 2½″ (27 x 15.9 x 6.4 CM)

The unique configuration of this coffee server demonstrates that an object does not need to be defined or constrained strictly by its function. This piece represents the artist's concern for inventing animated abstract forms while working with pure shapes and volumes.

Below. DAWN KIILANI HOFFMANN.
OVAL PUNCH BOWL AND LADLE. 1993.
STERLING SILVER; RAISED AND FORGED,
10½ x 15 x 12¼″ (26.7 x 38.1 x 31.1 CM)

The quiet and elegant simplicity of this handwrought oval punch bowl and its matching ladle allows one to fully appreciate the silver and its reflective qualities. The forged legs on the base have been carefully executed so as not to interrupt the sweeping lines of the fluted bowl. The ladle, made as a companion piece, echoes the design of the bowl.

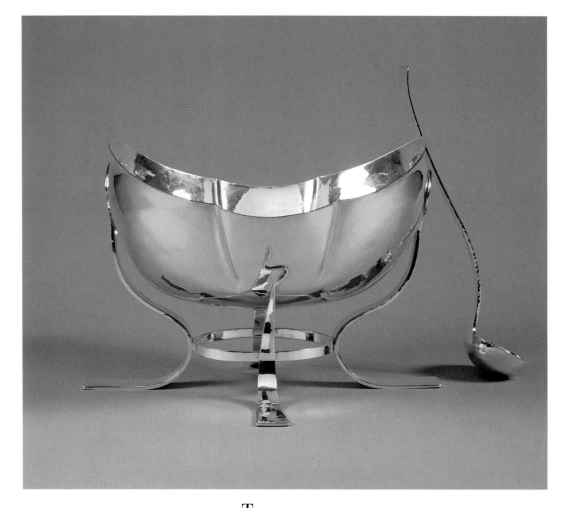

Right. ALBERT PALEY.
CANDLEHOLDERS. 1992.
STEEL; FORGED AND FABRICATED,
31 x 7⅜ x 6½″; 31½ x 7½ x 6½″
(78.7 x 18.7 x 16.5 CM; 80 x 19.1 x 16.5 CM)

This pair of forged steel candlesticks by Albert Paley illustrates his ability to coax fluid, sensual, and supple forms from an industrial material known for its rigidity. Mastery and refinement of smithing techniques allow for the bold freedom of design and rightness of proportion that are typical of this metalsmith's refined works.

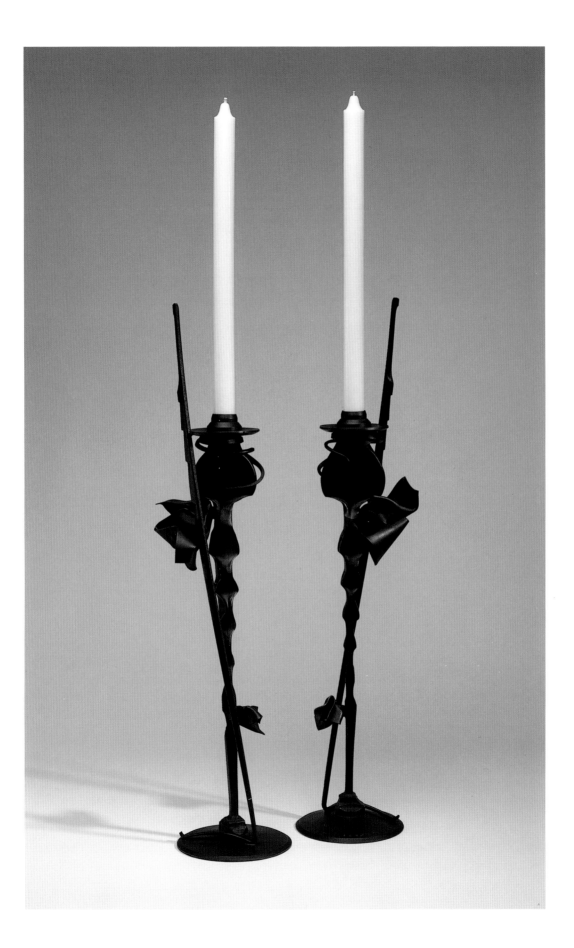

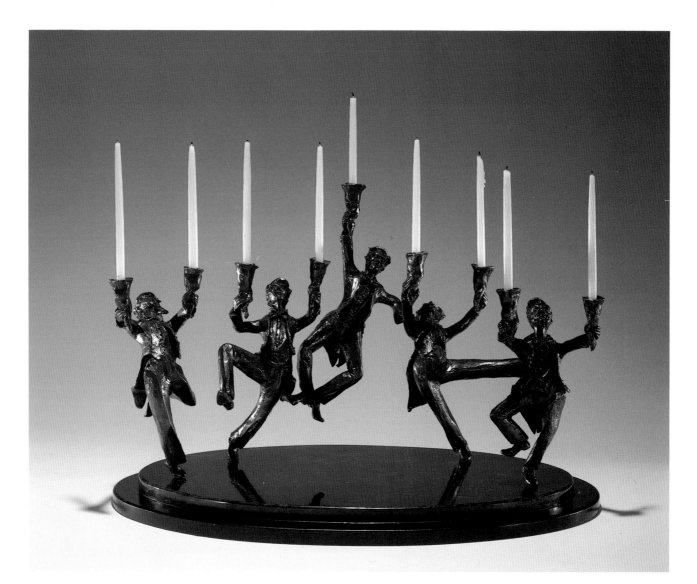

ZACHARY OXMAN.
A FESTIVAL OF LIGHT. 1993.
BRONZE, GRANITE, AND MARBLE; CAST,
15 x 24¾ x 17″ (38.1 x 62.9 x 43.2 CM)

The goal of this artist is to create functional pieces that combine a classic, figurative aesthetic with contemporary whimsy. Oxman's offbeat Hanukkah menorah comprised of five dancing men in tail coats is a joyous commemoration of this festival of lights.

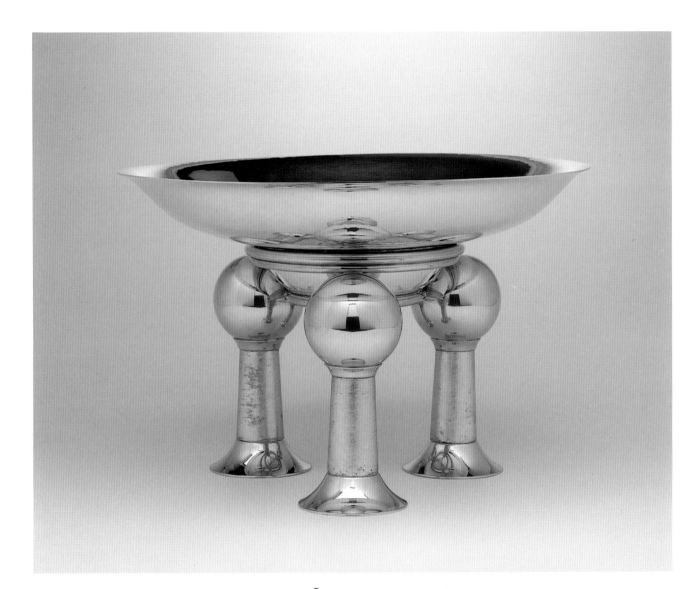

RANDY J. STROMSÖE.
CENTERPIECE BOWL ON THREE-LEGGED STAND. 1993.
STERLING SILVER, PEWTER, AND GOLD LEAF; FORGED AND RAISED,
9½ X 14½″ (24.1 X 36.8 CM)

It took this metalsmith more than 100,000 hammer blows to produce this handsome bowl, forged and shaped from a single disc of sterling silver. Inspired by architectural columns and the classical tripod form, Stromsöe fabricated and gold-leafed a bold pedestal base that elevates the bowl to a celebratory and ceremonial state.

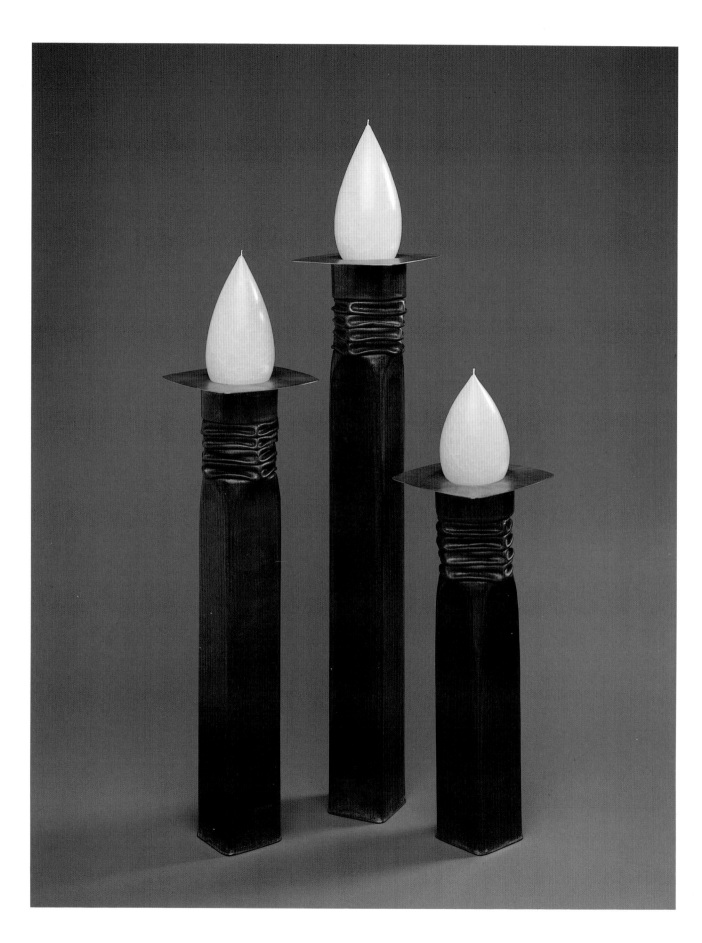

Left. THOMAS R. MARKUSEN.
RASPBERRY CANDLEHOLDERS #426-D. 1993.
COPPER AND BRASS; HOT-FORMED, COMPRESSED, AND FABRICATED,
30¾ x 7⅜ x 7⅜"; 24½ x 7¼ x 7¼"; 19¼ x 7¼ x 7¼"
(78.1 x 18.7 x 18.7 CM; 62.2 x 18.4 x 18.4 CM; 48.9 x 18.4 x 18.4 CM)

These three patinated candleholders, with their planar shafts and creased collars, reflect the fluid and plastic quality of red-hot copper when it is forged and shaped. A disc of polished brass at each collar acts as a reflective platform for candlelight.

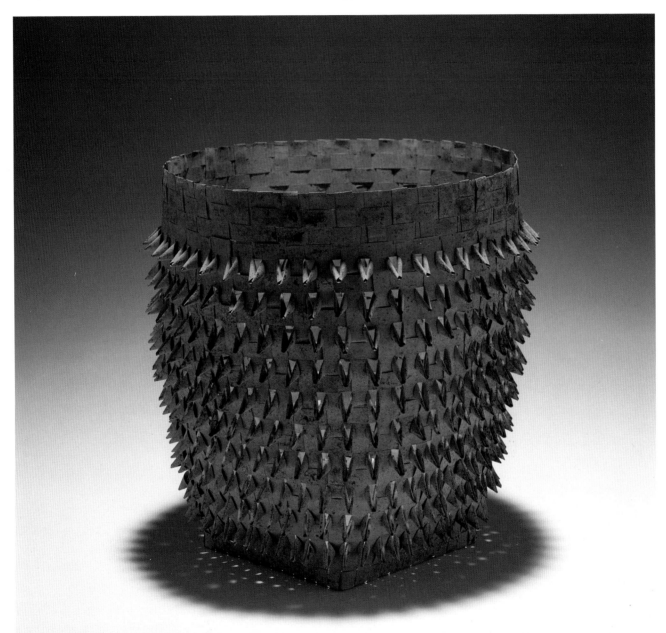

Above. KEN CARLSON.
PORCUPINE BASKET. 1993.
COPPER; WOVEN AND OXIDIZED,
10 x 9½" (25.4 x 24.1 CM)

This elaborately worked copper form illustrates the artist's fascination with the ancient basketry technique of plaiting. The ductile, yet structural, nature of copper, along with its natural ability to develop a rich, green patina, has led Carlson to explore its potential in unusual textured forms.

CERAMIC

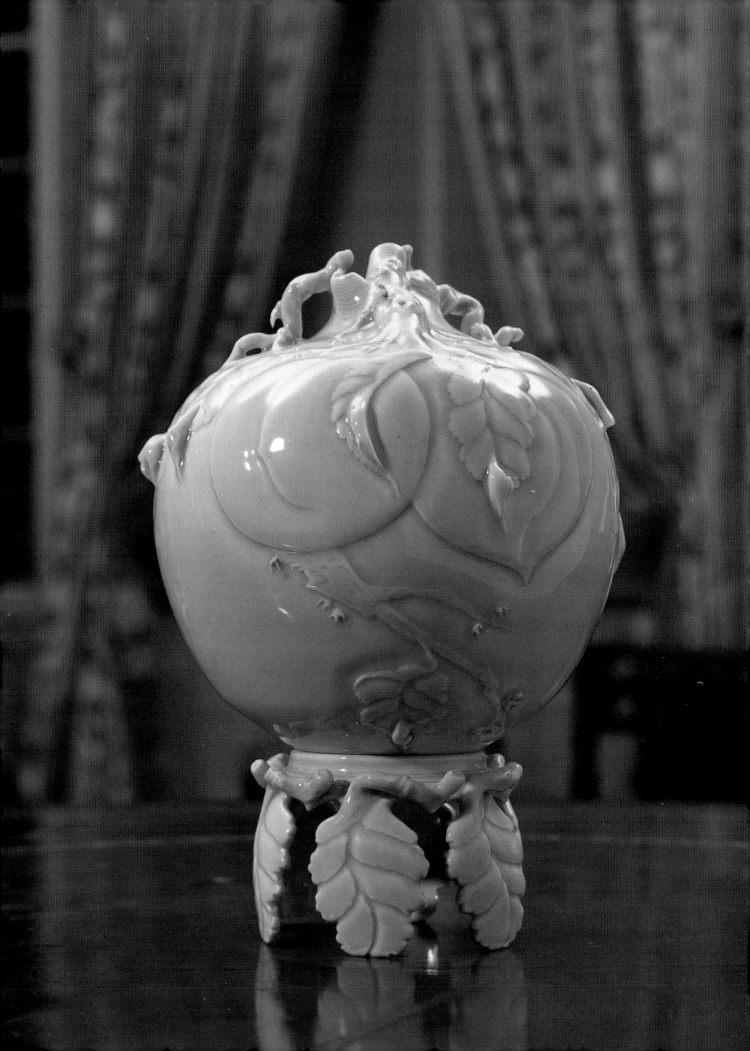

Below. CHERYL C. WILLIAMS.
PRAYER BOWLS. 1993.
STONEWARE, GOLD LEAF, AND
ACRYLIC PAINT; WHEEL-THROWN AND AIRBRUSHED,
14½ x 12¾"; 12 x 9½"; 6 x 10¾" (36.8 x 32.4 CM;
30.5 x 24.1 CM; 15.2 x 27.3 CM)

This trio of bowls reflects the potter's concern for simple, yet superbly executed forms and intense colors. For Williams, the contrast of the brilliant gold interior against the roughly textured exterior represents a metaphor for humankind: luminous on the inside, often plain and coarse on the outside.

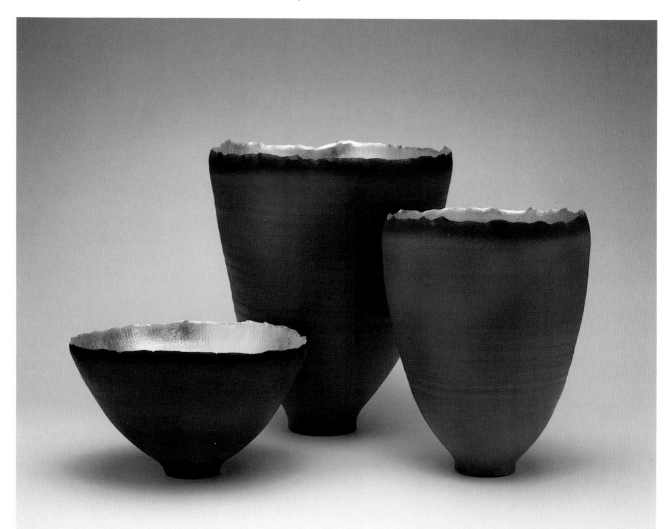

Right. MICHAEL SHERRILL.
INCANDESCENT BOTTLES. 1993.
WHITE STONEWARE, ALKALINE AND
BARIUM GLAZES; WHEEL-THROWN,
22½ x 5"; 18 x 5"; 10 x 7"
(57.2 x 12.7 CM; 45.7 x 12.7 CM; 25.4 x 17.8 CM)

The simple and attenuated forms of these bottles offer intriguing variations in the physical relationships among the parts of ceramic vessels: handle, foot, body, neck, and lip. Sherrill distinguished the parts by vibrant, incandescent hues on the chalky and pitted surfaces of the bottles.

Previous pages: **PEACH VASE ON A PEDESTAL** BY CLIFF LEE, in The White House Library

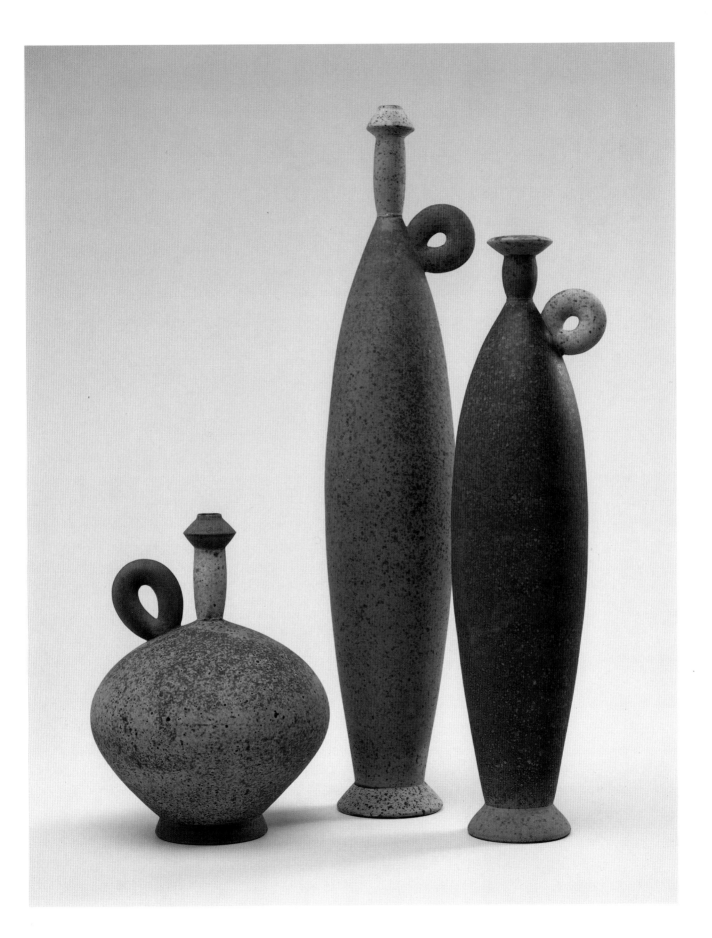

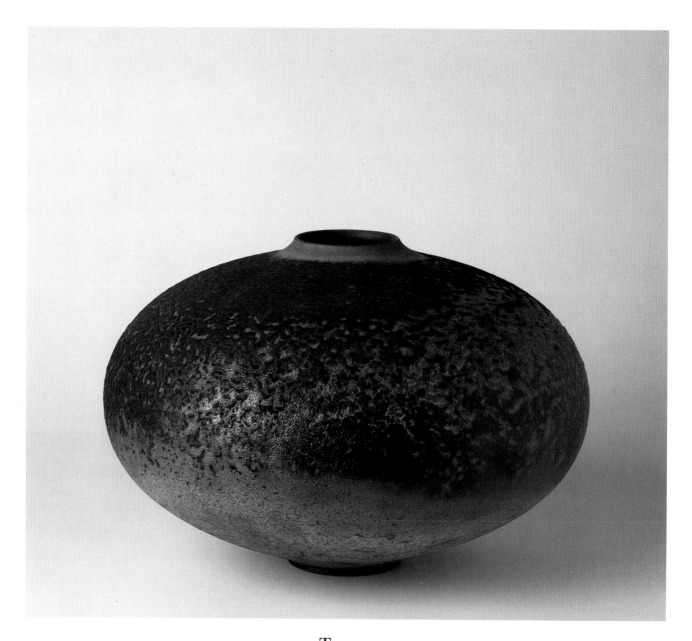

HARVEY S. SADOW, JR.
THE PEARL, GROUND ZERO SERIES. 1986.
CERAMIC; WHEEL-THROWN, GLAZED, RAKU-FIRED, AND SANDBLASTED,
11 X 14″ (28 X 35.6 CM)

This low and carefully wheel-thrown form serves the artist's vision of the vessel as a global metaphor. Repeated raku-firings have produced a highly corroded and pitted surface texture that simultaneously suggests the earth's primal beginnings and its apocalyptic death.

JAMES C. WATKINS.
RITUAL DISPLAY. 1992.
STONEWARE; WHEEL-THROWN AND SAGGER-FIRED,
19½ x 19¼″ (49.5 x 48.9 CM)

Influenced by the desert topography of the American Southwest, Watkins's double-walled and massive wheel-thrown cauldrons conjure up the scorched walls of deep canyons. Snakes and bird-shaped adornments serve as guardians on the rims of his bowls, evoking mystery, magic, and ritual.

THOMAS HOADLEY.
NERIKOMI BOWL. 1993.
COLORED PORCELAINS; HAND-BUILT AND NERIKOMI TECHNIQUE,
7⅛ x 9¼ x 10⅜" (18.1 x 23.5 x 26.4 CM)

The nerikomi technique of using colored porcelains allows the pattern to penetrate through the thickness of the wall so that it is visible both inside and out. Hoadley took advantage of this organic union of pattern and structure to create an intricately and richly designed vessel.

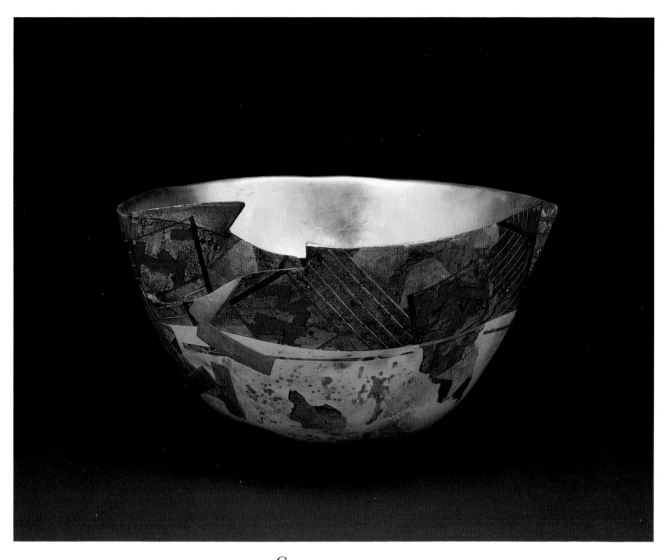

BENNETT BEAN.
THE WHITE HOUSE BOWL. 1993.
WHITE EARTHENWARE AND GOLD LEAF; GLAZED,
PIT-FIRED, AND PAINTED,
9½ x 16 x 16½″ (24.1 x 40.6 x 41.9 cm)

Created especially for the White House crafts collection, this extensively decorated bowl features an abstract and fragmented design motif inspired by the American flag. Bean contrasts the complex exterior patterns against a rich 24k gold interior.

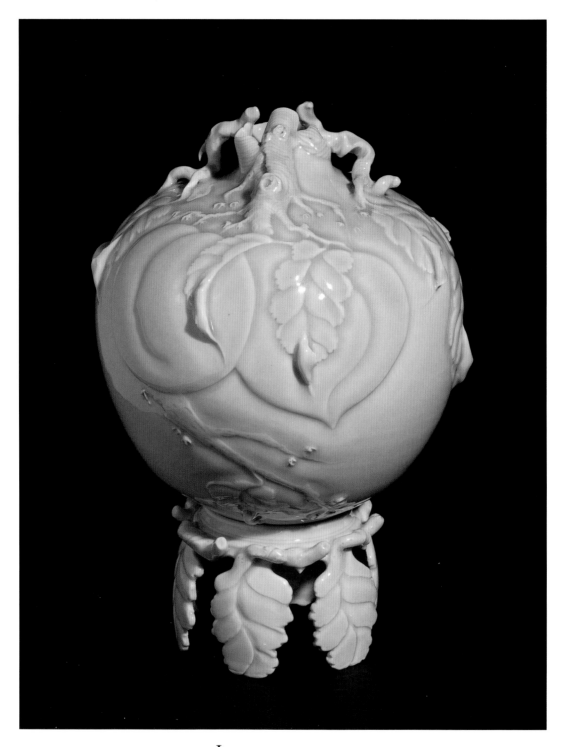

CLIFF LEE.
PEACH VASE ON A PEDESTAL. 1993.
PORCELAIN WITH CELADON GLAZE;
WHEEL-THROWN AND CARVED,
11⅞ x 8″ (30.2 x 20.3 CM)

Inspired by his Chinese heritage, potter Cliff Lee fuses a tradition of fine craftsmanship with the innovations of contemporary artisanry. This exquisitely incised and carved porcelain vase on a distinctive pedestal base is unified through its cool and elegant celadon glaze.

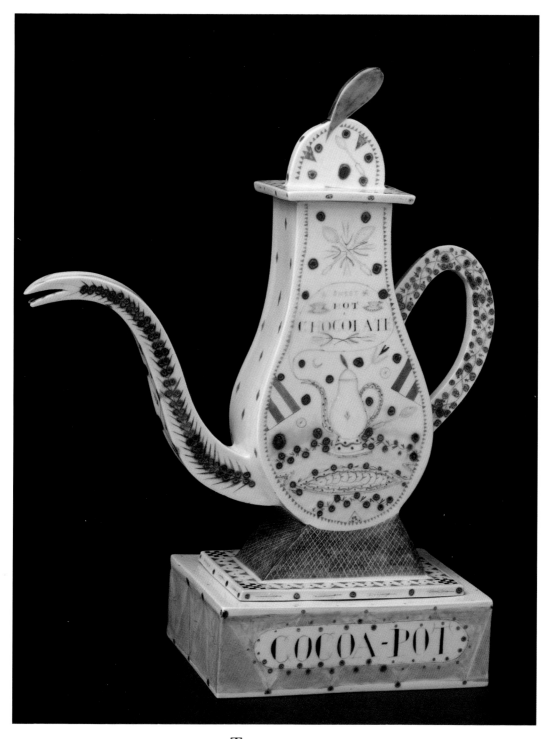

MARA SUPERIOR.
A COCOA POT. 1990.
PORCELAIN, UNDERGLAZES, AND CERAMIC OXIDES;
SLAB CONSTRUCTED,
19½ x 15⅞ x 6½″ (49.5 x 40.3 x 16.5 CM)

This highly decorated cocoa pot rests on a pedestal complete with a tablecloth, an indication of Mara Superior's delightful sense of humor. Inspired by the graphic qualities of embroidered samplers, Superior covered the flattened forms with abundantly drawn detail, including lettering, lace patterning, and a generous sprinkling of brown specs resembling cocoa beans. A sense of animation is achieved by the downward tilt of the spout in a beckoning gesture of hospitality.

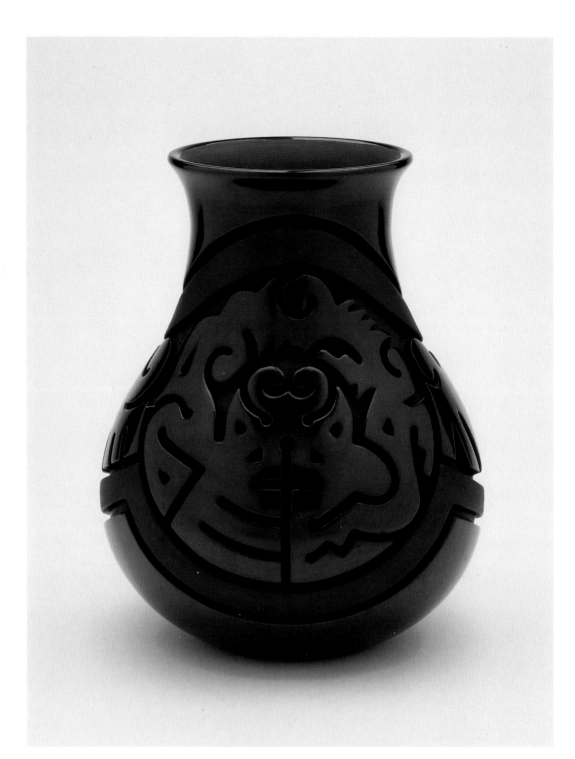

NATHAN YOUNGBLOOD.
BLACK CARVED JAR. 1991.
EARTHENWARE; HAND-COILED,
CARVED, AND BURNISHED,
11¾ x 9¼″ (29.9 x 23.5 CM)

This elaborately worked jar expresses Nathan Youngblood's distinctive style within the pottery tradition of the Santa Clara pueblo in New Mexico where the artist lives. The concise and deeply incised pattern portrays clouds, water, and mountains. Youngblood's objective is to integrate curvilinear design and geometric abstraction so that they flow effortlessly over the form of his vessels. The surface treatment of this unglazed jar, featuring a stone-burnished gloss with a contrasting matte finish in the channels, is characteristic of the pueblo's pottery.

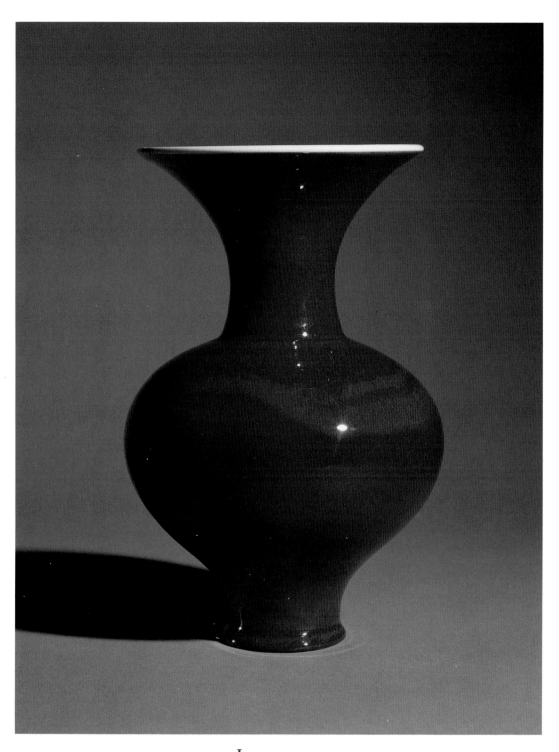

JOHN S. CUMMINGS.
PORCELAIN VASE—SANG-DE-BOEUF. 1985.
PORCELAIN AND SANG-DE-BOEUF
GLAZE; WHEEL-THROWN,
11⅜ x 6⅝″ (29.5 x 16.8 CM)

Inspired by classic Chinese glazes and ceramic forms, potter John Cummings strives for perfection, as illustrated by this exquisitely thrown and glazed porcelain vase.

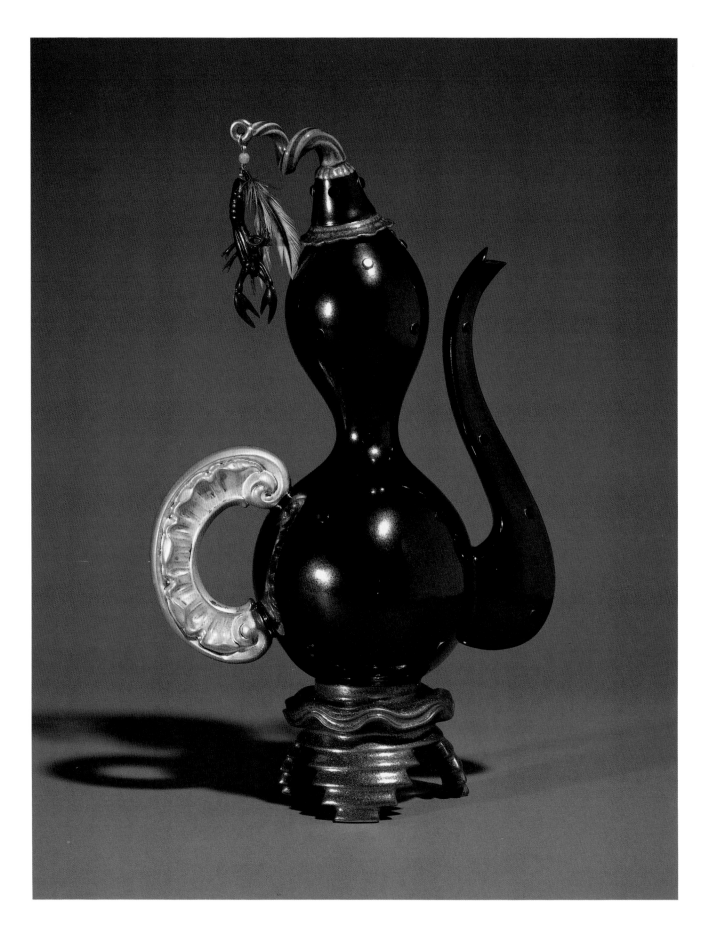

Left. ADRIAN SAXE.
UNTITLED EWER (IST). 1992.
PORCELAIN, LUSTERS, FISHHOOK, FEATHERS,
RUBBER CRAWFISH, AND PLASTIC,
12¾ x 7½ x 4″ (32.4 x 19.1 x 10.2 CM)

This elaborate ewer reflects the artist's desire to combine his eclectic interests and experiences in historical ceramic traditions with a contemporary style. The elegant and highly glossed body of the pot suggests a vegetable form, to which a flamboyant gold baroque handle and jaunty lid—with a tassel composed of a rubber crawfish and fishhook—have been added.

Above. ANNE HIRONDELLE.
TANDEM TEAPOT DIPTYCH. 1993.
STONEWARE CLAY; WHEEL-THROWN,
EXTRUDED AND ASSEMBLED ADDITIONS,
9½ x 14 x 7¾″; 8 x 14 x 8¼″
(24.1 x 35.6 x 19.7 CM; 20.3 x 35.6 x 21 CM)

These subtly colored, raku-fired teapots reflect Hirondelle's strong architectonic sense of design. The flowing, contoured shapes of the lids, handles, and spouts on the two teapots relate to each other as formal devices, demonstrating the artist's fondness for conceiving and arranging her pieces in complementary pairs.

Above left. CURTIS BENZLE AND SUZAN SCIANAMBLO BENZLE. **TUXEDO JUNCTION.** 1992. PORCELAIN COLORED INLAYS; HAND-BUILT, 6½ x 17¼ x 4″ (16.5 x 43.8 x 10.2 CM)

Mastery of technique is essential to the creation of delicate, multilayered porcelain vessels such as *Tuxedo Junction*. The unique eggshell-thin bowl, with its ruffled rim, allows light to pass through its intricately patterned surface, creating a translucent environment in full color.

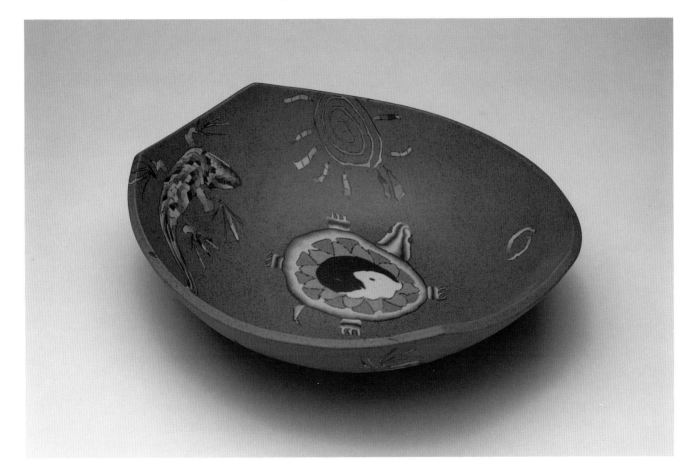

Below left. JOAN MONDALE. **BOWL.** 1993. STONEWARE AND SHINO GLAZE; WHEEL-THROWN, 3½ x 6½″ (8.9 x 16.5 CM)

This beautifully thrown stoneware bowl by potter Joan Mondale typifies her desire to produce useful objects. The ribbed exterior recalls the spinning motion of the potter's wheel while the bold and confidently applied calligraphic brushstoke visually energizes the surface.

Above. MICHAEL HALEY AND SUSY SIEGELE. **LIZARDS INTERPRETING THE ANCIENT SYMBOL.** 1993. COLORED PORCELAIN; SLAB-BUILT AND INLAID, 3¼ x 12 x 11″ (8.3 x 30.5 x 28 CM)

By using a variety of inlaid colored porcelains, these potters achieve designs that are integral to the structure of their pieces as opposed to being painted on the surface. Here, two lizards with subtly patterned bodies peer down from the walls of the bowl to contemplate a tortoise bearing the symbol of yin and yang, the ancient Chinese principles of cosmic harmony.

Below. PATRICK W. DRAGON.
UNTITLED. 1993.
WHITE EARTHENWARE WITH TERRA SIGILLATA, UNDER-
GLAZES, SLIPS, STAINS, OILS, ACRYLICS, INKS, AND 22K
GOLD LEAF; WHEEL-THROWN AND BURNISHED,
12⅜ X 11¼″ (31.4 X 28.6 CM)

The surface decoration on this bowl captures the illusion of pictorial space, immersing figurative motifs in an abstract landscape.

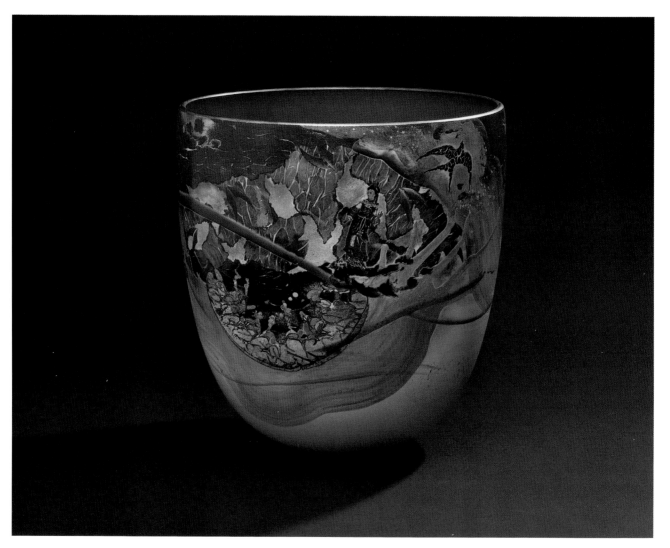

Right. RALPH BACERRA.
TEAPOT. 1992.
EARTHENWARE, SLIP CAST, CHROME RED GLAZE,
OVERGLAZE ENAMELS, AND LUSTER,
16½ X 13½ X 13¼″ (41.9 X 34.3 X 33.7 CM)

This large and dramatic teapot reflects the artist's experimentation with glazes and the effects produced by firing clay in the kiln at varying temperatures. Drawing his imagery from nature, Bacerra used an actual tree trunk and twigs to create a mold for the body, spout, and handle of this teapot and pedestal base. Featuring an unusually vibrant and saturated hue of red, Bacerra's pieces are accented with gold and brightly colored geometric patterns.

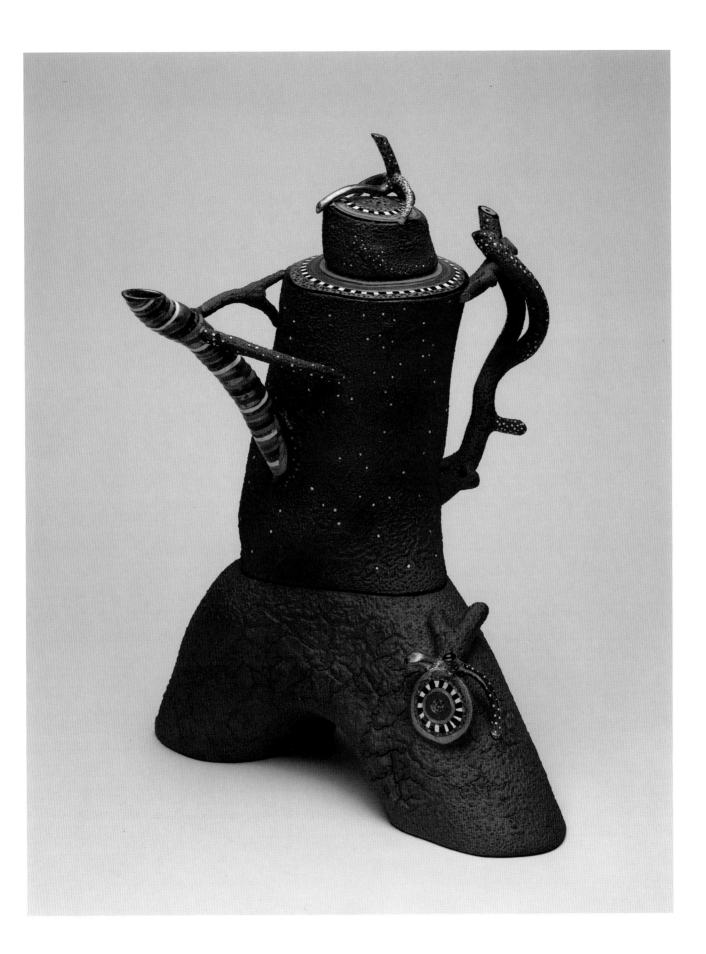

Mastery of technique was essential to the creation of this difficult and intricate vessel form. Oxman incorporated a multitude of decorative devices—from photo transfers to 22k gold—to convey a romantic and baroque sense of exuberance. Heavily encrusted with applied flowers and leaves, sensuously drawn contemporary nudes flaunt their lack of inhibition adjacent to nostalgic Victorian portraits of women.

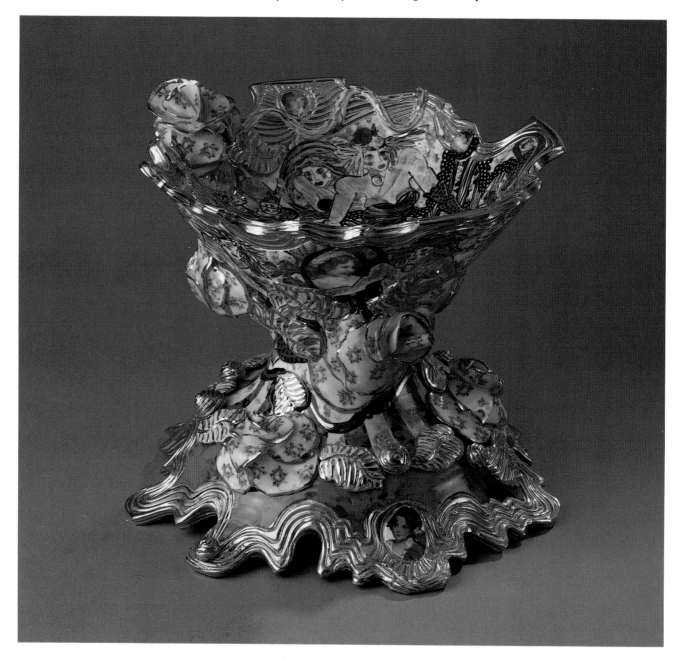

Andrea Gill's interest in painting and fifteenth-century decorated pottery, such as Spanish and Italian tin-glazed majolica, has inspired the surface treatment of her vases. This vessel brings to mind a large pitcher with its pinched spout and two-dimensional handle. The repeat pattern of dancing goblets suggests that a lively celebration is about to commence.

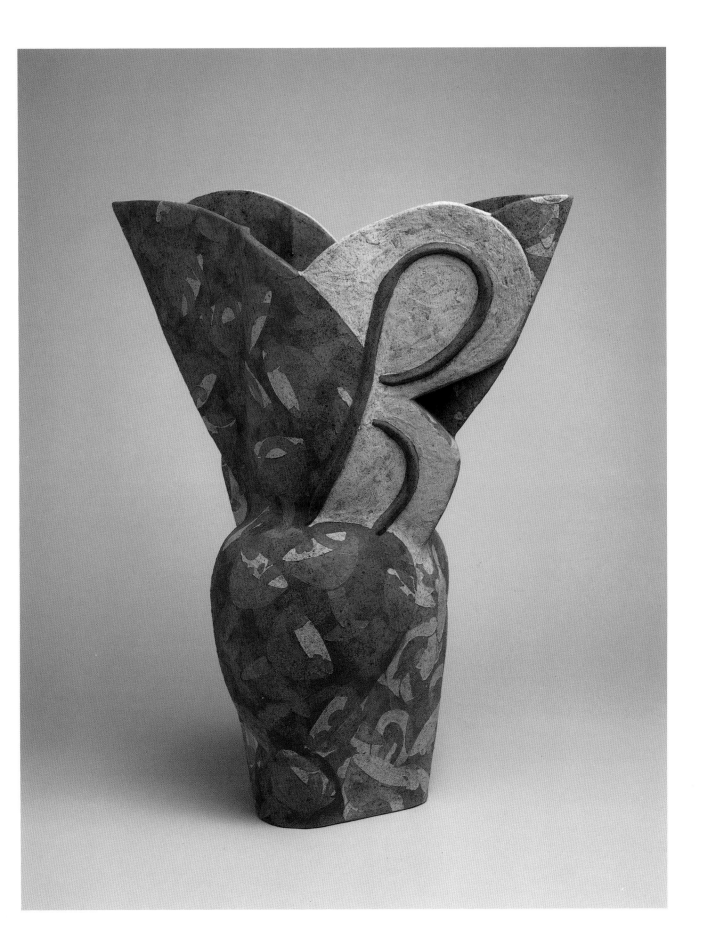

FIBER

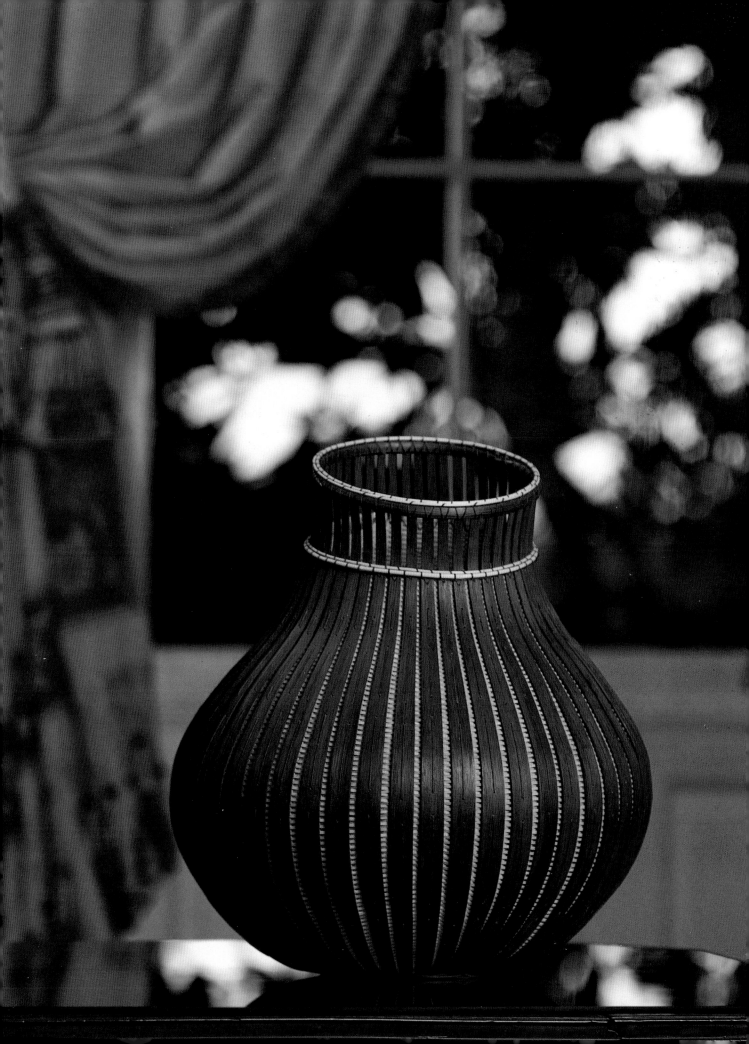

Careful not to detract from their baskets as vessels, these craft artists avoid unnecessary appendages to their beautifully constructed containers. This basket features a double layer of alternating strips, one dark and one light, that are delicately sewn together with linen threads. A sense of energy is conveyed by the bulging body, which is constrained only by its slanted and narrow collar.

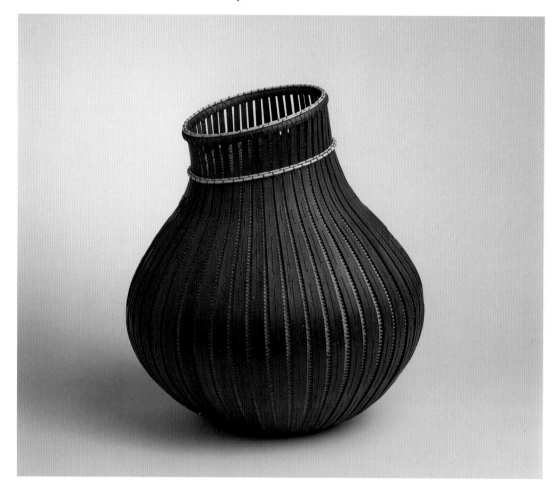

This artist has chosen basketry as a means of expression because it allows her great freedom to work with color and pattern in a rigid form. This piece was inspired by the strength and simplicity of Japanese courtyard gardens and the color and intimacy of English cottage gardens. Lønning developed a technique of construction that produces a double wall, prompting associations with the privacy and mystery of enclosed spaces.

Using natural white birch bark and wood materials of her native Wisconsin, Dona Look constructs perfectly symmetrical and elegant baskets. The natural vertical markings in the birch establish an organic pattern that is used to emphasize the vertical form. Using silk thread, she has sewn the sections of bark together with remarkable skill and sensitivity, demonstrating respect for the material and reminding us of the importance of harmony in our relationship with nature.

Previous pages: **EBURNA** BY SHARON AND LEON NIEHUES, in The Red Room

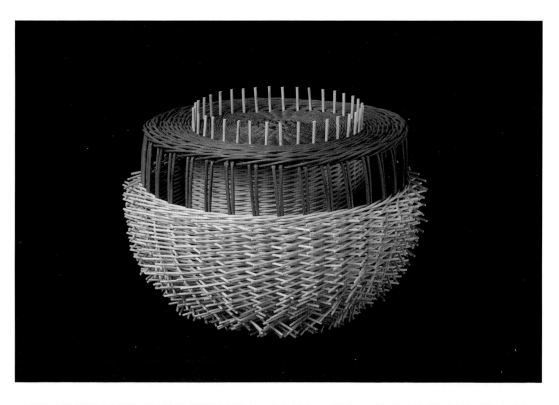

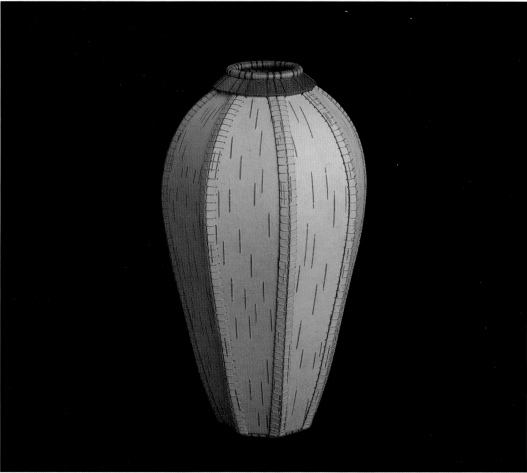

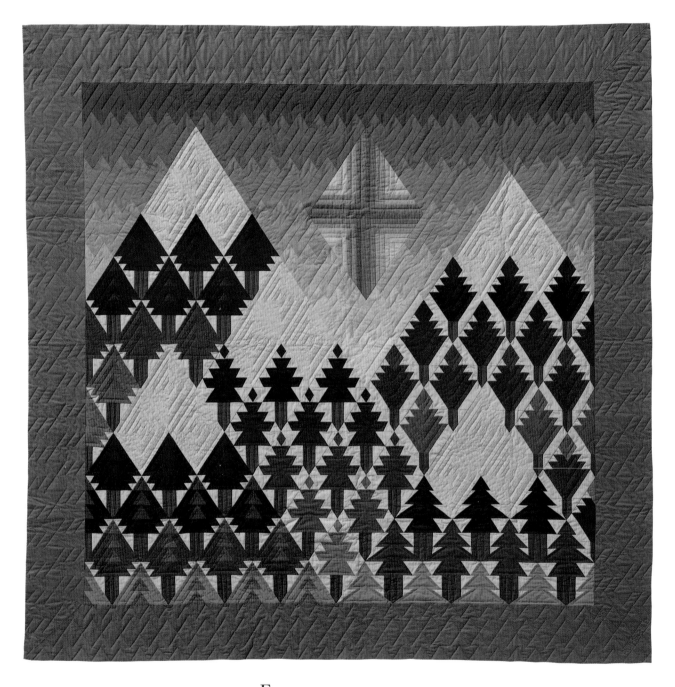

Entranced by the dazzling optical effects she had seen in Amish quilts, Adrien Rothschild began quilting fifteen years ago. Her early works in fabric were strictly geometric, repeat block designs in graduated colors. Since her travels to the mountains of New Zealand, Canada, and West Virginia, Rothschild has turned to portraying tree-covered mountains, as seen in this quilt.

ELLEN KOCHANSKY.
COUNTERPANE. 1992.
COTTON, ANTIQUE FABRICS, METALLIC THREAD, AND PAINT;
PIECED, MACHINE-STITCHED, QUILTED, AND EMBROIDERED,
47½ X 47¾″ (120.7 X 121.3 CM)

Ellen Kochansky is passionate about color, and a collector and admirer of assorted scraps of cloth. She quilts abstract images inspired by views of her flower garden through a window and the rural property surrounding her South Carolina studio, delighting in the visual disparity between that which is tiny and immediate and the vast and panoramic distance.

Above. AKIRA BLOUNT.
MAN IN LION COSTUME. 1993.
COTTON, WOOL, BUTTONS, AND BEADS; STITCHED AND PAINTED,
24 x 8½ x 11½″ (SEATED) (61 x 21.6 x 29.2 CM)

This jointed doll with a lion mask that lifts to reveal a human face is meant to represent the qualities of leadership symbolized by the lion in art and literature. Blount associates the lion with Aslan in *The Chronicles of Narnia* by C. S. Lewis, a character who embodies the attributes of love, compassion, and sacrifice. The mask suggests the human traits that animals in close relation to people often seem to possess.

Right. JUDY B. DALES.
SPIRIT FLIGHT. 1993.
COTTON AND POLYESTER; HAND- AND MACHINE-PIECED,
HAND-APPLIQUÉD, AND HAND-QUILTED,
73 x 53″ (185.4 x 134.6 CM)

This artist is known for her ability to create a painterly flow of color by combining a multitude of printed fabrics in soft, subtle hues. Dales made this quilt during an intense period of mourning following her mother's death. The tears cascading down the right side symbolize her feelings of grief and loss and the ethereal figure floating above the starry heavens represents the human spirit.

WOOD

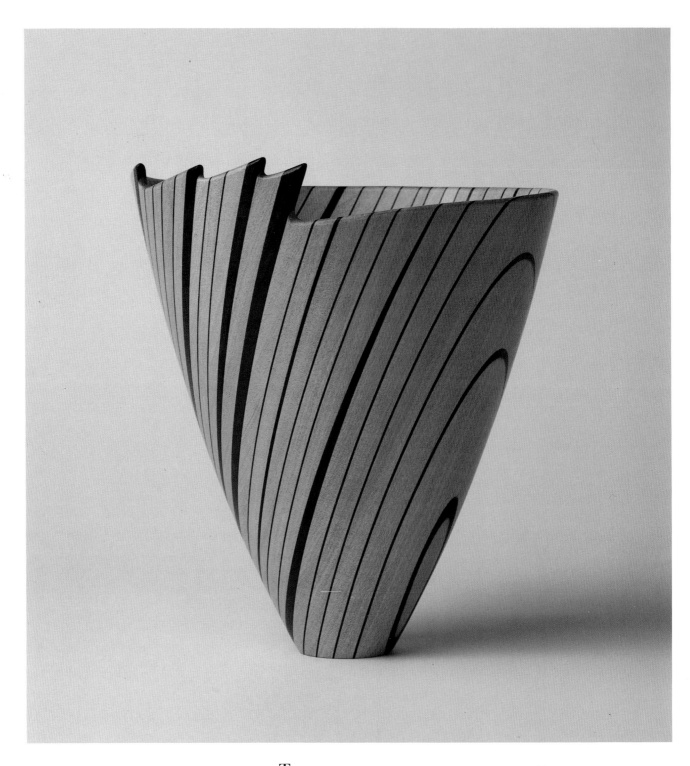

VIRGINIA DOTSON.
SUNLIGHT (#4). 1993.
IVORYWOOD AND EBONY; LAMINATED AND
LATHE-TURNED WITH CARVED RIM,
9 x 8″ (22.9 x 20.3 CM)

This bowl, featuring an asymmetrical rim, was inspired by the geological formations of the Arizona landscape where the artist lives. The chronological arrangement of rock layers and the stark contrast of light and shadow typical of that terrain are expressed in this piece.

Previous pages: **NEW BEGINNINGS** BY RONALD F. FLEMING, in The Red Room

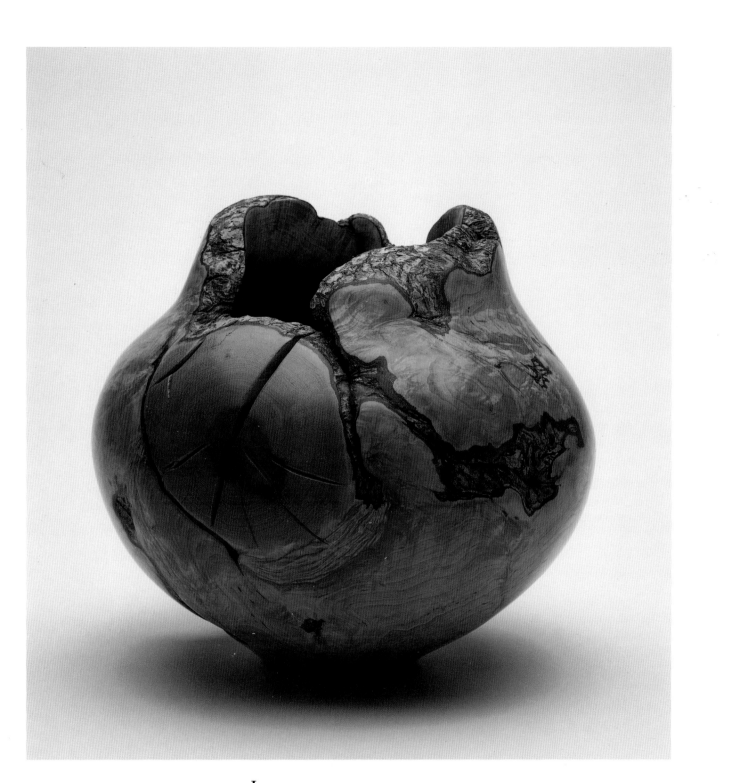

MELVIN LINDQUIST.
NATURAL TOP HOPI BOWL. 1993.
HOP HORNBEAM BURL; LATHE-TURNED,
9½ x 10″ (24.1 x 25.4 CM)

In pursuit of the ideal vase form, this craftsman has been turning bowls for over fifty years. Using skills and knowledge gained through his engineering and machinist background, Lindquist developed new tools and techniques for working with difficult woods. This vase, inspired by Native American ceramic forms, illustrates his fondness for exploiting the individual character of each piece of wood to enhance its imperfections and to suggest the creative process.

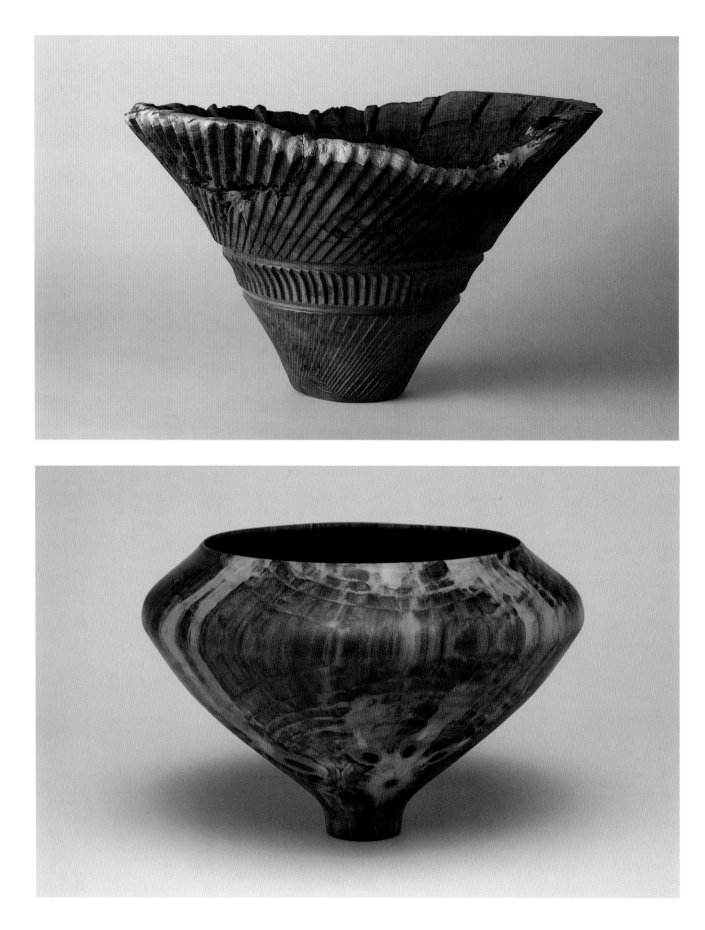

Above left. MARK LINDQUIST.
FLUTED VESSEL, ASCENDING, WITH RHYTHMIC MOTION. 1992.
CHERRY BURL; LATHE-TURNED AND CHAIN-SAWN,
9 x 15″ (22.9 x 38.1 CM)

Known for his spontaneous and direct approach to turning wood on a lathe, often rough-shaping his pieces with a chain saw, Mark Lindquist challenges the time-honored traditions of the craft. This piece features an undulating rim juxtaposed against two sets of opposing diagonal flutes that convey an effect of twisting movement.

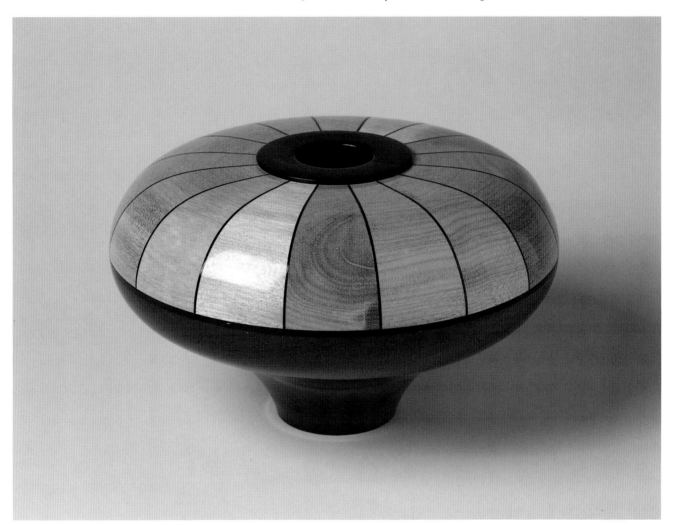

Above. BOB HAWKS.
LONGITUDINAL II. 1993.
PURPLE HEART AND YELLOW BOXWOOD;
SEGMENTED AND LATHE-TURNED,
4⅞ x 7⅞″ (12.4 x 20 CM)

The silhouette of this vessel creates the impression of an object ready to levitate. The dark lower portion, narrowed at the bottom, balances the lighter upper section which appears inflated and almost buoyant.

Below left. RONALD E. KENT.
TRANSLUCENT WOOD BOWL. 1993.
PACIFIC NORFOLK PINE; LATHE-TURNED,
MULTIPLE OIL-SOAKED, AND HAND-SANDED,
8½ x 12½″ (21.6 x 31.8 CM)

Ronald Kent's turned bowls are known for their remarkably narrow bases. The extreme thinness of his vessels allows the light to penetrate; here, he took full advantage of the striking grain of Pacific Norfolk pine to reveal patterns reminiscent of tortoiseshell.

Below. FRANK E. CUMMINGS III.
IT'S MAGIC. 1993.
MYRTLE BURL, EBONY, BLACK ONYX, AND 18K GOLD;
LATHE-TURNED AND INLAID WITH CARVED RIM,
7¼ x 5″ (18.4 x 12.7 CM)

Fashioned from a single burl of myrtle wood, this elegant vessel balances a strong and solid form with a delicate carved rim suggestive of lace. An inlaid band of onyx and gold provides additional contrast and drama.

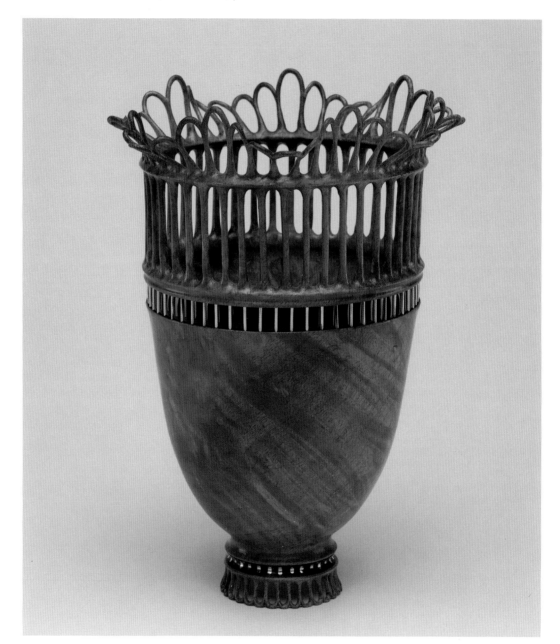

Right. WENDELL CASTLE.
PRESENCE CLOCK #7. 1990.
MAHOGANY, BRONZE, BRASS, AND CURLY MAPLE;
STAINED, PATINED, AND BLEACHED,
23⅝ x 17½ x 10″ (60 x 44.5 x 25.4 CM)

The theme of time has been an inspiration for Wendell Castle and for several years he has designed and built provocative, table-sized and tall case clocks. In this piece, Castle exploited the clock's potential as a form of sculpture. In contrast to the manifestation of balance and logic at its top, the unique pedestal base of uneasy asymmetry features two limp and surreal pairs of clock hands that appear to have fallen from exhaustion.

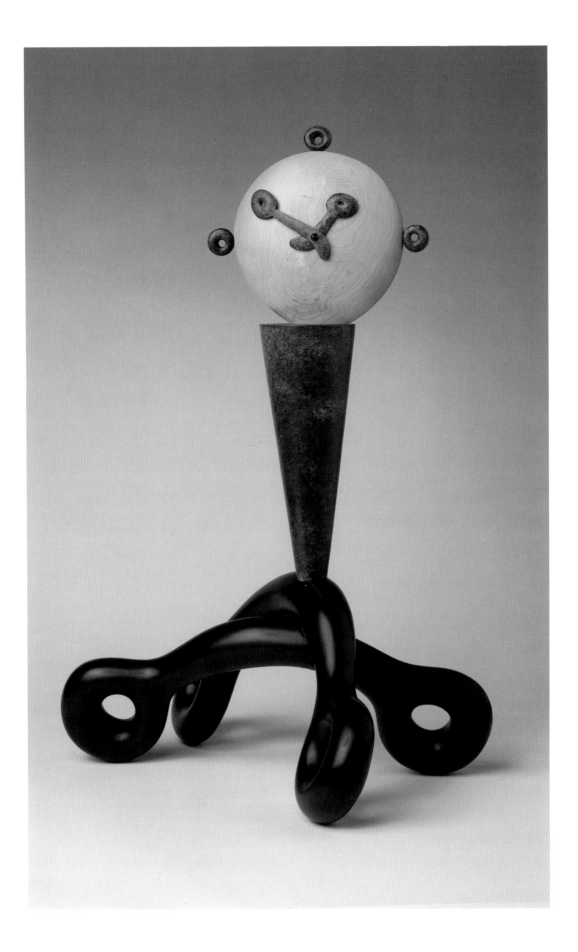

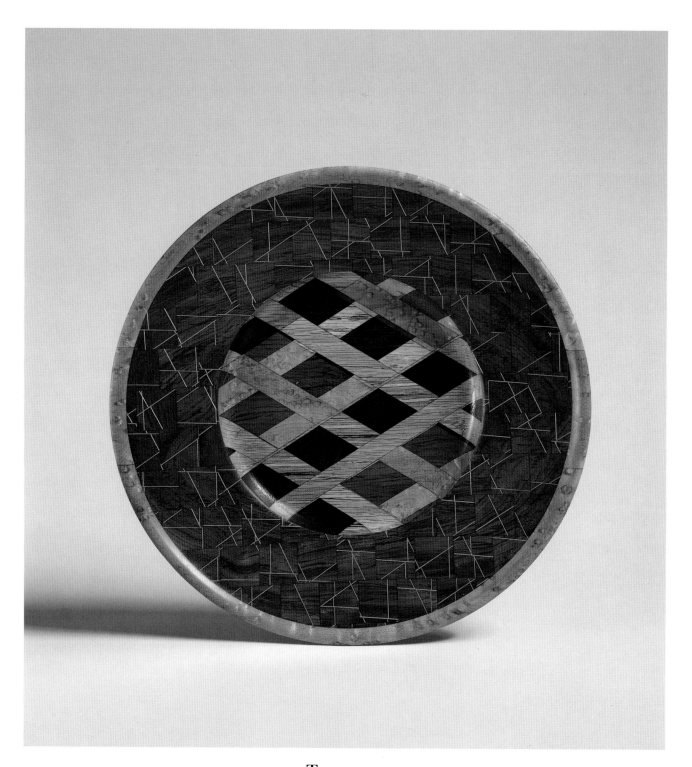

FLETCHER COX.
GOLDEN SECTION PLATE 1. 1993.
BIRD'S-EYE MAPLE, SPALTED RED OAK, BUBINGA,
WENGE, AND MAPLE VENEER; LATHE-TURNED,
12⅛ X 1½″ (30.8 X 3.8 CM)

The patterning in the broad rim of this plate results from an ordered but random encounter of wood pieces, while the central focal image is a calculated diamond pattern based on the traditional geometric formula of the golden section.

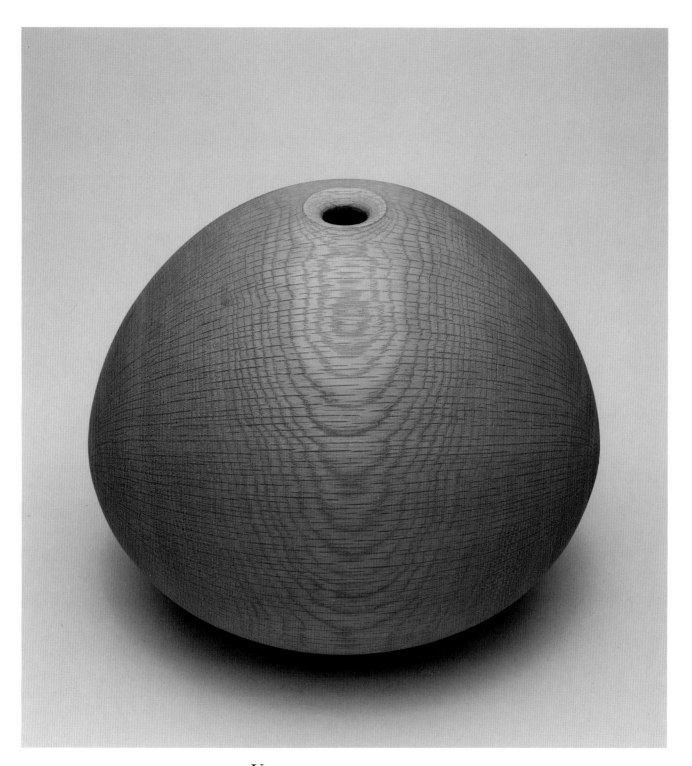

DAVID ELLSWORTH.
POT. 1993.
WHITE OAK; LATHE-TURNED,
8⅜ x 9 x 7¾″ (21.3 x 22.9 x 19.7 CM)

Understated but graceful form is the hallmark of this wood turner, who reveals in this piece his reverence for the subtle grain patterns that white oak produces. Ellsworth's primary concern has been to explore the expressive and contemplative qualities of wood as a means to transcend our conventional associations with function and use in regard to vessels.

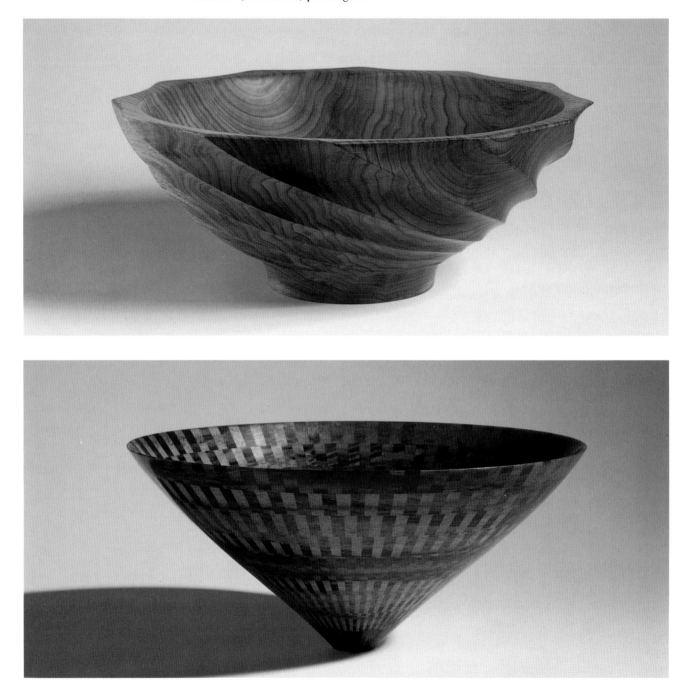

Below. ALAN STIRT.
SPIRAL FLUTED BUTTERNUT BOWL. 1993.
BUTTERNUT; LATHE-TURNED AND CARVED,
5½ x 14¼″ (14 x 36.2 CM)

This understated turned bowl balances a smooth interior with an exterior of carved flutes whose upward swirls relate beautifully to the undulating pattern of the grain.

Above. MICHAEL SHULER.
GONCALO ALVES BOWL #732. 1994.
GONCALO ALVES AND LACQUER; SEGMENTED,
LATHE-TURNED, AND HAND-RUBBED,
5½ x 12⅛″ (14 x 30.8 CM)

This conical bowl is a stunning example of the segmented technique, as practiced by wood turner Michael Shuler. The technique, which requires laminating hundreds of small pieces of wood into a larger block prior to turning, produces a complex and sometimes unexpected pattern. This piece seems to evoke a sense of gyrating motion.

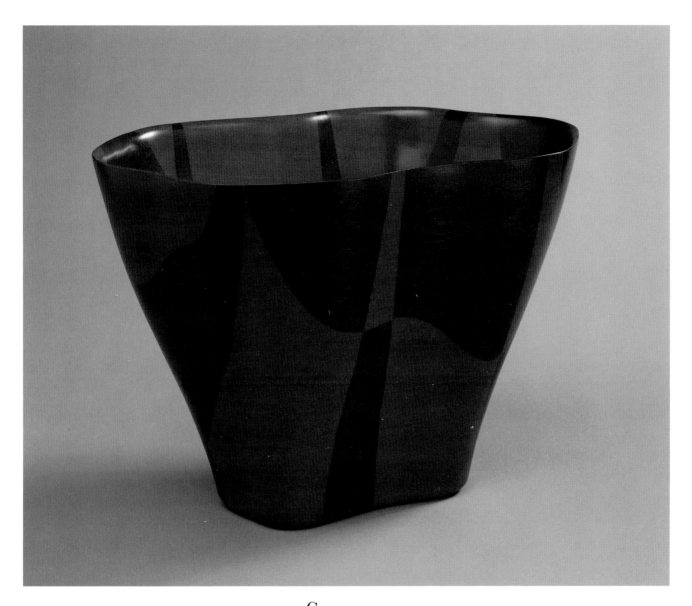

Above. PETER PETROCHKO.
WOOD VESSEL (TENT SERIES). 1993.
BRAZILIAN PURPLE HEART AND AFRICAN WENGE; BAND-SAWN,
LAMINATED, HAND-CARVED, AND DISC-SANDED,
12 x 16¼ x 11½″ (30.5 x 41.3 x 29.2 CM)

Challenged by the many possibilities of what a vessel might be, Peter Petrochko contrasted woods found on two different continents to create this striking bowl. By laminating his woods and passing them through a band saw, he is able to fashion vessels whose sides are curvilinear and sensuous in their configuration.

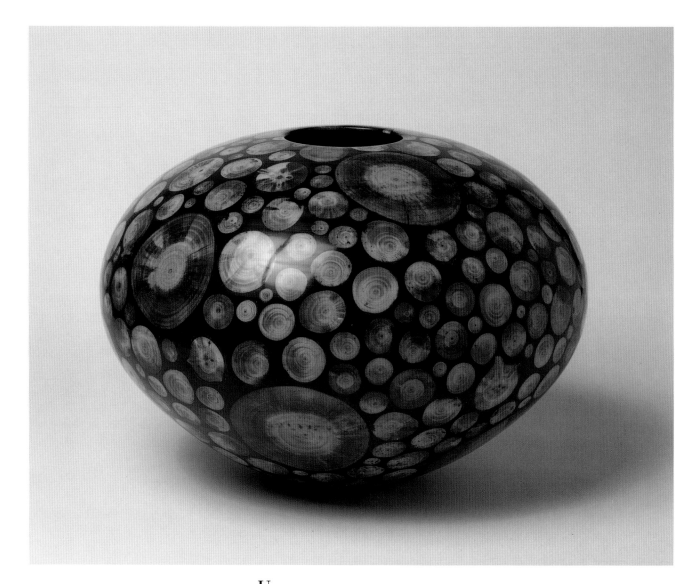

PHILIP MOULTHROP.
WHITE PINE MOSAIC BOWL. 1993.
WHITE PINE AND RESIN; LATHE-TURNED,
14¼ x 20½″ (36.2 x 52.1 CM)

Using woods native to the southeastern United States, Philip Moulthrop turns large and simple vessels that highlight the grain, beauty, texture, and color that is too often overlooked. This bowl is one of a series that Moulthrop developed in which cross sections of white pine are preserved and suspended in resin. The contrasting black ground heightens the visual impact of each disc of wood and focuses attention on its uniqueness.

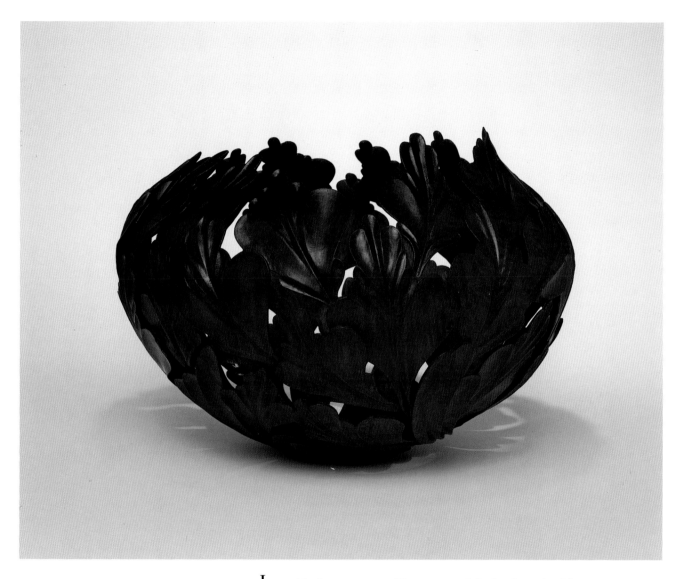

RONALD F. FLEMING.
NEW BEGINNINGS. 1993.
REDWOOD BURL; LATHE-TURNED AND CARVED,
13¼ x 17½″ (33.7 x 44.5 CM)

Inspired by forms in nature, Fleming created this handsome bowl from a single burl of redwood. After roughing out the shape of the bowl on a lathe, he began the intensive and laborious task of hand carving individual overlapping leaves in a design that suggests movement, growth, and enclosure.

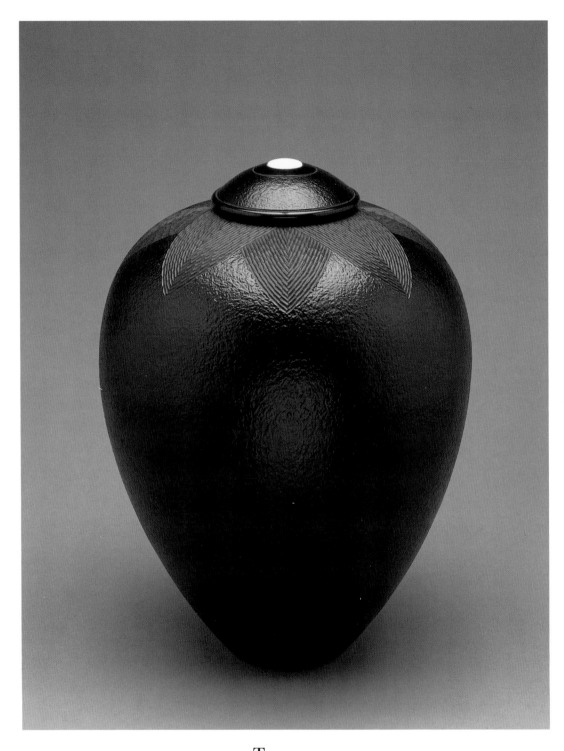

JOHN JORDAN.
BLACK TEXTURED JAR. 1993.
BOX ELDER, FOSSIL IVORY, INDIA INK, AND LACQUER;
LATHE-TURNED, CARVED, TEXTURED, DYED, AND INLAID,
13 x 8½" (33 x 21.6 CM)

This carved and textured lidded storage jar is typical of John Jordan's simple but finely detailed vessels. The woods that he uses are discards found at dumps and construction sites. Jordan finds great satisfaction in creating objects from materials that were destined to be buried or burned.

LINCOLN SEITZMAN.
WHITE MOUNTAIN APACHE OLLA BASKET ILLUSION. 1992.
GUATAMBU WOOD AND INK; LATHE-TURNED,
21 x 13″ (53.3 x 33 CM)

Although this large and elaborate vessel gives the illusion of being a basket woven with reeds, in reality it is made of wood turned on a lathe. Inspired by the designs and shapes of Apache baskets, Seitzman embellished this jar with delightful, bold geometric designs in the shapes of human figures and animals.

PO SHUN LEONG.
CITYSCAPE BOX. 1993.
BIRD'S-EYE MAPLE, EASTERN HARD MAPLE, BLACK
WALNUT, AND CHERRY; BAND-SAWN AND CARVED,
24 X 20¼ X 9″ (61 X 51.4 X 22.9 CM)

Originally trained as an architect, Po Shun Leong creates intricate cityscapes based on legendary archaeological and architectural sites, both real and imaginary. Using a variety of exotic woods, this complex diorama features numerous drawers that swing out to expose unexpected hiding places.

Below. EDWARD MOULTHROP.
RARE ASHLEAF MAPLE SPHEROID. 1993.
ASHLEAF MAPLE; LATHE-TURNED,
12 x 17" (30.5 x 43.2 CM)

For this wood turner, the exciting quest is to reveal the sensual and natural beauty hidden within each tree. Edward Moulthrop seeks the simplest forms and shapes in order to display the subtle and exotic range of colors and the infinite patterns of growth rings that nature has created.

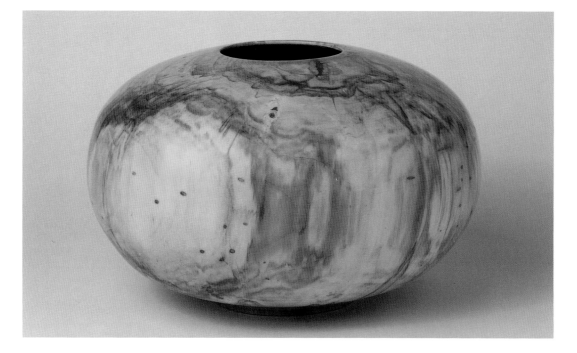

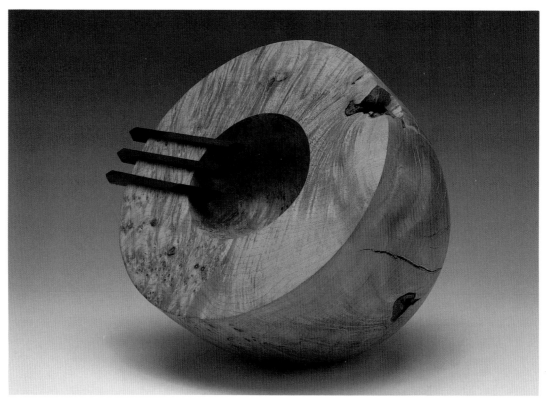

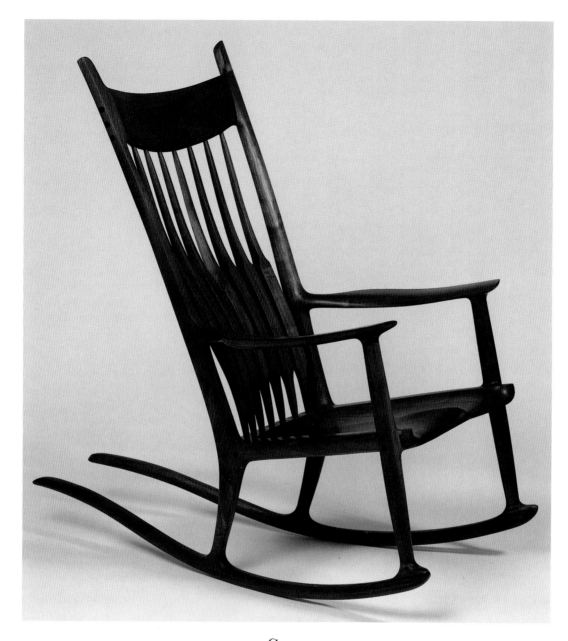

Above. SAM MALOOF.
ROCKER #60. 1982.
WALNUT; SAWN, LAMINATED, SHAPED,
SANDED, AND OIL-FINISHED,
45½ x 25¾ x 44¾″ (115.6 x 65.4 x 113.7 CM).
GIFT OF BARBARALEE DIAMONSTEIN AND CARL SPIELVOGEL

Considered by many craft artists to be the most difficult piece of furniture to make, the chair has become synonymous with the name of Sam Maloof. This rocker consists of simple, contoured parts that flow together gracefully, reflecting the artist's meticulous involvement with every detail of his work. Exquisitely designed, this piece invites you to sit and be embraced with comfort and understated elegance.

Below left. ROBYN HORN.
PIERCED GEODE #336. 1990.
MAPLE BURL, BLOODWOOD, AND EBONY;
LATHE-TURNED AND ROUTED,
10½ x 11¾ x 10½″ (26.7 x 29.9 x 26.7 CM)

In this turned, half-spherical wood piece, the artist was inspired by geodes, hollow stones full of quartz crystals. Three dovetailed ebony and bloodwood spears slice across the polished surface of the sphere, creating tensions of color and texture.

CHECKLIST OF THE EXHIBITION

This checklist is arranged alphabetically. Dimensions are in inches, followed (in parentheses) by centimeters, with height preceding width and depth. All objects are lent by the White House and, unless otherwise indicated, all are gifts of the artists.

SUZANNE L. AMENDOLARA *(page 56)*
FLORA, SCENT BOTTLE. 1993
sterling silver and 24k gold; smithed, fabricated, hydraulic-pressed, and die-formed
9⅜ x 2½ x 1⅝″ (23.8 x 6.4 x 4.1 cm)

RALPH BACERRA *(page 83)*
TEAPOT. 1992
earthenware, slip cast, chrome red glaze, overglaze enamels, and luster
16½ x 13½ x 13¼″ (41.9 x 34.3 x 33.7 cm)

BENNETT BEAN *(page 73)*
THE WHITE HOUSE BOWL. 1993
white earthenware and gold leaf; glazed, pit-fired, and painted
9½ x 16 x 16½″ (24.1 x 40.6 x 41.9 cm)

CURTIS BENZLE
SUZAN SCIANAMBLO BENZLE *(page 80)*
TUXEDO JUNCTION. 1992
porcelain colored inlays; hand-built
6½ x 17¼ x 4″ (16.5 x 43.8 x 10.2 cm)

SONJA BLOMDAHL *(page 37)*
CRIMSON/GREEN BLUE. 1992
blown glass
16½ x 9¼″ (41.9 x 23.5 cm)

AKIRA BLOUNT *(page 92)*
MAN IN LION COSTUME. 1993
cotton, wool, buttons, and beads; stitched and painted
24 x 8½ x 11½″ (seated) (61 x 21.6 x 29.2 cm)

KEN CARLSON *(page 65)*
PORCUPINE BASKET. 1993
copper; woven and oxidized
10 x 9½″ (25.4 x 24.1 cm)

WENDELL CASTLE *(page 101)*
PRESENCE CLOCK #7. 1990
mahogany, bronze, brass, and curly maple; stained, patined, and bleached
23⅝ x 17½ x 10″ (60 x 44.5 x 25.4 cm)

DALE CHIHULY *(page 46)*
CERULEAN BLUE MACCHIA WITH CHARTREUSE LIP WRAP. 1993
blown glass
22 x 31 x 30″ (55.9 x 78.7 x 76.2 cm)

ANTHONY A. CORRADETTI *(page 49)*
AWAKENING. 1993
blown glass, multiple firings with luster paints
17 x 13″ (43.2 x 33 cm)

FLETCHER COX *(page 102)*
GOLDEN SECTION PLATE 1. 1993
bird's-eye maple, spalted red oak, bubinga, wenge, and maple veneer; lathe-turned
12⅛ x 1½″ (30.8 x 3.8 cm)

FRANK E. CUMMINGS III *(page 100)*
IT'S MAGIC. 1993
myrtle burl, ebony, black onyx, and 18k gold; lathe-turned and inlaid with carved rim
7¼ x 5″ (18.4 x 12.7 cm)

JOHN S. CUMMINGS *(page 77)*
PORCELAIN VASE—SANG-DE-BOEUF. 1985
porcelain and sang-de-boeuf glaze; wheel-thrown
11⅝ x 6⅝″ (29.5 x 16.8 cm)

JUDY B. DALES *(page 93)*
SPIRIT FLIGHT. 1993
cotton and polyester; hand and machine-pieced, hand-appliquéd, and hand-quilted
73 x 53″ (185.4 x 134.6 cm)

VIRGINIA DOTSON *(page 96)*
SUNLIGHT (#4). 1993
ivorywood and ebony; laminated and lathe-turned with carved rim
9 x 8″ (22.9 x 20.3 cm)

PATRICK W. DRAGON *(page 82)*
UNTITLED. 1993
white earthenware with terra sigillata, under-glazes, slips, stains, oils, acrylics, inks, and 22k gold leaf; wheel-thrown and burnished
12⅜ x 11¼″ (31.4 x 28.6 cm)

DAVID ELLSWORTH *(page 103)*
POT. 1993
white oak; lathe-turned
8⅜ x 9 x 7¾″ (21.3 x 22.9 x 19.7 cm).

SUSAN R. EWING *(page 59)*
OBOR 1 COFFEE SERVER. 1990
24k goldplate over brass; formed, fabricated, sandblasted, and electroplated
10⅝ x 6¼ x 2½″ (27 x 15.9 x 6.4 cm)

RONALD F. FLEMING *(page 107)*
NEW BEGINNINGS. 1993
redwood burl; lathe-turned and carved
13¼ x 17½″ (33.7 x 44.5 cm)

ANDREA GILL *(page 85)*
PITCHER. 1991
low-fire terra-cotta clay, engobes, and glaze; press molded and slab constructed
24 x 18 x 10″ (61 x 45.7 x 25.4 cm)

MICHAEL HALEY, SUSY SIEGELE *(page 81)*
LIZARDS INTERPRETING THE ANCIENT SYMBOL. 1993
colored porcelain; slab-built and inlaid
3¼ x 12 x 11″ (8.3 x 30.5 x 28 cm)

WILLIAM HARPER *(page 57)*
PENTIMENTI #1: THE GOLDEN FLEECE. 1987
enamel on fine silver and fine gold, 14k gold, 24k gold, sterling silver, peridot, moonstone, pearl, plastic, and mirror; cloisonné
6 x 3 x ½″ (15.1 x 7.2 x 1.1 cm)
Gift of Norma and William Roth

BOB HAWKS *(page 99)*
LONGITUDINAL II. 1993
purple heart and yellow boxwood; segmented and lathe-turned
4⅞ x 7⅞″ (12.4 x 20 cm)

ANNE HIRONDELLE *(page 79)*
TANDEM TEAPOT DIPTYCH. 1993
stoneware clay; wheel-thrown, extruded and assembled additions
9½ x 14 x 7¾″; 8 x 14 x 8¼″ (24.1 x 35.6 x 19.7 cm; 20.3 x 35.6 x 21 cm)

THOMAS HOADLEY *(page 72)*
NERIKOMI BOWL. 1993
colored porcelains; hand-built and nerikomi technique
7⅛ x 9¼ x 10⅜″ (18.1 x 23.5 x 26.4 cm)

DAWN KIILANI HOFFMANN *(page 60)*
OVAL PUNCH BOWL AND LADLE. 1993
sterling silver; raised and forged
10½ x 15 x 12¼″ (26.7 x 38.1 x 31.1 cm)

ROBYN HORN *(page 112)*
PIERCED GEODE #336. 1990
maple burl, bloodwood, and ebony; lathe-turned and routed
10½ x 11¾ x 10½″ (26.7 x 29.9 x 26.7 cm)

SIDNEY R. HUTTER *(pages 52–3)*
WHITE HOUSE VASE #1. 1993
plate glass; cut, ground, polished, laminated; and ultraviolet curing adhesive
16½ x 10″ (41.9 x 25.4 cm)

JOHN JORDAN *(page 108)*
BLACK TEXTURED JAR. 1993
box elder, fossil ivory, India ink, and lacquer; lathe-turned, carved, textured, dyed, and inlaid
13 x 8½″ (33 x 21.6 cm)

RONALD E. KENT *(page 98)*
TRANSLUCENT WOOD BOWL. 1993
Pacific Norfolk pine; lathe-turned, multiple oil-soaked, and hand-sanded
8½ x 12½″ (21.6 x 31.8 cm)

ELLEN KOCHANSKY *(page 91)*
COUNTERPANE. 1992
cotton, antique fabrics, metallic thread, and paint; pieced, machine-stitched, quilted, and embroidered
47½ x 47¾″ (120.7 x 121.3 cm)

JON KUHN *(page 45)*
PASTEL SKIES. 1993
bora-silicate, lead-fluoride, and colored glass; ground, polished, and laminated
8¼ x 8¼ x 8¼″ (21 x 21 x 21 cm)

CLIFF LEE *(page 74)*
PEACH VASE ON A PEDESTAL. 1993
porcelain with celadon glaze; wheel-thrown and carved
11⅞ x 8″ (30.2 x 20.3 cm)

PO SHUN LEONG *(pages 110–1)*
CITYSCAPE BOX. 1993
bird's-eye maple, eastern hard maple, black walnut, and cherry; bandsawn and carved
24 x 20¼ x 9″ (61 x 51.4 x 22.9 cm)

DAVID W. LEVI *(page 42)*
BIRD JAR. 1993
blown glass
24⅜ x 13⅛ x 11⅜″ (61.9 x 33.3 x 28.9 cm)

MARK LINDQUIST *(page 98)*
FLUTED VESSEL, ASCENDING, WITH RHYTHMIC MOTION. 1992
cherry burl; lathe-turned and chainsawn
9 x 15″ (22.9 x 38.1 cm)

MELVIN LINDQUIST *(page 97)*
NATURAL TOP HOPI BOWL. 1993
hophornbeam burl; lathe-turned
9½ x 10″ (24.1 x 25.4 cm)

HARVEY K. LITTLETON *(page 47)*
BLUE ORCHID IMPLIED MOVEMENT. 1987
blown glass and barium/potash glass with multiple cased overlays of Kugler colors
36 x 14 x 5″; 31⅛ x 14 x 5″; 31⅝ x 10 x 4¼″
(91.4 x 35.6 x 12.7 cm; 79.1 x 35.6 x 12.7 cm;
80.3 x 25.4 x 10.8 cm)

JOHN LITTLETON
KATE VOGEL *(page 36)*
IMAGO BAG. 1993
blown glass; etched
13¾ x 12½ x 9½″ (34.9 x 31.8 x 24.1 cm)

KARI LØNNING *(page 89)*
ARCHITEXTURE. 1992
wood, rattan reed, and twigs; woven and dyed
8¾ x 12½″ (22.2 x 31.8 cm)

DONA LOOK *(page 89)*
BASKET #932. 1993
birch bark and silk thread; sewn and wrapped
12 x 6½″ (30.5 x 16.5 cm)
Gift of Karen Johnson Boyd

SAM MALOOF *(page 113)*
ROCKER #60. 1982
walnut; sawn, laminated, shaped, sanded, and oil-finished
45½ x 25¾ x 44¾″ (115.6 x 65.4 x 113.7 cm)
Gift of Barbaralee Diamonstein and Carl Spielvogel

DANTE MARIONI *(page 44)*
YELLOW PAIR. 1993
blown glass
31 x 8″; 18 x 17½ x 11¾″ (78.8 x 20.3 cm;
45.7 x 44.5 x 29.9 cm)

THOMAS R. MARKUSEN *(page 64)*
RASPBERRY CANDLEHOLDERS #426-D. 1993
copper and brass; hot-formed, compressed, and fabricated
30¾ x 7⅜ x 7⅜″; 24½ x 7¼ x 7¼″; 19¼ x
7¼ x 7¼″ (78.1 x 18.7 x 18.7 cm; 62.2 x
18.4 x 18.4 cm; 48.9 x 18.4 x 18.4 cm)

DIMITRI MICHAELIDES, DAVID W. LEVI *(page 43)*
BIRD VASE. 1993
blown glass
21 x 14½ x 8″ (53.3 x 36.8 x 20.3 cm)

JOAN MONDALE *(page 80)*
BOWL. 1993
stoneware and shino glaze; wheel-thrown
3½ x 6½″ (8.9 x 16.5 cm)

EDWARD MOULTHROP *(page 112)*
RARE ASHLEAF MAPLE SPHEROID. 1993
ashleaf maple; lathe-turned
12 x 17″ (30.5 x 43.2 cm)

PHILIP MOULTHROP *(page 106)*
WHITE PINE MOSAIC BOWL. 1993
white pine and resin; lathe-turned
14¼ x 20½″ (36.2 x 52.1 cm)

THOMAS P. MUIR *(page 58)*
ESPRESSO SERVER. 1991
sterling silver, nickel, and aluminum; formed, fabricated, cast, and oxidized
10½ x 3¼ x 5¾″ (26.7 x 8.3 x 14.6 cm)

JOEL PHILIP MYERS *(page 48)*
VALMUEN XXXXX. 1991
blown glass
14½ x 15 x 4″ (36.8 x 38.1 x 10.2 cm)

LEON NIEHUES, SHARON NIEHUES *(page 88)*
EBURNA. 1993
white oak, waxed linen thread, and coralberry; woven, split, dyed, drilled, and stitched
17½ x 15″ (44.5 x 38.1 cm)

LANEY K. OXMAN *(page 84)*
FEMININE NOSTALGIA. 1993
whiteware, underglaze pencils, stains, enamels, lusters, photo transfers, and 22k gold; hand-built and wheel-thrown
11½ x 14″ (29.2 x 35.6 cm)

ZACHARY OXMAN *(page 62)*
A FESTIVAL OF LIGHT. 1993
bronze, granite, and marble; cast
15 x 24¾ x 17″ (38.1 x 62.9 x 43.2 cm)

ALBERT PALEY *(page 61)*
CANDLEHOLDERS. 1992
steel; forged and fabricated
31 x 7⅜ x 6½″; 31½ x 7½ x 6½″ (78.7 x
18.7 x 16.5 cm; 80 x 19.1 x 16.5 cm)

ED PENNEBAKER, AMY NICHOLS *(page 38)*
COVERED BOWL WITH WOODPECKER FINIAL.
1993
blown glass
7½ x 4⅛″ (19.1 x 10.5 cm)

PETER PETROCHKO *(page 105)*
WOOD VESSEL (TENT SERIES). 1993
Brazilian purple heart and African wenge; bandsawn, laminated, hand-carved, and disc-sanded
12 x 16¼ x 11½″ (30.5 x 41.3 x 29.2 cm)

RICHARD Q. RITTER *(page 39)*
GRAIL SERIES #6. 1993
blown glass; sand-etched
9¼ x 10¾″ (23.5 x 27.3 cm)

ADRIEN ROTHSCHILD *(page 90)*
PURPLE MOUNTAINS MAJESTY. 1991
cotton; machine-pieced and hand-quilted
63 x 63″ (160 x 160 cm)

HARVEY S. SADOW, JR. *(page 70)*
THE PEARL, GROUND ZERO SERIES. 1986
ceramic; wheel-thrown, glazed, raku-fired, and sandblasted
11 x 14″ (28 x 35.6 cm)

ADRIAN SAXE *(page 78)*
UNTITLED EWER (IST). 1992
porcelain, lusters, fish hook, feathers, rubber crawfish, and plastic
12¾ x 7½ x 4″ (32.4 x 19.1 x 10.2 cm)

DAVID J. SCHWARZ *(page 40)*
Z-AXIS, OTHER FACETS 2-15-92. 1992
blown glass; ground, polished, sandblasted, and painted
10¾ x 16¼ x 14″ (27.3 x 41.3 x 35.6 cm)

LINCOLN SEITZMAN *(page 109)*
WHITE MOUNTAIN APACHE OLLA BASKET ILLUSION. 1992
Guatambu wood and ink; lathe-turned
21 x 13″ (53.3 x 33 cm)

MICHAEL SHERRILL *(page 69)*
INCANDESCENT BOTTLES. 1993
white stoneware, alkaline and barium glazes; wheel-thrown
22½ x 5″; 18 x 5″; 10 x 7″ (57.2 x 12.7 cm;
45.7 x 12.7 cm; 25.4 x 17.8 cm)

MICHAEL SHULER *(page 104)*
GONCALO ALVES BOWL #732. 1994
Goncalo alves and lacquer; segmented, lathe-turned, and hand-rubbed
5½ x 12⅛″ (14 x 30.8 cm)

JOSH SIMPSON *(page 41)*
MEGAWORLD. 1994
glass, silver reactive glass, and glass cane inclusions; multilayered, hot flame, and hot worked
10¼ x 9¾″ (23.5 x 21.6 cm)
Gift of Stewart G. Rosenblum in honor of William Jefferson Clinton and Hillary Rodham Clinton

ALAN STIRT *(page 104)*
SPIRAL FLUTED BUTTERNUT BOWL. 1993
butternut; lathe-turned and carved
5½ x 14¼″ (14 x 36.2 cm)

RANDY J. STROMSÕE *(page 63)*
CENTERPIECE BOWL ON THREE-LEGGED STAND.
1993
sterling silver, pewter, and gold leaf; forged and raised
9½ x 14½″ (24.1 x 36.8 cm)

MARA SUPERIOR *(page 75)*
A COCOA POT. 1990
porcelain, underglazes, and ceramic oxides; slab constructed
19½ x 15⅞ x 6½″ (49.5 x 40.3 x 16.5 cm)

JAMES C. WATKINS *(page 71)*
RITUAL DISPLAY. 1992
stoneware; wheel-thrown and sagger-fired
19½ x 19¼″ (49.5 x 48.9 cm)

CHERYL C. WILLIAMS *(page 68)*
PRAYER BOWLS. 1993
stoneware, gold leaf, and acrylic paint; wheel-thrown and airbrushed
14½ x 12¾″; 12 x 9½″; 6 x 10¾″ (36.8 x 32.4
cm; 30.5 x 24.1 cm; 15.2 x 27.3 cm)

NATHAN YOUNGBLOOD *(page 76)*
BLACK CARVED JAR. 1991
earthenware; hand-coiled, carved, and burnished
11¾ x 9¼″ (29.9 x 23.5 cm)

MARY ANN "TOOTS" ZYNSKY *(pages 50–1)*
BEAU COUPLE FROM THE CHAOS AND ORDER SERIES. 1993
glass; fused, slumped, and hand-formed
8 x 13 x 7″; 7¾ x 14 x 7″ (20.3 x 33 x 17.8 cm;
19.7 x 35.6 x 17.8 cm)

BIOGRAPHIES OF THE ARTISTS

SUZANNE L. AMENDOLARA
Edinboro, Pennsylvania
BORN: Youngstown, Ohio, 1963
EDUCATION: B.F.A., Miami U., Oxford, OH, 1985; M.F.A., Indiana U., Bloomington, 1988
AWARDS/HONORS: Faculty Research Grant, Edinboro University, 1992–94; Merit Award, Anticipation '93, Navy Pier Exhibition Hall, 1993; Pennsylvania Council on the Arts Fellowship, 1994
COLLECTIONS: Ohio Craft Museum, Columbus, OH; White House, Washington, DC
PUBLICATIONS: Bernstein Bernard, "A Sterling Exhibition," *Metalsmith*, Winter 1993; David and Shereen LaPlantz, *Jewelry/Metalwork Survey #2, A Way of Communicating*, S. LaPlantz, 1992; Michael Wolk, *Designing for the Table: Decorative and Functional Products*, Rizzoli, 1992; *Silver: New Forms and Expressions II*, Fortunoff, NYC, 1990; Janet Koplos, "Silver: New Forms and Expressions II," *Metalsmith*, Spring, 1991
RELATED PROFESSIONAL EXPERIENCE: faculty, School of Visual Arts, NYC, 1989–90; faculty, Miami U., Oxford, OH, 1990–91; faculty, Edinboro U., Edinboro, PA, 1991–present

RALPH BACERRA
Pasadena, California
BORN: Garden Grove, California, 1938
EDUCATION: B.F.A., Chouinard Art School, Los Angeles, CA, 1961
COLLECTIONS: American Craft Museum, NYC; Everson Museum of Art of Syracuse & Onondaga County, NY; Los Angeles County Museum of Art, CA; National Museum of Modern Art, Kyoto, Japan; Renwick Gallery of the National Museum of American Art, Smithsonian Institution, Washington, DC; Wichita Art Museum, Wichita, KS; White House, Washington, DC
PUBLICATION: Paul J. Smith and Edward Lucie-Smith, *Craft Today: Poetry of the Physical*, American Craft Museum, Weidenfeld & Nicolson, 1986
RELATED PROFESSIONAL EXPERIENCE: faculty, Chouinard Art School, Los Angeles, CA, 1961–72; faculty, Otis College of Art and Design, Los Angeles, CA, 1983–present

BENNETT BEAN
Blairstown, New Jersey
BORN: Cincinnati, Ohio, 1941
EDUCATION: B.A., Iowa State U., Ames, 1963; M.F.A., Claremont Graduate School, CA, 1966

AWARDS/HONORS: New Jersey State Council on the Arts Fellowship, 1978; Visual Artists Fellowship, the National Endowment for the Arts, 1980
COLLECTIONS: Newark Museum, Newark, NJ; New Jersey State Museum, Trenton, NJ; St. Louis Art Museum, MO; White House, Washington, DC; Whitney Museum of American Art, NYC
PUBLICATION: Paul J. Smith and Edward Lucie-Smith, *Craft Today: Poetry of the Physical*, American Craft Museum, Weidenfeld & Nicolson, 1986
RELATED PROFESSIONAL EXPERIENCE: artist-in-residence, Artpark, Lewiston, NY, 1980; artist-in-residence, Sun Valley Center for the Arts, ID, 1981; faculty, Arrowmont School of Arts and Crafts, Gatlinburg, TN; faculty, Penland School of Crafts, NC; independent studio artist, 1979–present

CURTIS BENZLE
Hilliard, Ohio
BORN: Lakewood, Ohio, 1949
EDUCATION: B.F.A., Ohio State U., Columbus, 1972; M.A., Northern Illinois U., DeKalb, 1978
AWARDS/HONORS: Visual Artists Fellowship, the National Endowment for the Arts, 1980; Ohio Arts Council Individual Fellowship Grant, 1981, 1983, 1984, 1988; Greater Columbus Arts Council Individual Fellowship Grant, 1987
COLLECTIONS: Cleveland Museum of Art, OH; Everson Museum of Art of Syracuse & Onondaga County, NY; Los Angeles County Museum of Art, CA; Renwick Gallery of the National Museum of American Art, Smithsonian Institution, Washington, DC; White House, Washington, DC
PUBLICATIONS: Lloyd E. Herman, *American Porcelain: New Expressions in an Ancient Art*, Timber Press, 1980; Lloyd E. Herman, *Art That Works: Decorative Arts of the Eighties, Crafted in America*, U. of Washington Press, 1990; Martha Drexler Lynn, *Clay Today: Contemporary Ceramists and Their Work*, Los Angeles County Museum of Art, Chronicle Books, 1990; Phyllis George, *Craft in America: Celebrating the Creative Work of the Hand*, The Summitt Group, 1993
RELATED PROFESSIONAL EXPERIENCE: faculty, Savannah College of Art and Design, GA, 1979–80; faculty, Arrowmont School of Arts and Crafts, Gatlinburg, TN, 1983, 1985, 1988; faculty, Columbus College of Art and Design, OH, 1982–present; owner, Applied Arts, Hilliard, OH, 1988–present

SUZAN SCIANAMBLO BENZLE
Upper Arlington, Ohio
BORN: Dayton, Ohio, 1950
EDUCATION: B.F.A., Ohio State U., Columbus, 1972; M.F.A., Northern Illinois U., DeKalb, 1979
AWARDS/HONORS: Visual Artists Fellowship, the National Endowment for the Arts, 1980; Ohio Arts Council, Individual Artists Grant, 1981, 1983, 1984, 1988; Greater Columbus Arts Council, Individual Artist Grant, 1987
COLLECTIONS: Cleveland Museum of Art, OH; Dayton Art Institute, OH; Everson Museum of Art of Syracuse & Onondaga County, NY; Indianapolis Museum of Art, IN; Los Angeles County Museum of Art, CA; Museo Internazionale delle Ceramiche, Faenze; Renwick Gallery of the National Museum of American Art, Smithsonian Institution, Washington, DC; White House, Washington, DC
PUBLICATIONS: Lloyd E. Herman, *American Porcelain: New Expressions in an Ancient Art*, Timber Press, 1980; John Gibson, *Contemporary Pottery Decoration*, Chilton, 1987; *American Ceramics Now*, Everson Museum of Art of Syracuse & Onondaga County, NY, Museum Press, 1988; Lloyd E. Herman, *Art That Works: Decorative Arts of the Eighties, Crafted in America*, U. of Washington Press, 1990; Martha Drexler Lynn, *Clay Today: Contemporary Ceramists and Their Work*, Los Angeles County Museum of Art, Chronicle Books, 1990
RELATED PROFESSIONAL EXPERIENCE: faculty, Northern Illinois U., DeKalb, 1977–89; faculty, Arrowmont School of Arts and Crafts, Gatlinburg, TN, 1983, 1985, 1988; faculty, Columbus College of Art and Design, OH, 1984–86; owner/producer, Benzle Signature Collection, Dublin, OH, 1993–present

SONJA BLOMDAHL
Seattle, Washington
BORN: Waltham, Massachusetts, 1952
EDUCATION: B.F.A., Massachusetts College of Art, Boston, 1974; Glass School, Orrefors Glass Factory, Orrefors, Sweden, 1976
COLLECTIONS: American Craft Museum, NYC; Corning Museum of Glass, Corning, NY; Fine Arts Museum of the South at Mobile, AL; MCI Telecommunications Corporation, Inc., Washington, DC; Safeco Corporation, Seattle, WA; Seattle Arts Commission, Seattle, WA; Washington State Arts Commission, Seattle, WA; White House, Washington, DC
PUBLICATIONS: Paul J. Smith and Edward Lucie-

Smith, *Craft Today: Poetry of the Physical*, American Craft Museum, Weidenfeld & Nicolson, 1986; Susan Biskeborn, *Artists at Work: 25 Northwest Glassmakers, Ceramists and Jewelers*, Alaska Northwest Books, 1990; *Northwest Originals: Washington Women and Their Art*, Matrimedia, 1990; Bonnie Miller, *Out of the Fire: Contemporary Glass Artists and Their Work*, Chronicle Books, 1991
RELATED PROFESSIONAL EXPERIENCE: faculty, Pratt Fine Arts Center, Seattle, WA, 1980–84; faculty, Pilchuck Glass School, Stanwood, WA, 1985; faculty, Appalachian Center for Crafts, Smithville, TN, 1986; independent studio artist, 1983–present

AKIRA BLOUNT
Bybee, Tennessee
BORN: Columbus, Ohio, 1945
EDUCATION: B.S., U. of Wisconsin, Madison, 1967
AWARDS/HONORS: Tennessee Arts Commission, Glady and Ross Faeries Crafts Fellowship; Merit Award, Tennessee Craft Fair, 1982, 1983, 1984, 1985, 1986, 1988, 1990, 1992, 1993, 1994; Award of Excellence, Piedmont Crafts Fair, Winston-Salem, NC, 1994
COLLECTIONS: Louvre, Paris, France; Musée de Poupées, Josselin, France; White House, Washington, DC
PUBLICATIONS: *Fiberarts Design Book III*, Lark Books, 1987; *The Art of the Doll: Contemporary Work of the National Institute of American Doll Artists*, National Institute of American Doll Artists, 1992; Phyllis George, *Craft in America: Celebrating the Creative Work of the Hand*, The Summitt Group, 1993; "Fabric and Fantasy Dolls by Akira," *Doll Life*, October 1993
RELATED PROFESSIONAL EXPERIENCE: Tennessee Association of Craft Artists, Board of Trustees, 1990–94, executive officer, 1993; Southern Highlands Handicraft Guild, Board of Trustees, 1991–93, executive officer, 1993; independent studio artist, 1970–present

KEN CARLSON
Belgrade, Montana
BORN: Modesto, California, 1945
EDUCATION: self-taught
COLLECTIONS: American Craft Museum, NYC; MCI Telecommunications Corporation, Inc., Washington, DC; Museum of Art, Rhode Island School of Design, Providence, RI; White House, Washington, DC
PUBLICATIONS: Jack Lenor Larsen, *Interlacing: The Elemental Fabric*, Kodansha Press, 1987; "Braiding," *World Book Encyclopedia*, 1988; Jack Lenor Larsen, *The Tactile Vessel: New Basket Forms*, Erie Art Museum, 1989
RELATED PROFESSIONAL EXPERIENCE: independent studio artist, 1976–present

WENDELL CASTLE
Scottsville, New York
BORN: Emporia, Kansas, 1932
EDUCATION: B.F.A., M.F.A., U. of Kansas, Lawrence, 1958, 1961
AWARDS/HONORS: Louis Comfort Tiffany Foundation Grant, 1972; Visual Artists Fellowship, the National Endowment for the Arts, 1973, 1975, 1976, 1988; Honorary Ph.D., Maryland Institute, College of Art, Baltimore,

MD, 1979; New York Foundation for the Arts Fellowship, 1986; Honorary Ph.D., St. John Fisher College, 1987; Golden Plate, American Academy of Achievement, 1988; Visionaries of the American Craft Movement, American Craft Museum, NYC, 1994
COLLECTIONS: American Craft Museum, NYC; Art Institute of Chicago, IL; Brooklyn Museum, NY; Cincinnati Art Museum, OH; Detroit Institute of Arts, MI; Everson Museum of Art of Syracuse & Onondaga County, NY; Hunter Museum of Art, Chattanooga, TN; Metropolitan Museum of Art, NYC; Milwaukee Art Museum, WI; Museum of Applied Arts, Oslo, Norway; Museum of Fine Arts, Boston, MA; Museum of Fine Arts, Houston, TX; Philadelphia Museum of Art, PA; Rochester Institute of Technology, NY; Renwick Gallery of the National Museum of American Art, Smithsonian Institution, Washington, DC; White House, Washington, DC
PUBLICATIONS: Wendell Castle, *The Wendell Castle Book of Wood Lamination*, Van Nostrand Reinhold, 1980; Barbaralee Diamonstein, *Handmade in America: Conversations with Fourteen Craftmasters*, Harry N. Abrams, Inc., 1983; Paul J. Smith and Edward Lucie-Smith, *Craft Today: Poetry of the Physical*, American Craft Museum, Weidenfeld & Nicolson, 1986; Joseph Giovannini, Davira S. Taragin, and Edward S. Cooke, Jr., *Furniture by Wendell Castle*, Hudson Hills Press, 1989; R. Craig Miller, *Modern Design 1890–1990: The Design Collections of the Metropolitan Museum of Art*, Harry N. Abrams, Inc., 1990; Tommy Simpson and William B. Seitz, *Hand and Home: The Homes of American Craftsmen*, Little, Brown and Co., 1994
RELATED PROFESSIONAL EXPERIENCE: president, Wendell Castle School, Scottsville, NY, 1980–88; artist-in-residence, Rochester Institute of Technology, NY, 1984–present; independent studio artist, 1962–present

DALE CHIHULY
Seattle, Washington
BORN: Tacoma, Washington, 1941
EDUCATION: B.A., U. of Washington, Seattle, 1965; M.S., U. of Wisconsin, Madison, 1967; M.F.A., Rhode Island School of Design, Providence, 1968
AWARDS/HONORS: Louis Comfort Tiffany Foundation Grant, 1967; Fulbright Fellowship, 1968; Visual Artists Fellowship, the National Endowment for the Arts, 1975, 1977; Rhode Island School of Design, President's Fellow, 1984; Visual Artists Award, American Council for the Arts, 1984; Honorary Ph.D., Rhode Island School of Design, 1986; Honorary Ph.D., U. of Puget Sound, 1986; Honorary Ph.D., California College of Arts and Crafts, 1988
COLLECTIONS: American Craft Museum, NYC; Cooper-Hewitt, National Design Museum, Smithsonian Institution, NYC; Corning Museum of Glass, Corning, NY; Indianapolis Museum of Art, IN; Lobmyer Museum, Vienna, Austria; Metropolitan Museum of Art, NYC; Musée des Arts Décoratifs, Paris, France; Museum of Contemporary Art, Chicago, IL; Museum of Fine Arts, Boston, MA; Museum of Modern Art, NYC; National Museum of Modern Art, Kyoto, Japan; Philadelphia Museum of Art, PA; Renwick Gallery of the National Museum of

American Art, Smithsonian Institution, Washington, DC; Seattle Art Museum, WA; White House, Washington DC; Victoria and Albert Museum, London, England
PUBLICATIONS: Linda Norden, *Chihuly: Glass*, Tucson Museum of Art, 1982; Barbaralee Diamonstein, *Handmade in America: Conversations with Fourteen Craftmasters*, Harry N. Abrams, Inc., 1983; Karen S. Chambers and Jack Cowart, *Chihuly: A Decade of Glass*, Bellevue Art Museum, WA, 1984; Paul J. Smith and Edward Lucie-Smith, *Craft Today: Poetry of the Physical*, American Craft Museum, Weidenfeld & Nicolson, 1986; Dale Chihuly, Henry Geldzahler, and Michael Monroe, *Chihuly: Color, Glass and Form*, Kodansha Press, 1986
RELATED PROFESSIONAL EXPERIENCE: faculty, Rhode Island School of Design (RISD), Providence, 1968–80; artist-in-residence, RISD, 1981–present; co-founder and artist-in-residence, Pilchuck Glass School, Stanwood, WA, 1971–present

ANTHONY A. CORRADETTI
Baltimore, Maryland
BORN: Chester, Pennsylvania, 1955
EDUCATION: B.F.A., Temple University, Tyler School of Art, Philadelphia, PA, 1978
AWARD/HONOR: Maryland State Arts Council Individual Artist Grant, 1993
COLLECTIONS: Corning Museum of Glass, Corning, NY; MCI Telecommunications Corporation, Inc., Washington, DC; Wheaton Museum of American Glass, Millville, NJ; White House, Washington, DC
PUBLICATIONS: *Sculptural Glass Invitational Exhibition*, Tucson Museum of Art, 1983; "By Design: Studio Glass," *Metropolis Magazine*, Sept. 1987; Suzanne Frantz, *Contemporary Glass: A World Survey from the Corning Museum of Glass*, Harry N. Abrams, Inc., 1989; *New Glass Review II*, Corning Museum of Glass, 1990; *International Exhibition of Glass '90*, Kanazawa, Japan, 1990
RELATED PROFESSIONAL EXPERIENCE: glassblower, Wheaton Village Glass, Millville, NJ, 1978–80; faculty, Temple University, Tyler School of Art, Philadelphia, PA, 1992; independent studio artist, Baltimore, MD, 1981–present

FLETCHER COX
Tougaloo, Mississippi
BORN: Williamsburg, Virginia, 1948
EDUCATION: A.B., Columbia College, NYC, 1970
AWARDS/HONORS: Award of Merit, Southeast Crafts '78; "Spotlight," Southeast Crafts '83, Sawtooth Center, Winston-Salem, NC; Mississippi Arts Commission Project Fellowship, 1985; Jackson (MS) Arts Alliance, 1987; Mississippi Arts Commission Individual Fellowship, 1989; Tau Sigma Delta Faculty Book Award, Mississippi State U. School of Architecture, 1993
COLLECTIONS: Arkansas Arts Center, Little Rock; Fine Arts Museum of the South at Mobile, AL; Mississippi Museum of Art, Jackson; White House, Washington, DC
PUBLICATIONS: *Lathe Turned Objects: An International Exhibition*, Wood Turning Center, Philadelphia, PA, 1988; *Fine Woodworking*, 1977, 1979, 1986, 1990; *Fine Woodworking Design Book Four*, 1987

RELATED PROFESSIONAL EXPERIENCE: faculty, Mississippi State U.; independent studio artist, 1974–present

FRANK E. CUMMINGS III
Long Beach, California
BORN: Los Angeles, California, 1938
EDUCATION: B.A., California State U., Long Beach, 1968; M.A., California State U., Fullerton, 1971
AWARDS/HONORS: California State U. Creative Activity Award, 1979; California State U. Administrative Fellow Recipient, 1981
COLLECTION: White House, Washington, DC
PUBLICATIONS: *Artistic Woodturning*, Brigham Young Press, 1980; *Woodworking: The New Wave*, Crown Publishers, 1981; "The International Turned Object Show," *Fine Woodworking*, February 1989; "Southland Profile," *The Southern California Woodworker*, January 1990; "Design—Theory and Practice," *Woodturning—England*, October 1992
RELATED PROFESSIONAL EXPERIENCE: faculty, California State University, Long Beach, 1980–82; visiting artist, U. of Iowa, 1985; visiting scholar, U. of Wisconsin, Madison, WI, 1987; faculty, California State U., Fullerton, 1982–present

JOHN S. CUMMINGS
Nashville, Tennessee
BORN: St. Louis, Missouri, 1940
EDUCATION: B.S., U. of Missouri, Columbia, 1965
COLLECTIONS: Nashville Century III Collection, TN; New Orleans Art Museum, LA; State of Tennessee Early Eighties Collection, Nashville; White House, Washington, DC
RELATED PROFESSIONAL EXPERIENCE: independent studio artist, 1980–present

JUDY B. DALES
Boonton Township, New Jersey
BORN: Baltimore, Maryland, 1945
EDUCATION: Self-taught
AWARDS/HONORS: First Place, National Quilting Association Show, Easton, PA, 1987; Semi-Finalist for New Jersey, Great American Quilt Festival II, Museum of American Folk Art, NYC, 1988; New Jersey State Council on the Arts Fellowship Grant, 1989; First Place, Northeast Quilts Unlimited, Arts Guild of Old Forge, NY, 1993; First Place, Vermont Quilt Festival, Northfield, VT, 1994
COLLECTIONS: National Institutes of Health, Bethesda, MD; Newark Museum, Newark, NJ; White House, Washington, DC
PUBLICATIONS: Robert L. Bishop and Carter Houck, *All Flags Flying: American Patriotic Quilts*, E.P. Dutton, 1986; *Quiltmakers 1989*, Leone Publications, Los Altos, CA; *American Quilter*, Schroeder Publishers, Paducah, KY, Spring 1989, Winter 1992; *Quilt Art 92, 93*, American Quilter's Society, Paducah, KY
RELATED PROFESSIONAL EXPERIENCE: independent studio artist, 1979–present

VIRGINIA DOTSON
Scottsdale, Arizona
BORN: Newton, Massachusetts, 1943
EDUCATION: B.F.A., Arizona State U., Tempe, 1985
AWARDS/HONORS: Arizona Commission on the

Arts Governor's Awards for the Arts, 1987, 1993; Jurors' Award, juried exhibition of *Arizona Designer Craftsmen*, Arizona State Capitol West Wing Gallery, 1992–93
COLLECTIONS: Arizona State U., Tempe; Dowse Art Museum, Lower Hutt, New Zealand; Fine Arts Museum of the South at Mobile, AL; Wood Turning Center, Philadelphia, PA; White House, Washington, DC
PUBLICATIONS: Dona Meilach, *Creating Small Wood Objects as Functional Sculpture*, Crown Publishers, 1987; "Crosswinds," *American Woodturner*, December 1989; *Woodturning*, Spring 1991; *American Craft*, February–March 1994; *American Woodturner*, March 1994
RELATED PROFESSIONAL EXPERIENCE: independent studio artist, 1985–present

PATRICK W. DRAGON
Orlando, Florida
BORN: Detroit, Michigan, 1952
EDUCATION: B.S., Northern Michigan U., Marquette, 1974
COLLECTIONS: City Hall, City of Orlando, FL; Maitland Art Center, Maitland, FL; Northern Michigan U., Marquette; Steelcase Furniture Inc., Grand Rapids, MI; Walt Disney World, Orlando, FL; White House, Washington, DC
RELATED PROFESSIONAL EXPERIENCE: independent studio artist, Dragon Clay Studio, Orlando, FL, 1987–present

DAVID ELLSWORTH
Quakertown, Pennsylvania
BORN: Iowa City, Iowa, 1944
EDUCATION: B.F.A., M.F.A., U. of Colorado, Boulder, 1971, 1973
AWARDS/HONORS: Colorado Artist Craftsman Award, 1977; Visual Artists Fellowship, the National Endowment for the Arts, 1984; Pennsylvania Council on the Arts Fellowship, 1988
COLLECTIONS: Denver Art Museum, CO; High Museum of Art, Atlanta, GA; Museum of Fine Arts, Boston, MA; Renwick Gallery of the National Museum of American Art, Smithsonian Institution, Washington, DC; Sheldon Memorial Art Museum, Lincoln, NE; White House, Washington, DC
PUBLICATION: Paul J. Smith and Edward Lucie-Smith, *Craft Today: Poetry of the Physical*, American Craft Museum, Weidenfeld & Nicolson, 1986
RELATED PROFESSIONAL EXPERIENCE: artist-in-residence, Anderson Ranch Art Center, Aspen, CO, 1974–75; artist-in-residence, Artpark, Lewiston, NY, 1983; faculty, Rochester Institute of Technology, NY, 1985; president, American Association of Woodturners, 1986–present; independent studio artist, 1977–present

SUSAN R. EWING
Oxford, Ohio
BORN: Lawrenceville, Illinois, 1955
EDUCATION: B.A., M.F.A., Indiana U., Bloomington, 1977, 1980
AWARDS/HONORS: Ohio Arts Council Visual Artist Fellowship, 1987, 1989, 1991, 1994; Grant for Academic Excellence, School of Fine Arts, Miami U., 1985, 1987, 1988, 1994; Ford Foundation Project Grant, Indiana U., Bloomington, 1980

COLLECTIONS: Evansville Museum of Arts and Science, Evansville, IN; Indiana U. Art Museum, Bloomington; Ohio Craft Museum, Columbus; White House, Washington, DC
PUBLICATIONS: W. Otie and Rosemary Kilmer, *Designing Interiors*, Holt, Rinehart and Winston, 1991; Michael Wolk, *Designing for the Table: Decorative and Functional Products*, Rizzoli, 1992; "Conceptual Complexity," *American Craft*, April 1992; "CU3: 1991 National Metal Competition," *Metalsmith*, Spring 1992; "The Ubiquitous Teapot," *American Craft*, April/May 1994
RELATED PROFESSIONAL EXPERIENCE: faculty, Rochester Institute of Technology, NY, summer 1988; director/faculty, Miami U. International Summer Workshop, "Classical Jewelry Studio in Rome, Italy," summer 1990; faculty, Miami U., Oxford, OH, 1984–present

RONALD F. FLEMING
Tulsa, Oklahoma
BORN: Oklahoma City, Oklahoma, 1937
EDUCATION: self-taught
COLLECTIONS: Arkansas Arts Center, Little Rock; Kirkpatrick Center, Oklahoma City, OK; White House, Washington, DC
PUBLICATIONS: *Lathe-Turned Objects: An International Exhibition*, Wood Turning Center, Philadelphia, PA, 1988; *Fine Woodworking Design Book Five*, 1990; *Challenge IV: International Lathe-Turned Objects*, Wood Turning Center, Philadelphia, PA, 1991; *Fine Woodworking Design Book Six*, 1992; *Challenge V: International Lathe-Turned Objects*, Wood Turning Center, Philadelphia, PA, 1993
RELATED PROFESSIONAL EXPERIENCE: independent studio artist, 1985–present

ANDREA GILL
Alfred, New York
BORN: Newark, New Jersey, 1948
EDUCATION: B.F.A., Rhode Island School of Design, Providence, 1971; M.F.A., New York State College of Ceramics at Alfred U., Alfred, 1976
AWARDS/HONORS: Visual Artists Fellowship, the National Endowment for the Arts, 1978, 1985; Ohio Arts Council Individual Artist Grant, 1981, 1982, 1983, 1984, 1985; Individual Artist Fellowship, New York Foundation for the Arts, 1989, 1993
COLLECTIONS: Los Angeles County Museum of Art, CA; Massillon Museum, OH; MCI Telecommunications Corporation, Inc., Washington, DC; Museum of Art, Rhode Island School of Design, Providence; Museum of Contemporary Art, Druithuis, Netherlands; Philadelphia Museum of Art, PA; Victoria and Albert Museum, London, England; White House, Washington, DC
PUBLICATION: Paul J. Smith and Edward Lucie-Smith, *Craft Today: Poetry of the Physical*, American Craft Museum, Weidenfeld & Nicolson, 1986
RELATED PROFESSIONAL EXPERIENCE: faculty, New York State College of Ceramics at Alfred U., 1984–present

MICHAEL HALEY
Huntsville, Arkansas
BORN: Pittsburg, Texas, 1947

EDUCATION: B.B.A., North Texas State U., Denton, 1970; M.A., Texas Women's U., Denton, 1976
COLLECTION: White House, Washington, DC
RELATED PROFESSIONAL EXPERIENCE: workshops: "Colored Clays in Patterns," Dallas Craft Guild, TX; "Colored Clay," Ossage Pottery, Berryville, AR; "Colored Porcelain at Tarrant County College," Fort Worth, TX; "Nenage Slab Construction," Cedar Valley College, Lancaster, TX; independent studio artist, 1975–present

WILLIAM HARPER
Tallahassee, Florida
BORN: Bucyrus, Ohio, 1944
EDUCATION: B.A., M.S., Case Western Reserve U., Cleveland, OH, 1966, 1967
AWARDS/HONORS: Visual Artists Fellowship, the National Endowment for the Arts, 1974, 1978, 1979; Individual Artist Fellowship, Florida Arts Council, 1980, 1985
COLLECTIONS: American Craft Museum, NYC; Arkansas Art Center, Little Rock; Cleveland Museum of Art, OH; Detroit Institute of Art, MI; Metropolitan Museum of Art, NYC; Museum of Fine Arts, Boston, MA; Philadelphia Museum of Art, PA; Renwick Gallery of the National Museum of American Art, Smithsonian Institution, Washington, DC; Vatican Museum, Rome, Italy; White House, Washington, DC; Yale U. Art Gallery, New Haven, CT
PUBLICATIONS: *Step by Step Enameling*, Western Publishing, 1973; Paul J. Smith and Edward Lucie-Smith, *Craft Today: Poetry of the Physical*, American Craft Museum, Weidenfeld & Nicolson, 1986; Marcia and Thomas Manhart, *The Eloquent Object*, Philbrook Museum of Art, Tulsa, OK, 1987; *William Harper: Artist as Alchemist*, Orlando Museum of Art, Orlando, FL, 1989; David Watkins, *Best in Contemporary Jewelry*, Quatro Publishing, London, England, 1994; Susan Grant Lewin, *One of a Kind: American Art Jewelry Today*, Harry N. Abrams, Inc., 1994
RELATED PROFESSIONAL EXPERIENCE: faculty, Florida State U., Tallahassee, FL, 1974–91; independent studio artist, 1991–present

BOB HAWKS
Tulsa, Oklahoma
BORN: Hiawatha, Kansas, 1920
EDUCATION: Highland Junior College, 1938–40; The Art Center School, Los Angeles, CA, 1946–48
COLLECTION: White House, Washington, DC
RELATED PROFESSIONAL EXPERIENCE: owner, Bob Hawks Photography, Inc., 1949–90; independent studio artist, 1987–present

ANNE HIRONDELLE
Port Townsend, Washington
BORN: Vancouver, Washington, 1944
EDUCATION: B.A., U. of Puget Sound, Tacoma, WA, 1966; M.A., Stanford U., CA, 1967; School of Law, U. of Washington, Seattle, 1973; Factory of Visual Art, Seattle, 1974; B.F.A., U. of Washington, Seattle, 1976
AWARDS/HONORS: Visual Artists Fellowship, the National Endowment for the Arts, 1988; First Place, Cedar Creek National Teapot Show, 1989; First Place, "Women in Washington: The First Century," 1989

COLLECTIONS: American Craft Museum, NYC; Arizona State U. Art Museum, Tempe; Los Angeles County Museum of Art, CA; Newark Museum, Newark, NJ; University of Iowa Museum of Art, Iowa City; White House, Washington, DC
PUBLICATIONS: Matthew Kangas, "Tablets of Earth," *American Ceramics*, Fall 1983; Martha Drexler Lynn, *Clay Today: Contemporary Ceramists and Their Work*, Los Angeles County Museum of Art, Chronicle Books, 1990; "Anne Hirondelle," *Ceramics Monthly*, March 1993
RELATED PROFESSIONAL EXPERIENCE: independent studio artist, 1976–present

THOMAS HOADLEY
Lanesborough, Massachusetts
BORN: North Adams, Massachusetts, 1949
EDUCATION: B.A., Amherst College, Amherst, MA, 1971; M.S., Illinois State U., Normal, 1977
AWARDS/HONORS: Massachusetts Artists Fellowship Finalist, 1981, 1989; Massachusetts Artists Fellowship, 1985; American Craft Museum Design Award, 1985; Visual Artists Fellowship, the National Endowment for the Arts, 1990, 1992
COLLECTIONS: Los Angeles County Museum of Art, CA; MCI Telecommunications Corporation, Inc., Washington, DC; Philadelphia Museum of Art, PA; Renwick Gallery of the National Museum of American Art, Smithsonian Institution, Washington, DC; White House, Washington, DC
PUBLICATIONS: Katherine Pearson, *American Crafts: A Sourcebook for the Home*, Stewart, Tabori & Chang, 1983; Peter Lane, *Ceramic Form, Design and Decoration*, Rizzoli, 1988; Caroline Whyman, *The Complete Potter: Porcelain*, Pennsylvania Press, 1994; Peter Lane, *Contemporary Porcelain*, Rizzoli, 1994
RELATED PROFESSIONAL EXPERIENCE: independent studio artist, 1980–present

DAWN KIILANI HOFFMANN
Hagerstown, Maryland
BORN: Honolulu, Hawaii, 1956
EDUCATION: B.F.A., U. of Wisconsin, Madison, 1983
COLLECTION: White House, Washington, DC
RELATED PROFESSIONAL EXPERIENCE: National Arts Camp, Interlochen, MI, 1977; Lawson Brass Instruments, Boonsboro, MD, 1979–82; independent studio artist, 1983–present

ROBYN HORN
Little Rock, Arkansas
BORN: Fort Smith, Arkansas, 1951
EDUCATION: B.A., Hendrix College, Conway, AR, 1973
COLLECTIONS: Fine Arts Museum of the South at Mobile, AL; White House, Washington, DC; Wood Turning Center, Philadelphia, PA
PUBLICATIONS: "Sheoake Geode," *American Woodworker*, September/October 1988; *Challenge IV: International Lathe-Turned Objects Catalog*, 1991; *Fine Woodworking Design Book Six*, 1992; *Out of the Woods: Turned Wood by American Craftsmen*, 1992; *Arkansas Year of American Craft 1993*, 1993; *Challenge V: International Lathe-Turned Objects*, Wood Turning Center, Philadelphia, PA, 1994

RELATED PROFESSIONAL EXPERIENCE: independent studio artist, 1983–present

SIDNEY R. HUTTER
Waltham, Massachusetts
BORN: Champaign, Illinois, 1954
EDUCATION: B.S., Illinois State U., Normal, 1977; Lowell Institute of MIT, Cambridge, MA, 1979–80; M.F.A., Massachusetts College of Art, Boston, 1979
COLLECTIONS: Corning Museum of Glass, Corning, NY; Headly-Whitney Museum, Lexington, KY; Milwaukee Art Museum, WI; Renwick Gallery of the National Museum of American Art, Smithsonian Institution, Washington, DC; Toledo Museum of Art, OH; White House, Washington, DC
RELATED PROFESSIONAL EXPERIENCE: faculty, Boston Public Schools, MA, 1980–86; faculty, Massachusetts College of Art, Boston, 1978–89; owner/president, Hutter Glass and Light Company, Boston, MA, 1987–present

JOHN JORDAN
Antioch, Tennessee
BORN: Nashville, Tennessee, 1950
EDUCATION: self-taught
COLLECTIONS: American Craft Museum, NYC; Fine Arts Museum of the South at Mobile, AL; High Museum of Art, Atlanta, GA; White House, Washington, DC
PUBLICATIONS: *The Art of Woodworking—Wood Turning*, Time-Life Books; *Fine Woodworking Design Book Six*, 1992
RELATED PROFESSIONAL EXPERIENCE: faculty, Brookfield Craft Center, Brookfield, CT, 1989; faculty, Arrowmont School of Arts and Crafts, Gatlinburg, TN, 1990–95; faculty, California State U., 1993; faculty, Arizona State U., Tempe, 1992; faculty, John C. Campbell Folk School, NC, 1988–95; independent studio artist, 1986–present

RONALD E. KENT
Honolulu, Hawaii
BORN: Chicago, Illinois, 1931
EDUCATION: B.S., U. of California, Los Angeles, 1957
AWARDS/HONORS: works by the artist presented to the following: President William Clinton by the state of Hawaii; Presidents Ronald Reagan and George Bush by the Hawaii Republican Party; and Emperor Akahito of Japan by the Consulate-General of Japan
COLLECTIONS: American Craft Museum, NYC; Albrecht Art Museum, St. Joseph, MO; Bishop Museum, Honolulu Academy of Arts, HI; Cooper-Hewitt, National Design Museum, Smithsonian Institution, NYC; Detroit Institute of Arts, MI; High Museum of Art, Atlanta, GA; Musée des Arts Décoratifs, Paris, France; Metropolitan Museum of Art, NYC; Museum of Fine Arts, Boston, MA; Newark Museum, Newark, NJ; Renwick Gallery of the National Museum of American Art, Smithsonian Institution, Washington, DC; Vatican Museum, Rome, Italy; White House, Washington, DC; Yale U. Art Gallery, New Haven, CT
PUBLICATION: Paul J. Smith and Edward Lucie-Smith, *Craft Today: Poetry of the Physical*, American Craft Museum, Weidenfeld & Nicolson, 1986

RELATED PROFESSIONAL EXPERIENCE: independent studio artist, 1980–present

ELLEN KOCHANSKY
Pickens, South Carolina
BORN: New York, New York, 1947
EDUCATION: B.F.A., Syracuse U., NY, 1969
AWARDS/HONORS: Association of Women Professionals, Clemson, SC, 1989; American Craft Enterprises, Board of Directors, 1988–90; South Carolina Arts Commission Individual Artists Fellowship, 1978, 1993; American Craft Council, Trustee, 1990–92, Emeritus, 1993
COLLECTIONS: Aetna Insurance Company, NYC; Columbia Museum of Art and Science, SC; Emory U., Atlanta, GA; Ernst & Young, NYC; Hanes Group, Winston-Salem, NC; Gerald Hines Partnership, Chemed Center, Cincinnati, OH; White House, Washington, DC
PUBLICATIONS: Fiberarts Design Book III, Lark Publications, 1987; Southern Quilts, A New View, 1991; Phyllis George, Craft in America: Celebrating the Creative Work of the Hand, The Summitt Group, 1993; American Quilter Magazine, Winter 1993; The Crafts Report, October 1991, February 1994
RELATED PROFESSIONAL EXPERIENCE: faculty, Arrowmont School of Arts and Crafts, Gatlinburg, TN, 1980, 1981, 1983, 1993; independent studio artist, 1970–present

JON KUHN
Winston-Salem, North Carolina
BORN: Chicago, Illinois, 1949
EDUCATION: B.F.A., Washburn U., Topeka, KS, 1972; M.F.A., Virginia Commonwealth U., Richmond, VA, 1978
COLLECTIONS: Chrysler Museum, Norfolk, VA; Corning Museum of Glass, Corning, NY; Detroit Institute of Arts, MI; Glasmuseum, Ebeltoft, Denmark; High Museum of Art, Atlanta, GA; Huntington Museum of Art, Inc., Huntington, WV; Metropolitan Museum of Art, NYC; Mint Museum of Art, Charlotte, NC; Musée des Arts Décoratifs, Lausanne, Switzerland; Museum für Kunst und Gewerbe, Hamburg, Germany; National Museum of American History, Smithsonian Institution, Washington, DC; White House, Washington, DC
PUBLICATIONS: Katherine Pearson, American Craft: A Source Book for the Home, Stewart, Tabori, & Chang, 1983; Neues Glas, 1988; Dan Klein, Glass: A Contemporary Art, Rizzoli, 1989; Jon Kuhn, Dennos Museum Center, Traverse City, MI, 1993
RELATED PROFESSIONAL EXPERIENCE: independent studio artist, 1978–present

CLIFF LEE
Stevens, Pennsylvania
BORN: Taiwan, Republic of China, 1951
EDUCATION: Eastern Mennonite College, Harrisonburg, VA, 1968–71; Hershey Medical School, Pennsylvania State College, Hershey, PA, 1972–74; M.A., James Madison U., Harrisonburg, VA, 1975–76
AWARD/HONOR: The Great American Bowl, The Art Association of Newport, RI
COLLECTION: White House, Washington, DC
RELATED PROFESSIONAL EXPERIENCE: independent studio artist, 1975–present

PO SHUN LEONG
Winnetka, California
BORN: Northampton, England, 1941
EDUCATION: Architectural Association School of Architecture, London, England, 1959-64
AWARD/HONOR: Travel Scholarship, Michael Ventris Memorial Award, 1966
COLLECTION: White House, Washington, DC
PUBLICATIONS: Lloyd E. Herman, Art That Works: Decorative Arts of the Eighties, Crafted in America, U. of Washington Press, 1990; Bill Kraus, Contemporary Crafts for the Home, Kraus Sikes, Inc., Madison, WI, 1990; Tony Lydgate, The Art of Making Elegant Wood Boxes, Chapelle/Sterling Publishers, 1992
RELATED PROFESSIONAL EXPERIENCE: independent studio artist, 1987–present

DAVID W. LEVI
Seattle, Washington
BORN: St. Louis, Missouri, 1959
EDUCATION: B.F.A., Washington U., St. Louis, MO, 1983; Haystack Mountain School of Crafts, Deer Isle, ME, 1986
AWARDS/HONORS: American Scandinavian Foundation Thord-Grey Memorial Grant, 1984; American Craft Museum, Young Americans Merit Award, 1988; Visual Artists Fellowship, the National Endowment for the Arts, 1988; Creative Glass Center of America, Masterworks Fellowship, 1990
COLLECTIONS: American Craft Museum, NYC; Corning Museum of Glass, Corning, NY; St. Louis Art Museum, MO; MCI Telecommunications Corporation, Inc., Washington, DC; White House, Washington, DC
RELATED PROFESSIONAL EXPERIENCE: partner, Ibex Glass Studio, St. Louis, MO, 1985; faculty, Pilchuck Glass School, Stanwood, WA, 1985, 1990, 1991; independent studio artist, 1984–present

MARK LINDQUIST
Quincy, Florida
BORN: Oakland, California, 1949
EDUCATION: B.A., New England College, Henniker, NH, 1971; M.F.A., Florida State U., Tallahassee, FL, 1990
AWARDS/HONORS: New Hampshire Commission on the Arts grant, 1984; Massachusetts Council on the Arts and Humanities grant, 1985; National Endowment for the Arts Fellowship, Southern Arts Federation, 1989
COLLECTIONS: American Craft Museum, NYC; Dallas Museum of Art, TX; High Museum of Art, Atlanta, GA; Metropolitan Museum of Art, NYC; Museum of Fine Arts, Boston, MA; Philadelphia Museum of Art, PA; Renwick Gallery of the National Museum of American Art, Smithsonian Institution, Washington, DC; White House, Washington, DC
PUBLICATIONS: Paul J. Smith and Edward Lucie-Smith, Craft Today: Poetry of the Physical, American Craft Museum, Weidenfeld & Nicolson, 1986; John Perreault, "Turning Point," American Craft, February/March 1989; Carol M. Cropper, "Collectors . . . Turned Wood," Forbes, September 1992; Contemporary Crafts and the Saxe Collection, Toledo Museum of Art, OH, 1993; Josephine Gear, Beyond Nature: Wood Into Art, Lowe Art Museum, Coral Gables, FL, 1994

RELATED PROFESSIONAL EXPERIENCE: independent studio artist, 1969–present

MELVIN LINDQUIST
Quincy, Florida
BORN: Kingsburg, California, 1911
EDUCATION: B.S., Oakland Polytechnic College of Engineering, 1935
AWARDS/HONORS: American Society of Quality Control; New England Living Art Treasure, U. of Massachusetts, Amherst, 1983; National Woodturning Conference Award, Arrowmont School of Arts and Crafts, Gatlinburg, TN, 1985; Lifetime Member, American Association of Woodturners, 1993
COLLECTIONS: Fine Arts Museum of the South at Mobile, AL; Metropolitan Museum of Art, NYC; Schenectady Museum and Planetarium, Schenectady, NY; White House, Washington, DC
RELATED PROFESSIONAL EXPERIENCE: independent studio artist, 1965–present

HARVEY K. LITTLETON
Spruce Pine, North Carolina
BORN: Corning, New York, 1922
EDUCATION: B.D., U. of Michigan, Ann Arbor, 1947; M.F.A., Cranbrook Academy of Art, Bloomfield Hills, MI, 1951
AWARDS/HONORS: Louis Comfort Tiffany Foundation Grant, 1970; Honorary Member, National Council on Education for the Ceramic Arts, 1972; Fellow, American Craft Council, 1975; Honorary Life Membership, Glass Art Society, 1976; Visual Artists Fellowship, the National Endowment for the Arts, 1978; Honorary Ph.D., Philadelphia College of Art, PA, 1982
COLLECTIONS: American Craft Museum, NYC; Cooper-Hewitt, National Design Museum, Smithsonian Institution, NYC; Corning Museum of Glass, Corning, NY; Metropolitan Museum of Art, NYC; Museum of Modern Art, Kyoto, Japan; Museum of Modern Art, NYC; Renwick Gallery of the National Museum of American Art, Smithsonian Institution, Washington, DC; Victoria and Albert Museum, London, England; White House, Washington, DC
PUBLICATIONS: Glassblowing—A Search for Form, Van Nostrand Reinhold, 1971; Paul J. Smith and Edward Lucie-Smith, Craft Today: Poetry of the Physical, American Craft Museum, Weidenfeld & Nicolson, 1986
RELATED PROFESSIONAL EXPERIENCE: faculty, U. of Wisconsin, Madison, 1951–77; Professor Emeritus, 1977–present; independent studio artist, 1977–present

JOHN LITTLETON
Bakersville, North Carolina
BORN: Madison, Wisconsin, 1957
EDUCATION: Interlochen Arts Academy, Interlochen, MI, 1974; B.S.A., U. of Wisconsin, Madison, 1979
COLLECTIONS: Glasmuseum, Ebeltoft, Denmark; Glasmuseum Frauenau, Frauenau, Germany; High Museum of Art, Atlanta, GA; Milwaukee Art Museum, WI; Mint Museum of Art, Charlotte, NC; Musée des Arts Décoratifs, Lausanne, Switzerland; St. Louis Art Museum, MO; White House, Washington, DC
RELATED PROFESSIONAL EXPERIENCE: independent studio artist, 1980–present

KARI LØNNING
Ridgefield, Connecticut
BORN: Torrington, Connecticut, 1950
EDUCATION: U. of Oslo, Norway, 1971; B.F.A., Syracuse U., NY, 1972; Handarbetets Vanner, Stockholm, Sweden, 1972
AWARDS/HONORS: Chairperson, Connecticut Council for the Crafts, 1980; American Craft Museum Design Award, 1985; Master Craftswoman, Society for Connecticut Crafts, 1987; Connecticut Commission on the Arts Grant, 1991; Award for Excellence in Basketry, Society for Connecticut Crafts, 1991, 1992
COLLECTIONS: Arkansas Arts Center, Little Rock; Renwick Gallery of the National Museum of American Art, Smithsonian Institution, Washington, DC; White House, Washington, DC
RELATED PROFESSIONAL EXPERIENCE: faculty, Arrowmont School of Arts and Crafts, Gatlinburg, TN, 1985; faculty, Penland School of Crafts, Penland, NC; faculty, School of Visual Arts, NYC; faculty, Haystack Mountain School of Crafts, Deer Isle, ME, 1987, 1993; independent studio artist, 1974–present

DONA LOOK
Algoma, Wisconsin
BORN: Port Washington, Wisconsin, 1948
EDUCATION: B.A., U. of Wisconsin, Oshkosh, 1970
AWARDS/HONORS: American Craft Museum Design Award, 1985; Craftsmen's Award, Philadelphia Craft Show, 1986; National Endowment for the Arts Midwest Fellowship, 1987; Visual Artists Fellowship, the National Endowment for the Arts, 1988
COLLECTIONS: American Craft Museum, NYC; Arkansas Arts Center, Little Rock; Erie Art Museum, PA; MCI Telecommunications Corporation, Inc., Washington, DC; Philadelphia Museum of Art, PA; White House, Washington, DC; Charles A. Wustum Museum of Fine Arts, Racine, WI
PUBLICATIONS: Paul J. Smith and Edward Lucie-Smith, *Craft Today: Poetry of the Physical*, American Craft Museum, Weidenfeld & Nicolson, 1986; *National Craft Invitational*, Arkansas Arts Center, Little Rock, 1987; Jack Lenor Larsen, *Interlacing: The Elemental Fabric*, Kodansha Press, 1987; Martina Margetts, ed., *International Crafts*, Thames and Hudson, 1991
RELATED PROFESSIONAL EXPERIENCE: faculty, Sydney and Tamworth, New South Wales, Australia, 1976–78; design partner, Look & Heaney Studio, Byron Bay, New South Wales, Australia, 1978–80; design partner, Loeber/Look Studio, Algoma, WI, 1980–present; independent studio artist, 1980–present

SAM MALOOF
Alta Loma, California
BORN: Chino, California, 1916
EDUCATION: Chino High School, 1934; self-taught
AWARDS/HONORS: Louis Comfort Tiffany Foundation Grant, 1969; Fellow, American Craft Council, 1975; Visual Artists Fellowship, the National Endowment for the Arts, 1984; MacArthur Foundation Fellowship, 1985
COLLECTIONS: American Craft Museum, NYC; Craft and Folk Art Museum, Los Angeles, CA; Los Angeles County Museum of Art, CA; Minnesota Art Museum, St. Paul; Museum of Fine Arts, Boston, MA; Oakland Museum, CA; Philadelphia Museum of Art, PA; Renwick Gallery of the National Museum of American Art, Smithsonian Institution, Washington, DC; St. Louis Art Museum, MO; Vice-President's Residence, Washington, DC; White House, Washington, DC
PUBLICATIONS: Barbaralee Diamonstein, *Handmade in America: Conversations with Fourteen Craftmasters*, Harry N. Abrams, Inc., 1983; *Sam Maloof: Woodworker*, Kodansha International, 1983; Paul J. Smith and Edward Lucie-Smith, *Craft Today: Poetry of the Physical*, American Craft Museum, Weidenfeld & Nicolson, 1986
RELATED PROFESSIONAL EXPERIENCE: independent studio artist, 1934–present

DANTE MARIONI
Seattle, Washington
BORN: Mill Valley, California, 1964
EDUCATION: Colorado Mountain College, Vail, 1983; Penland School of Crafts, Penland, NC, 1983; Pilchuck Glass School, Stanwood, WA, 1984–85
AWARDS/HONORS: Glass Eye Scholarship, Seattle, WA, 1986; Louis Comfort Tiffany Foundation Grant, 1987; American Craft Museum Young Americans Award, 1988; Young Artist Trustee, Haystack Mountain School of Crafts, 1993
COLLECTIONS: American Craft Museum, NYC; Corning Museum of Glass, Corning, NY; MCI Telecommunications, Inc., Washington, DC; Microsoft, Redmond, WA; National Gallery of Victoria, Melbourne, Australia; White House, Washington, DC; Yokohama Museum of Art, Yokohama, Japan
PUBLICATIONS: Bonnie Miller, *Out of the Fire: Contemporary Glass Artists and Their Work*, Chronicle Books, 1991; Lloyd E. Herman, *Clearly Art: Pilchuck's Glass Legacy*, University of Washington Press, 1992; Shawn Waggoner, "Dante Marioni: Upholding the Vessel Tradition," *Glass Art*, Winter 1993; Matthew Kangas, "Dante Marioni: Apprentice to Tradition," *American Craft*, February/March 1994
RELATED PROFESSIONAL EXPERIENCE: employed, Glass Eye Studio, Seattle, WA, 1979–86; master craftsman-in-residence, Pilchuck Glass School, Stanwood, WA, 1986; faculty, Rhode Island School of Design, Providence, 1993; faculty, Haystack Mountain School of Crafts, Deer Isle, ME, 1994; faculty, Penland School of Crafts, Penland, NC, 1994; faculty, Pilchuck Glass School, Stanwood, WA; independent studio artist, 1985–present

THOMAS R. MARKUSEN
Kendall, New York
BORN: Chicago, Illinois, 1940
EDUCATION: B.S., M.S., U. of Wisconsin, Madison, 1964, 1966
AWARDS/HONORS: Faculty Research Fellowship, State U. of New York (SUNY) Research Foundation, 1979; *Niche Magazine* Design Award, 1990, 1991, 1994; Arts for Greater Rochester Grant, 1993
COLLECTIONS: American Craft Museum, NYC; Vatican Museum, Rome, Italy; White House, Washington, DC; Charles A. Wustum Museum of Fine Arts, Racine, WI

RELATED PROFESSIONAL EXPERIENCE: faculty, State University of New York, College at Brockport; independent studio artist, 1968–present

DIMITRI MICHAELIDES
Freeland, Washington
BORN: St. Louis, Missouri, 1961
EDUCATION: New York State College of Ceramics at Alfred U., Alfred, 1980; Rhode Island School of Design, Providence, 1983; B.A., Brown U., Providence, RI, 1984
AWARDS/HONORS: American Craft Museum, Young Americans Merit Award, 1988; Visual Artists Fellowship, the National Endowment for the Arts, 1988; Creative Glass Center of America, Masterworks Fellowship, 1990
COLLECTIONS: American Craft Museum, NYC; Corning Museum of Glass, Corning, NY; MCI Telecommunications, Inc., Washington, DC; St. Louis Art Museum, MO; White House, Washington, DC
RELATED PROFESSIONAL EXPERIENCE: founding member and partner, Ibex Glass Studio, St. Louis, MO, 1985; faculty, Pilchuck Glass School, Stanwood, WA, 1990, 1991; independent studio artist, 1984–present

JOAN MONDALE
Tokyo, Japan
BORN: Eugene, Oregon, 1930
EDUCATION: B.A., Macalester College, St. Paul, MN, 1952
RELATED PROFESSIONAL EXPERIENCE: studied with Vally Possony, Falls Church, VA, and Warren MacKenzie, Stillwater, MN

EDWARD MOULTHROP
Atlanta, Georgia
BORN: Cleveland, Ohio, 1916
EDUCATION: B.A., Case Western Reserve U., Cleveland, OH, 1939; M.F.A., Princeton U., NJ, 1941
AWARDS/HONORS: American Institute of Architects Award, 1978, 1980; Georgia Governor's Award, 1981; Fellow, American Craft Council, 1987
COLLECTIONS: American Craft Museum, NYC; Coca-Cola Company, Atlanta, GA; Detroit Institute of Arts, MI; Fine Arts Museum of the South at Mobile, AL; High Museum of Art, Atlanta, GA; International Paper, NYC; MCI Telecommunications Corporation, Inc., Washington, DC; Metropolitan Museum of Art, NYC; Mint Museum of Art, Charlotte, NC; Museum of Fine Arts, Boston, MA; Museum of Fine Arts, Houston, TX; Museum of Modern Art, NYC; Renwick Gallery of the National Museum of American Art, Smithsonian Institution, Washington, DC; White House, Washington, DC
PUBLICATION: Paul J. Smith and Edward Lucie-Smith, *Craft Today: Poetry of the Physical*, American Craft Museum, Weidenfeld & Nicolson, 1986
RELATED PROFESSIONAL EXPERIENCE: independent studio artist, 1973–present

PHILIP MOULTHROP
Marietta, Georgia
BORN: Atlanta, Georgia, 1947
EDUCATION: B.A., West Georgia College,

Carrollton, 1969; Woodrow Wilson College of Law, Atlanta, GA, 1978
COLLECTIONS: Detroit Institute of Arts, MI; Fine Arts Museum of the South at Mobile, AL; High Museum of Art, Atlanta, GA; Huntsville Museum of Art, Huntsville, AL; Kresge Art Museum, Michigan State U., East Lansing; Renwick Gallery of the National Museum of American Art, Smithsonian Institution, Washington, DC; White House, Washington, DC
RELATED PROFESSIONAL EXPERIENCE: independent studio artist, 1979–present

THOMAS P. MUIR
Perrysburg, Ohio
BORN: Atlanta, Georgia, 1956
EDUCATION: B.V.A. Georgia State U., Atlanta, 1982; M.F.A. Indiana U., Bloomington, 1985
COLLECTIONS: Art Institute of Chicago, IL; Ball State University Art Gallery, Muncie, IN; National Air and Space Museum, Smithsonian Institution, Washington, DC; State of Georgia Art Collection; White House, Washington, DC
PUBLICATIONS: Michael Wolk, *Designing for the Table: Decorative and Functional Products*, Rizzoli, 1992; Sara Bodine and Michael Dunas, *Design Visions: The Australia International Crafts Triennial*, Art Gallery of Western Australia, 1992; *Metalsmith*, Spring 1992; *American Craft Magazine*, April/ May 1992; *American Jewelry Manufacturer*, October 1992; "The Ubiquitous Tea Pot," *American Craft Magazine*, April/May 1994
RELATED PROFESSIONAL EXPERIENCE: faculty, Indiana U., Bloomington, 1984–85; faculty, Center for Creative Studies, College of Art and Design, Detroit, MI, 1985–91; faculty, School of Art, Bowling Green State U., Bowling Green, OH, 1991–present

JOEL PHILIP MYERS
Bloomington, Illinois
BORN: Paterson, New Jersey, 1934
EDUCATION: certificate, Parsons School of Design, NYC, 1954; B.F.A., M.F.A., New York State College of Ceramics at Alfred U., Alfred, 1963, 1968
AWARDS/HONORS: Visual Artists Fellowship, the National Endowment for the Arts, 1976, 1984; Fellow, American Craft Council, 1980; Honorary Life Member, The Glass Art Society, 1993
COLLECTIONS: American Craft Museum, NYC; Art Institute of Chicago, IL; Corning Museum of Glass, Corning, NY; Detroit Institute of Arts, MI; Hokkaido Museum of Modern Art, Sapporo, Japan; MCI Telecommunications Corporation, Inc., Washington, DC; Metropolitan Museum of Art, NYC; Museum of Applied Arts, Frankfurt, Germany; White House, Washington, DC
PUBLICATION: Paul J. Smith and Edward Lucie-Smith, *Craft Today: Poetry of the Physical*, American Craft Museum, Weidenfeld & Nicolson, 1986
RELATED PROFESSIONAL EXPERIENCE: director of design, Blenko Glass Company, Milton, WV, 1963–70; faculty, Illinois State U., Normal, 1970–present

AMY NICHOLS
Akron, Ohio
BORN: Akron, Ohio, 1958

EDUCATION: B.F.A., Cleveland Institute of Art, OH, 1982
COLLECTION: White House, Washington, DC
PUBLICATIONS: *Early American Life*, June 1988; *Ozark Mountaineer*, August 1988; *Country Home*, December 1988
RELATED PROFESSIONAL EXPERIENCE: independent studio artist, 1982–present

LEON NIEHUES
Huntsville, Arkansas
BORN: Seneca, Kansas, 1951
EDUCATION: self-taught
AWARDS/HONORS: Best of Show, Riverfest Festival, Little Rock, AR, 1984; 1985; 1987; 1988; 1990; Best of Show, Milwaukee Lakefront Festival of the Arts, Milwaukee Art Museum, WI, 1988; Best of Show, Arkansas Art, Craft and Design Fair, Little Rock, 1989; Governor's Award, Little Rock, AR, 1990; Arkansas Arts Council Fellowship Grant, 1992; First Place, St. Louis Art Fair, MO, 1994
COLLECTIONS: Arkansas Arts Center, Little Rock; Hot Springs Art Museum, AR; White House, Washington, DC
PUBLICATIONS: *Fiber Arts Magazine*, November 1987, January 1988, Summer 1992; *The Basketmaker Magazine*, Winter 1990; "The Crafts of America Find Recognition at the Top," *New York Times*, December 23, 1993
RELATED PROFESSIONAL EXPERIENCE: faculty, Tennessee Basketry Conference National Symposium, Appalachian Center for the Crafts, Smithville, TN, 1987; faculty, "Basketry: From All Directions," National Conference, Arrowmont School of Arts and Crafts, Gatlinburg, TN, 1991; teaching, "Midwest Basketry Focus, An Alternative Conference," Cincinnati, OH, 1994; independent studio artist, 1974–present

SHARON NIEHUES
Huntsville, Arkansas
BORN: Alton, Illinois, 1952
EDUCATION: self-taught
AWARDS/HONORS: Best of Show, Riverfest Festival, Little Rock, AR, 1984, 1985, 1987, 1988, 1990; Best of Show, Milwaukee Lakefront Festival of the Arts, Milwaukee Art Museum, WI, 1988; Best of Show, Arkansas Art, Craft and Design Fair, Little Rock, 1989; Governor's Award, Little Rock, AR, 1990; Arkansas Arts Council Fellowship Grant, 1992; First Place, St. Louis Art Fair, MO, 1994
COLLECTIONS: Arkansas Arts Center, Little Rock; Hot Springs Art Museum, AR; White House, Washington, DC
PUBLICATIONS: *Fiber Arts Magazine*, November 1987, January 1988, Summer 1992; *The Basketmaker Magazine*, Winter 1990; "The Crafts of America Find Recognition at the Top," *New York Times*, December 23, 1993
RELATED PROFESSIONAL EXPERIENCE: faculty, Tennessee Basketry Conference National Symposium, Appalachian Center for the Crafts, Smithville, TN, 1987; faculty, "Basketry: From All Directions," National Conference, Arrowmont School of Arts and Crafts, Gatlinburg, TN, 1991; teaching, "Midwest Basketry Focus, An Alternative Conference," Cincinnati, OH, 1994, independent studio artist, 1974–present

LANEY K. OXMAN
Hillsboro, Virginia
BORN: Washington, DC, 1946
EDUCATION: self-taught
AWARDS/HONORS: *Niche Magazine* Design Award, 1990, 1992, 1993
COLLECTIONS: Corning Museum of Glass, Corning, NY; Virginia Museum of Fine Arts, Richmond, VA; White House, Washington, DC
RELATED PROFESSIONAL EXPERIENCE: independent studio artist, 1977–present

ZACHARY OXMAN
Hillsboro, Virginia
BORN: Fairfax, Virginia, 1968
EDUCATION: Corcoran School of Art, Washington, DC, 1985; Studio Arts Center International, Florence, Italy, 1988; B.F.A., Carnegie Mellon U., Pittsburgh, PA, 1990; Penland School of Crafts, Penland, NC, 1993
RELATED PROFESSIONAL EXPERIENCE: faculty, Pittsburgh Center for the Arts, PA, 1991–92; independent studio artist, 1990–present

ALBERT PALEY
Rochester, New York
BORN: Philadelphia, Pennsylvania, 1944
EDUCATION: B.F.A., M.F.A., Temple U., Tyler School of Art, Philadelphia, PA, 1966, 1969
AWARDS/HONORS: Master Craftsman Apprentice Grant, the National Endowment for the Arts (NEA), 1975, 1976, 1979; Visual Artists Fellowship, NEA, 1976, 1984
COLLECTIONS: Birmingham Museum of Art, AL; Detroit Institute of Arts, MI; Hunter Museum of Art, Chattanooga, TN; Metropolitan Museum of Art, NYC; Museum of Fine Arts, Boston, MA; Museum of Fine Arts, Houston, TX; Philadelphia Museum of Art, PA; Renwick Gallery of the National Museum of American Art, Smithsonian Institution, Washington, DC; Strong Museum, Rochester, NY; Virginia Museum of Fine Arts, Richmond, VA; White House, Washington, DC; Yale U. Art Gallery, New Haven, CT
PUBLICATIONS: Susan and Michael Southworth, *Ornamental Ironwork: An Illustrated Guide to Its Design, History and Use in American Architecture*, David Godine, 1978; Barbaralee Diamonstein, *Handmade in America: Conversations with Fourteen Craftmasters*, Harry N. Abrams, Inc., 1983; Paul J. Smith and Edward Lucie-Smith, *Craft Today: Poetry of the Physical*, American Craft Museum, Weidenfeld & Nicolson, 1986; R. Craig Miller, *Modern Design 1890–1990: The Design Collections of the Metropolitan Museum of Art*, Harry N. Abrams, Inc., 1990; *Collecting American Decorative Arts and Sculptures, 1971–1991*, Museum of Fine Arts, Boston, MA, 1991; *Albert Paley: Sculptural Adornment*, introduction by Edward Lucie-Smith, essays by Deborah L. Norton and Matthew Drutt, Renwick Gallery of the National Museum of American Art, Smithsonian Institution, Washington, DC, in association with the U. of Washington Press, 1991; David L. Barquist, *American Tables and Looking Glasses*, Yale U. Art Gallery, New Haven, CT, 1992; Penelope Hunter-Stiebel, *Organic Logic*, foreword by Peter T. Joseph, Peter Joseph Gallery, NYC, 1994
RELATED PROFESSIONAL EXPERIENCE: faculty,

School for American Craftsmen, Rochester Institute of Technology, NY, 1972–84, faculty and artist-in-residence, 1984–present; major architectural commissions in forged metal, nationwide, 1974–present

ED PENNEBAKER
Green Forest, Arkansas
BORN: Pratt, Kansas, 1955
EDUCATION: A.A., Garden City Community College, KS, 1975; B.F.A., M.A., Emporia State U., KS, 1977, 1978
COLLECTION: White House, Washington, DC
PUBLICATIONS: *Early American Life*, June 1988; *Ozark Mountaineer*, August 1988; *Country Home*, December 1988
RELATED PROFESSIONAL EXPERIENCE: independent studio artist, 1980–present; Red Fern Glass, 1985–present

PETER PETROCHKO
Oxford, Connecticut
BORN: Bridgeport, Connecticut, 1948
EDUCATION: U. of Cincinnati, OH, 1966–69; Rhode Island School of Design, Providence, 1969; Silvermine Guild Art Center, New Canaan, CT, 1969–70
AWARDS/HONORS: Master Craftsman Award, Society for Connecticut Crafts, 1988; Purchase Award, ACC Craft Show, Atlanta, 1990; Excellence for Wood Award, 57th Annual Exhibit Society for Connecticut Crafts, 1992
COLLECTIONS: Museum of Fine Arts, Boston, MA; White House, Washington, DC
PUBLICATIONS: *Fine Woodworking Techniques No. 7*, 1975; *American Craft Magazine*, October/November 1982; *American Craft Magazine*, August/September, 1984; *Fine Woodworking Design Book 5*, 1990; *Craft Arts International Magazine*, November/January 1990; *Fine Woodworking Design Book 6*, 1992; Phyllis George, *Craft in America: Celebrating the Creative Works of the Hand*, The Summit Group, 1993
RELATED PROFESSIONAL EXPERIENCE: artist-in-residence, Artpark, Lewiston, NY, 1987, 1989; independent studio artist, 1980–present

RICHARD Q. RITTER
Bakersville, North Carolina
BORN: Detroit, Michigan, 1940
EDUCATION: B.A., Art School of the Society of Arts and Crafts, Detroit, MI, 1968; Penland School of Crafts, Penland, NC, 1971
COLLECTIONS: American Craft Museum, NYC; Chrysler Museum, Norfolk, VA; Corning Museum of Glass, Corning, NY; Detroit Institute of Arts, MI; High Museum of Art, Atlanta, GA; Hunter Museum, Chattanooga, TN; St. Louis Art Museum, MO; J. B. Speed Art Museum, Louisville, KY; White House, Washington, DC
RELATED PROFESSIONAL EXPERIENCE: faculty, Penland School of Crafts, Penland, NC, 1972–74, 1979, 1981, 1988, 1990, 1993; independent studio artist, 1968–present

ADRIEN ROTHSCHILD
Baltimore, Maryland
BORN: Baltimore, Maryland, 1949
EDUCATION: Rhode Island School of Design, Providence, 1968; Maryland Institute, College of Art, Baltimore, 1969; Towson State U.,

Towson, MD, 1974–76; B.A. Johns Hopkins U., Baltimore, MD, 1978
AWARDS/HONORS: First Place, Palm Beach Quilt Fest, West Palm Beach, FL, 1991; First Place, Vermont Quilt Festival, 1991; Honorable Mention, Mid-Atlantic Quilt Festival III, 1992
COLLECTIONS: APT International, Tokyo, Japan; Museum of the American Quilter's Society, Paducah, KY; White House, Washington, DC
PUBLICATIONS: Victoria Faoro, ed., *Award-Winning Quilts and Their Makers: Vol. III*, American Quilter's Society, Paducah, KY, 1993; Dairy Barn Quilt National, *The New Quilt II*, Taunton Press, 1993; Paul D. Pilgrim and Gerald E. Roy, *Quilts: Old and New, a Similar View*, American Quilter's Society, Paducah, KY 1993
RELATED PROFESSIONAL EXPERIENCE: independent studio artist, 1985–present

HARVEY S. SADOW, JR.
Jupiter, Florida
BORN: New York, New York, 1946
EDUCATION: B.A., Knox College, Galesburg, IL, 1968; M.A., M.F.A., U. of Iowa, Iowa City, 1970, 1971
AWARDS/HONORS: Lennox Award for Excellence in Ceramics, 1984; Artists Fellowship, Montgomery County, Maryland, 1987; Florida Artists Fellowship, 1991
COLLECTIONS: Arkansas Arts Center, Little Rock; Boca Raton Museum of Art, FL; Everson Museum of Art of Syracuse & Onondaga County, NY; High Museum of Art, Atlanta, GA; Museum of Ceramic Art at Alfred, New York State College of Ceramics at Alfred U.; White House, Washington, DC; Charles A. Wustum Museum of Art, Racine, WI
PUBLICATIONS: Paul S. Donhauser, *History of American Ceramics*, Kendall-Hunt Publishers, 1978; Kenneth Clark, *The Potter's Manual*, MacMillan Publishers, London, 1983; Leon Nigrosh, *Clayworks* (2nd edition), Davis Publications, Inc., 1986; Phyllis George, *Craft in America: Celebrating the Creative Work of the Hand*, The Summit Group, 1993
RELATED PROFESSIONAL EXPERIENCE: faculty, U. of Wisconsin, Whitewater, WI, 1973–77; faculty, Montgomery College, Rockville, MD, 1979–80; independent studio artist, 1977–present

ADRIAN SAXE
Los Angeles, California
BORN: Glendale, California, 1943
EDUCATION: Chouinard Art Institute, Los Angeles, CA, 1965–69; B.F.A., California Institute of the Arts, Valencia, 1974
AWARDS/HONORS: Atelier experimental de recherche de création, Manufacture nationale de Sèvres, Centre national des arts plastiques, France, Artist Fellowship, 1983; Art Council, U. of California, Los Angeles, Faculty Grant, 1984; Visual Artists Fellowship, the National Endowment for the Arts, 1986; United States/France Exchange Fellowship, U.S.I.A. and the Government of France, 1987
COLLECTIONS: Everson Museum of Art of Syracuse & Onondaga County, NY; Los Angeles County Museum of Art, CA; Musée des Arts Décoratifs, Paris, France; Musée National de Céramique de Sèvres, Sèvres, France; Nelson-

Atkins Museum of Art, Kansas City, MO; Oakland Museum, CA; Renwick Gallery of the National Museum of American Art, Smithsonian Institution, Washington, DC; White House, Washington, DC
PUBLICATIONS: Garth Clark, *A Century of Ceramics in the United States, 1878–1978*, E. P. Dutton, 1979; Peter Dormer, *The New Ceramics*, Thames and Hudson, London, 1986; Paul J. Smith and Edward Lucie-Smith, *Craft Today: Poetry of the Physical*, American Craft Museum, Weidenfeld & Nicolson, 1986; Garth Clark, *The Eccentric Teapot*, Abbeville Press, 1988; Elaine Levin, *The History of American Ceramics: 1607 to the present*, Harry N. Abrams, Inc., 1988; Martha Drexler Lynn, *Clay Today: Contemporary Ceramists and Their Work*, Los Angeles County Museum of Art, Chronicle Books, 1990; Martha Drexler Lynn, *The Clay Art of Adrian Saxe*, Los Angeles County Museum of Art, 1993
RELATED PROFESSIONAL EXPERIENCE: faculty, California State U., Long Beach, 1971–72; faculty, U. of California, Los Angeles, 1973–present

DAVID J. SCHWARZ
Ridgefield, Washington
BORN: Vancouver, Washington, 1952
EDUCATION: Associate in Arts and Science and Associate in Applied Science/Engineering Technology, Clark College, Vancouver, WA, 1977; B.A., Central Washington University, Ellensburg, 1979; M.S., Illinois State U., Normal, 1982
COLLECTIONS: Corning Museum of Glass, Corning, NY; High Museum of Art, Atlanta, GA; Hunter Museum of Art, Chattanooga, TN; White House, Washington, DC
PUBLICATIONS: Dan Klein, *Glass: A Contemporary Art*, Rizzoli, 1989; Susanne K. Frantz, *Contemporary Glass: A World Survey From the Corning Museum of Glass*, Harry N. Abrams, Inc., 1989; Bonnie Miller, *Out of the Fire: Contemporary Glass Artists and Their Work*, Chronicle Books, 1991; *Tiffany to Ben Tré: A Century of Glass*, Milwaukee Art Museum, WI, 1993
RELATED PROFESSIONAL EXPERIENCE: independent studio artist, 1985–present

LINCOLN SEITZMAN
West Long Branch, New Jersey
BORN: New York, New York, 1923
EDUCATION: B.S., Rensselaer Polytechnic Institute, Troy, NY, 1943
COLLECTION: White House, Washington, DC
RELATED PROFESSIONAL EXPERIENCE: independent studio artist, 1981–present

MICHAEL SHERRILL
Hendersonville, North Carolina
BORN: Providence, Rhode Island, 1954
EDUCATION: self-taught
AWARDS/HONORS: Visual Artist Fellowship, North Carolina Arts Council, 1992–93; Guest of Honor, Arida Arts Symposium, Blue Ridge Community College, Hendersonville, NC, 1994
COLLECTIONS: Mint Museum of Art, Charlotte, NC; MCI Telecommunications Corporation, Inc., Washington, DC; White House, Washington, DC

PUBLICATIONS: *Ceramics Monthly*, September 1993; *American Craft Magazine*, April/May 1994; John Perreault, *Michael Sherrill: New Forms in Clay*, Western Carolina U., Cullowhee, NC, 1994
RELATED PROFESSIONAL EXPERIENCE: faculty, Asheville-Buncome County Schools, NC; faculty, Arrowmont School of Arts and Crafts, Gatlinburg, TN; faculty, Penland School of Crafts, Penland, NC; faculty, U. of Nevada, Las Vegas, NV; independent studio artist, 1980–present

MICHAEL SHULER
Santa Cruz, California
BORN: Trenton, New Jersey, 1950
EDUCATION: self-taught
COLLECTIONS: American Craft Museum, NYC; Fine Arts Museum of the South at Mobile, AL; High Museum of Art, Atlanta, GA; Museum of Fine Arts, Boston, MA; White House, Washington, DC; Wood Turning Center, Philadelphia, PA
PUBLICATIONS: "Monochrome Assembly," *The American Woodturner*, December 1989; "Segmented Turning," *Fine Woodworking*, May/June 1989; *Wall Street Journal*, June 30, 1991; "Segmented Turning," *Small Woodworking Projects: The Best of Fine Woodworking*, Taunton Press, 1992; *American Craft Magazine*, June/July 1994
RELATED PROFESSIONAL EXPERIENCE: independent studio artist, 1973–present

SUSY SIEGELE
Huntsville, Arkansas
BORN: Coffeyville, Kansas, 1953
EDUCATION: B.A., Texas Women's U., Denton, 1977
COLLECTIONS: White House, Washington, DC
RELATED PROFESSIONAL EXPERIENCE: Workshops: "Colored Clays in Patterns," Dallas Craft Guild, TX; "Colored Clay," Ossage Pottery, Berryville, AR; "Colored Porcelain at Tarrant County College," Fort Worth, TX; "Nenage Slab Construction," Cedar Valley College, Lancaster, TX; independent studio artist, 1975–present

JOSH SIMPSON
Shelburne Falls, Massachusetts
BORN: New Haven, Connecticut, 1949
EDUCATION: B.A., Hamilton College, Clinton, NY, 1972
AWARDS/HONORS: First Prize, *Wichita National*, Wichita Art Association, 1986; Jurors' Award, Philadelphia Craft Show, 1989, 1992; Humanitarian Award, *Niche Magazine* Design Award, 1993; Massachusetts Cultural Council, Individual Project Support Grant, 1993
COLLECTIONS: Bergstrom-Mahler Museum, Neenah, WI; Corning Museum of Glass, Corning, NY; Museum Bellerive, Zurich, Switzerland; National Air and Space Museum, Smithsonian Institution, Washington, DC; White House, Washington, DC; Yale U. Art Gallery, New Haven, CT
PUBLICATIONS: Phil Patton, "How Art Geared Up to Face Industry in Modern America," *Smithsonian Magazine*, November 1986; Susanne K. Frantz, *Contemporary Glass: A World Survey From the Corning Museum of Glass*, Harry N. Abrams, Inc., 1989; Dan Klein, *Glass: A Contemporary Art*, Rizzoli, 1989; *Glass*

Magazine, Summer 1992, Fall 1994; *New Glass Review*, Corning Museum of Glass, NY, 1979, 1984, 1987, 1990, 1992, 1993; Constantina Oldknow, *Josh Simpson: New Work, New Worlds*, Emerson Gallery, Hamilton College, Clinton, NY, 1994
RELATED PROFESSIONAL EXPERIENCE: faculty, Penland School of Crafts, Penland, NC, 1989; faculty, Haystack Mountain School of Crafts, Deer Isle, ME, 1990; faculty, Tokyo Glass Art Institute, Tokyo, Japan, 1993; faculty, Noto-jima Glass Art Center, Noto-jima, Japan, 1993; independent studio artist, 1972–present

ALAN STIRT
Enosburg Falls, Vermont
BORN: Brooklyn, New York, 1946
EDUCATION: self-taught
COLLECTIONS: American Craft Museum, NYC; Arizona State U., Tempe; Fine Arts Museum of the South at Mobile, AL; High Museum of Art, Atlanta, GA
PUBLICATIONS: Edward Jacobson, *The Art of Turned Wood Bowls*, E. P. Dutton, 1985; Richard Raffin, *Turned Bowl Design*, Taunton Press, 1988; *Small Woodworking Projects: The Best of Fine Woodworking*, Taunton Press, 1992; Lloyd E. Herman and Matthew Kangas, *Tales and Traditions: Storytelling in Twentieth-Century American Craft*, U. of Washington Press, 1993
RELATED PROFESSIONAL EXPERIENCE: faculty, Arrowmont School of Arts and Crafts, Gatlinburg, TN, 1985, faculty, 1987–94; faculty, Haystack Mountain School of Crafts, Deer Isle, ME, 1987; independent studio artist, 1974–present

RANDY J. STROMSÖE
Cambria, California
BORN: Los Angeles, California, 1951
EDUCATION: apprentice to Master Silversmith, Porter Blanchard, 1970–73; training with Lewis A. Wise, 1973–75; designer and superintendent, Porter Blanchard Silversmiths, Inc., Calabasas, CA, 1975–79
AWARDS/HONORS: US State Department, International Presidential Gifts, 1983–85, presented to: Jacques Chirac, France; King Hussein, Jordan; Prime Minister Spadolini, Italy; King Olaf, Norway; François Mitterrand, France; Helmut Schmidt, West Germany
COLLECTIONS: MCI Telecommunications Corporation, Inc., Washington, DC; Oakland Museum, CA; White House, Washington, DC; Vatican Museum, Rome, Italy
PUBLICATIONS: Constance Stapleton, *Crafts of America*, Harper & Row, 1988; Michael Wolk, *Designing for the Table: Decorative and Functional Products*, Rizzoli, 1992
RELATED PROFESSIONAL EXPERIENCE: independent studio artist, 1975–present

MARA SUPERIOR
Williamsburg, Massachusetts
BORN: New York, New York, 1951
EDUCATION: B.F.A., U. of Connecticut, Storrs, 1975; M.A.T., U. of Massachusetts, Amherst, 1980
AWARDS/HONORS: Prize for Craftsmanship and Design, Philadelphia Craft Show, PA, 1981; Judges' Award, Craftsperson, Washington Craft

Show, Smithsonian Institution, Washington, DC, 1985; Fellow, Massachusetts Artists Fellowship, 1988, 1991; Visual Artists Fellowship, the National Endowment for the Arts, 1990; Fellow, Massachusetts Cultural Council, 1992
COLLECTIONS: White House, Washington, DC; Charles A. Wustum Museum of Fine Arts, Racine, WI
PUBLICATIONS: Garth Clark, *The Eccentric Teapot*, Abbeville Press, NY, 1989; Angela Fina, Review, *American Ceramics*, April 1990; Lloyd E. Herman, *Art that Works: Decorative Arts of the Eighties, Crafted in America*, U. of Washington Press, 1990; review of "The Hearth" at the Ferrin Gallery, *Ceramics Monthly*, March 1990; "Philadelphia Craft Show Portfolio," *Ceramics Monthly*, May 1990; "1990 NEA Grants," *Ceramics Monthly*, December 1990; Bill Kraus, *Contemporary Crafts for the Home*, Kraus Sikes, Inc., Madison, WI, 1990
RELATED PROFESSIONAL EXPERIENCE: independent studio artist, 1980–present

KATE VOGEL
Bakersville, North Carolina
BORN: England, 1956
EDUCATION: Santa Haperata Graphic Center, Florence, Italy, 1977; B.S.A., U. of Wisconsin, Madison, 1978
COLLECTIONS: Glasmuseum, Ebeltoft, Denmark; Glasmuseum Frauenau, Frauenau, Germany; High Museum of Art, Atlanta, GA; Milwaukee Art Museum, WI; Mint Museum of Art, Charlotte, NC; Musée des Arts Décoratifs, Lausanne, Switzerland; St. Louis Art Museum, MO; White House, Washington, DC
RELATED PROFESSIONAL EXPERIENCE: independent studio artist, 1980–present

JAMES C. WATKINS
Lubbock, Texas
BORN: Louisville, Kentucky, 1951
EDUCATION: B.F.A., Kansas City Art Institute, MO, 1973; M.F.A., Indiana U., Bloomington, 1977
AWARD/HONOR: The President's Excellence in Teaching Award, 1990; Texas Commission on the Arts Grant, 1991–92
COLLECTION: White House, Washington, DC
PUBLICATIONS: "Clay Heritage: African American Ceramics," *NCECA Journal 1992–1993*, 1993; *American Craft*, April/May 1993; *Uncommon Beauty in Common Objects: The Legacy of African Craft Art*, Wilberforce, OH, 1993; *The International Review of African Art: Living in a Glass House, Passing Through Glass*, Hampton U. Museum, 1994
RELATED PROFESSIONAL EXPERIENCE: Resident Artist, The Shigaraki Institute of Ceramic Studies, Shigaraki, Japan, 1994; Resident Scholar, The Japan Center for Michigan Universities, Hikone, Japan, 1994; faculty, Texas Tech U., Junction, 1983–present

CHERYL C. WILLIAMS
Eugene, Oregon
BORN: Arcadia, California, 1958
EDUCATION: San Francisco Art Institute, CA, 1976–77; City College of San Francisco, CA, 1980–82

COLLECTIONS: MCI Telecommunications Corporation, Inc., Washington, DC; White House, Washington, DC; Charles A. Wustum Museum of Fine Arts, Racine, WI
PUBLICATIONS: *Matter Monthly*, 1990; *Ceramics Monthly*, 1991
RELATED PROFESSIONAL EXPERIENCE: independent studio artist, 1985–present

NATHAN YOUNGBLOOD
Santa Clara Pueblo
BORN: Fort Carson, Colorado, 1954
EDUCATION: self-taught
AWARDS/HONORS: New Mexico State Fair, 1976, 1978, 1979, 1980; Best of Class, Intertribal Ceremonial, Gallup, NM, 1972, 1975, 1977, 1978, 1979, 1980, 1981; Best of Class, Undecorated, Indian Market, Santa Fe, NM, 1977; Best of Class, Carved, Indian Market, Santa Fe, NM, 1979, 1982, 1988; Excellence in Santa Clara Pottery, Indian Market, Santa Fe, NM, 1987; Best Traditional Large Jar, Indian Market, Santa Fe, NM, 1987
COLLECTION: White House, Washington, DC

PUBLICATIONS: *New Mexico Craft*, Issue One; *Artline*, August 1985; *Southwest Profile*, May/June 1986
RELATED PROFESSIONAL EXPERIENCE: independent studio artist, 1974–present

MARY ANN "TOOTS" ZYNSKY
Philadelphia, Pennsylvania
BORN: Lynnfield, Massachusetts, 1951
EDUCATION: B.F.A., Rhode Island School of Design, Providence, 1973
AWARDS/HONORS: Artist-in-Residence Grant, New York State Council for the Arts, 1982; Visual Artists Fellowship, the National Endowment for the Arts, 1982, 1986; Amsterdam Research Grant, Stricting Klanschap, 1984
COLLECTIONS: American Craft Museum, NYC; Boymans van Beuningen, Rotterdam, Netherlands; Cooper-Hewitt, National Design Museum, Smithsonian Institution, NYC; Corning Museum of Glass, Corning, NY; Glasmuseum, Ebeltoft, Denmark; Leigh Yawkey Woodson Art Museum, Wausau, WI; Musée des Arts Décoratifs, Paris, France; Musée des Arts Décoratifs, Lausanne, Switzerland; Museum Bellerive Zurich, Switzerland; Museum of Modern Art, NYC; Philadelphia Museum of Art, PA; J. B. Speed Museum, Louisville, KY; Toledo Museum of Art, OH; White House, Washington, DC
PUBLICATIONS: Paul J. Smith and Edward Lucie-Smith, *Craft Today: Poetry of the Physical*, American Craft Museum, Weidenfeld & Nicolson, 1986; Robert Charleston, *Masterpieces of Glass: A World History from the Corning Museum of Glass*, 1990; Martina Margetts, *International Crafts*, Thames and Hudson, 1991; *Design Visions*, Art Gallery of Western Australia, Perth, Australia, 1992; *All About Glass*, Shinahusha Co., Ltd., Tokyo, Japan, 1992; Lloyd E. Herman, *Clearly Art: Pilchuck's Glass Legacy*, U. of Washington Press, 1992; *Survey of Glass in the World*, Kyuryudo Art Publishing Co., Ltd., Tokyo, Japan, 1992; *Contemporary Crafts and the Saxe Collection*, Toledo Museum of Art, OH, 1993
RELATED PROFESSIONAL EXPERIENCE: independent studio artist, 1978–present

ACKNOWLEDGMENTS

To President William Jefferson Clinton and First Lady Hillary Rodham Clinton I owe a great debt of gratitude for their willingness to share their enthusiasm for the arts, and for embracing the visual expressions of America's craft artists in the White House.

Without the support and cooperation of the White House staff, an undertaking of this magnitude would not be possible. Maggie Williams, Assistant to the President and Chief of Staff to the First Lady, deserves thanks for her generous assistance. To Ann Stock, Special Assistant to the President and Social Secretary, go my very special thanks. Her belief in the importance of contemporary American crafts was vital to sustaining the momentum of this project. Her two able Special Assistants, Joyce Bonnett and Tracy LaBrecque, were particularly helpful in communicating with the artists and organizing a myriad of details.

To the White House curatorial staff, Rex Scouten, Curator; Betty Monkman, Associate Curator; and William Allman, Assistant Curator, warm thanks for their assistance in documenting objects, overseeing their movement, and reviewing text. A special acknowledgment goes to Gary Walters, Chief Usher, whose handling and coordination of the 1993 holiday celebration were greatly appreciated. To Nancy Clarke, Chief Floral Designer, goes my respect and admiration for her ability to transform the White House with a stunning holiday display using more than six thousand handcrafted ornaments and seventy-two craft objects.

Sincere thanks are owed to G. Neel Lattimore, Deputy Press Secretary to the First Lady, for extending himself to assure that several critical aspects of this project could be accomplished in a timely manner. I am grateful to Allison Muscatine for communicating the spirit of this effort. Credit is also due to Nancy Ellison for her excellent photograph of Mrs. Clinton used on the back of the book jacket.

Marvin Krislov and Kathleen Whalen, Assistant Counsels to the President, and Stephen Neuwirth, Associate Counsel to the President, were especially important in drafting language that will ensure that these objects continue to be appreciated by future generations. To Robert Barnett, much appreciation is due for his wise counsel concerning this publication.

In the opening days of the Clinton administration, it was Dorothy Kalins, Editor-in-Chief of *Garden Design* and *Saveur* magazines, Meigher Communications, who first encouraged the First Family to entertain in the White House by highlighting a distinctive style featuring American cuisine, crafts, and the visual and performing arts.

The 1993 "Year of American Craft: A Celebration of the Creative Work of the Hand" started as a project of the Crafts Report Educational Fund, Inc. The concept was originally inspired by and first introduced to the craft community through Hortense Green's leadership of the successful "All Join Hands" celebration of crafts in New Jersey. I am indebted to her for her determined lobbying efforts on behalf of craft groups in the United States and for her

vision of a model on which to build a national and international celebration of craft.

The official planning of the Year of American Craft began in 1989, and a national steering committee was organized. The committee wisely elected Susie Gray, founder of the Smithsonian craft show in Washington, D.C., to chair their group. Very special thanks go to her for her remarkable leadership and guidance. It was as a result of her efforts, in conjunction with the crucial support and sponsorship of the American Crafts Council, that on October 23, 1993, the 102nd Congress passed the resolution H. J. RES 380, followed by President George Bush's Presidential Proclamation designating calendar year 1993 as the Year of American Craft.

An articulate spokesperson and craft advocate, Phyllis George Brown, wife of former Kentucky Governor John Brown and founder of the Kentucky Arts and Crafts Foundation, played a vital role as honorary chair and national spokesperson. She made numerous appearances on behalf of the yearlong celebration, for which I am most grateful. Special appreciation is also owed to Linda Van Trump, Executive Director of the Arkansas Craft Guild, and Susie Gray for their tremendous assistance in identifying craft artists to be invited to create holiday ornaments.

Additionally, I would like to thank the members of the Year of American Craft steering committee, who devoted countless hours of their expertise. They include: Joann H. Stevens, Vice Chair; Joan Foster Tooke, Secretary; Carolyn A. Hecker, Treasurer; Terrance Demas; Ray Dockstader; Robert G. Hart; Evangeline J. Montgomery; Alice Rooney; and Rita Steinberg. Carol Sedestrom Ross and Hortense Green of the American Craft Council were effective and supportive liaisons. My sincere thanks to each of the state coordinators of the Year of American Craft who were unfailing sources of good information and good humor.

To John Bigelow Taylor and S. Dianne Dubler goes my great appreciation for the exquisite photography in this book. John's ability to capture the rich color and texture of the handcrafted objects is quite remarkable, and the series of photographs styled by Dianne that picture the crafts in the various rooms of the White House are truly breathtaking. In addition, many thanks to Michael Vitti for his careful photographic assistance.

To Barbaralee Diamonstein, my sincere gratitude for her essay, which surveys the historical development of the American craft movement with clarity and insight.

To my staff at the Renwick Gallery I remain forever indebted for their attention to detail and deep reservoirs of energy and patience. Marguerite Hergesheimer, Megan Neal, and Gary Wright were invaluable in many ways, including compiling artists' biographical materials and completing a range of other organizational tasks that demanded skill, patience, and devotion.

At the National Museum of American Art, the parent museum of the Renwick Gallery and the location of this exhibition, I am indebted to Elizabeth Broun, Director, whose belief in craft art and commitment to this project were instrumental to its success. She wholly embraced the idea of showing the White House crafts collection as an exhibition. Val Lewton, Chief of Design and Production at the National Museum of American Art, together with Robyn Kennedy have once again produced an exceptional gallery installation. Also, I thank Melissa Kroning, Registrar, Office of Registration and Collections Management at the National Museum of American Art, for assuring that all aspects of the registration and handling of the objects for the exhibition received careful attention. To Katie Ziglar, Public Affairs Officer, special thanks for communicating her enthusiasm for this project to the press.

At Harry N. Abrams, Inc., I thank Paul Gottlieb for his ardent vision. His steadfast

commitment to this project from conception to completion remains an inspiration. To my editor, Elisa Urbanelli, my sincere gratitude for her patience, diligence, and thoughtful editing. I especially appreciate the handsome design of this publication by art director Samuel N. Antupit and designer Liz Trovato whose magnificent efforts enhance the strength and beauty of the objects.

Most important, my appreciation extends to the craft artists themselves. Their spirit of generosity has made this collection possible, and their cooperation in supplying information about their work and themselves has been profoundly gratifying. Four of the pieces in this collection were donated by generous patrons of the artists. To them, Karen Johnson Boyd, Barbaralee Diamonstein and Carl Spielvogel, Stewart G. Rosenblum, and Norma and William Roth, I extend my gratitude.

Finally, I hope that the reader and the museum visitor will be moved to explore further the world of contemporary American crafts. To each individual who lent his or her commitment, knowledge, and enthusiasm to this project, your efforts have immeasurably enriched all of us.

Michael W. Monroe
Curator-in-Charge, Renwick Gallery